MW01285013

JEAN-MARC
THÉVENET

MOTORBIKES
AND COUNTERCULTURE

Imprint

Published 2019 by

GINGKO PRESS

Gingko Press Verlags GmbH
Schulterblatt 58
D-20357 Hamburg
Germany
Tel: +49 (0)40-291425
Fax: +49 (0)40-291055
Email: gingkopress@t-online.de

Gingko Press Inc
2332 Fourth Street, Suite E
Berkeley, CA 94710
USA
Tel: (510) 898 1195
Fax: (510) 898 1196
Email: books@gingkopress.com
www.gingkopress.com

ISBN: 978-3-943330-27-4

Translation from the French: Joseph Laredo © Gingko Press Verlags GmbH
Copyediting: John Stilwell
Typesetting: Weiß-Freiburg GmbH – Graphik und Buchgestaltung

Printed in Slovenia

Published originally under the title: Moto, le temps de la liberté
© 2018 by Editions Tana, a department of Edi8, Paris
English translation copyright: © 2019 by Gingko Press Verlags GmbH

For the original French edition:
Editorial manager: Marie Baumann
Project manager: Laurence Basset
Copy-Editing: Karine Elsener
Graphic design and layout: Julian Jeanne
Photogravure : Natalie Cicurel@Poisson Rouge, Paris

All rights reserved. No part of this publication may be reproduced or transmitted in
any form or by any means, electronic or mechanical, including photocopy, recording
or any other information storage and retrieval system, without prior permission in
writing from the copyright holders.

MOTORBIKES
AND COUNTERCULTURE

JEAN-MARC THÉVENET

GINGKO PRESS

CONTENTS

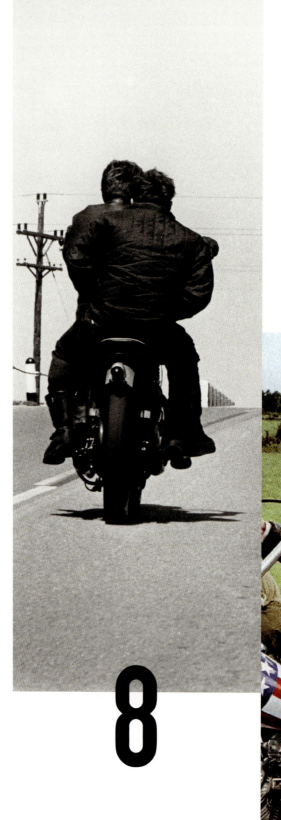

52

8

128

90

166

FOREWORD

Riding—an escape from routine, a revolt against the dictates of society, a flight into other worlds, real or imaginary, the road to freedom. By the mid-20th century, the motorbike had become the perfect vehicle for modern Men of La Mancha who chased, not conquests, but dreams. The British writer T. E. Lawrence, aka "Lawrence of Arabia" (and author of *Seven Pillars of Wisdom*, a vivid and masterful account of the Arab revolt against the Ottoman Empire during the First World War), was fatally injured while riding his Brough Superior in 1935 and died at the age of 46. Before achieving iconic status for his role in the Cuban revolution of 1958, Che Guevara "drifted aimlessly" across Argentina, Chile, Peru, Columbia, and Venezuela on a Norton 500. And after them came other famous bikers—in literature and journalism, in the movies, and on the race track. Heralds rather than heroes, since biking is largely a state of mind. A motorcycle is "merely a tool," according to Anne-France Dautheville, the first woman to ride around the world (in 1973) on a 100 cc Kawasaki—not the obvious choice for such a marathon. Whether solo or in groups—"gangs," as the hacks of the 1950s described them in an attempt to sensationalize the phenomenon and terrify their law-abiding readers—motorcyclists gradually became known as "bikers," and they came to symbolize all that was off limits, as well as the search for identity and a yearning for a world without boundaries.

The moral and economic dislocation caused by the Second World War; the subsequent struggle to return to some kind of "normality;" the other war, the so-called Cold War, with its ideological conflict between capitalists and communists; the generation gap that opened up in the 1960s, with its succession of "freedoms"—of speech, of sexuality, of music—and the ephemeral speed worship in the 1970s; all this provided fertile soil for the growth of a counterculture whose most prominent symbol was the motorcycle. A counterculture that was satirized in Jerry Leiber's and Mike Stoller's 1955 hit *Black Denim Trousers and Motorcycle Boots*, according to which a biker was a fool who "never washed his face and never combed his hair." A "terror," no less.

Today, bikers no longer terrorize law-abiding citizens. Yes, they are still tribal, with their codes and their badges, their rituals and their rendezvous—Daytona, the Isle of Man, Biarritz, Montlhéry... But over time, the motorcycle has become a source of nostalgia. Like Proust's madeleine, it conjures up a lost past, a youth that will never be recaptured but that a ride on a Honda CB750 or a Kawasaki 900 or a Suzuki T500 might yet re-evoke.

The freedom afforded by motorcycle riding is like a vast continent, with its mythical locations (often asphalt tracks or sand circuits); its men and women from every culture and walk of life, each adding a stone to the great but invisible edifice that is "riding;" its defined periods and its defining vocabulary (words that aren't even in the Scrabble dictionary, such as farkle, motard, panny, rubbie and bitza); and its peace-loving gang leaders (well, most of them), perpetuating the legends and dreaming of impossible rides... like freedom itself, riding arouses either fascination or incomprehension in the uninitiated. But then, freedom is not for everyone. It is a quest—and riding is its vehicle.

A life on the road promises freedom—the freedom evoked by Jack Kerouac—as the Beat Generation gives way to the world of hippies and bikers.

6

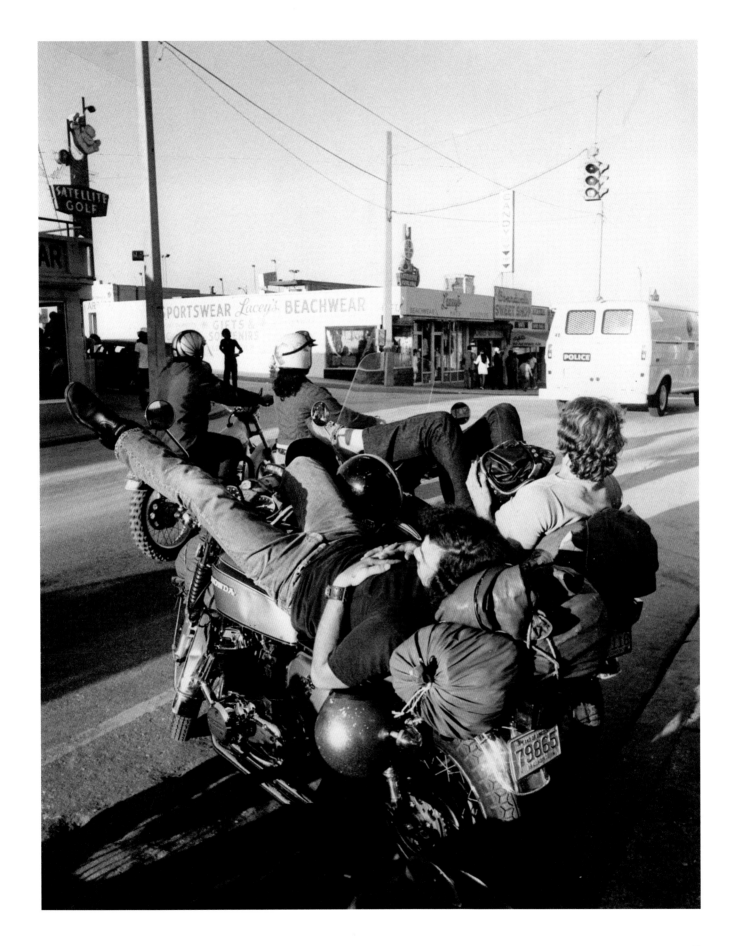

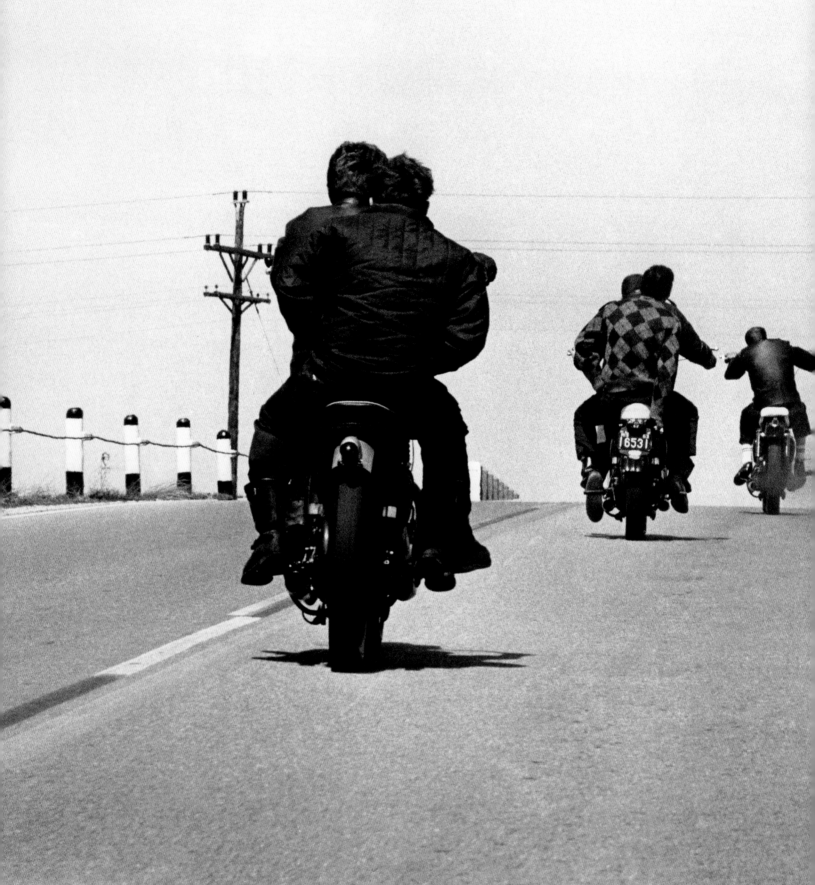

A LIFE ON THE ROAD

The 1950s saw the birth of a new vision of the world—a vision based on the word "freedom." Che Guevara, Marlon Brando, and Steve McQueen were among those who paved the way. From the Beat Generation to the Summer of Love (1967), from biker Z movies to the outbreak of the Vietnam War, a whole new generation seemed to heed the call, as if responding to the dictum that "today is the first day of the rest of your life."[1]

Danny Lyon was one of America's first photographers to take an interest in riders. This picture was taken on Route 12 in Wisconsin, in 1963.

CHE GUEVARA'S "PODEROSA II"

At the time, they were just young men dreaming of a better world. They were devoted friends living in oppression in Argentina. They knew little about riding and even less about navigation. But their names were Ernesto Guevara and Alberto Granado, and their journey would become legendary.

It was in December 1951 that a young Argentinian of 23, frail and asthmatic, decided to travel "across 'the Big Part of America"[2] with his friend Alberto Granado. His name was Ernesto Guevara, but he would become known to the world as Che Guevara. Then studying medicine, he had previously worked as a nurse on an oil-tanker and as an orderly in a municipal health center.

The "Big Part of America" he set out to cross was in fact North America, which the two men never actually reached. They were guided only by a rough itinerary scribbled on a piece of paper: "Chile 752 miles (1,210 km), Peru 1478 miles (2,379 km), Buenaventura 3900 miles (6,276 km)." Guevara, nicknamed "The Furious" by his rugby teammates, would not bother with a real road map! He was not to know, of course, that exactly seven years later, in December 1958, he and Fidel Castro would end the bloody dictatorship of Rubén Zaldívar, known as Fulgencio Batista, of Cuba. For the time being, his own country, Argentina, was suffering another dictatorship—that of Juan Perón. As for Guevara's friend Granado, he had just given up his job at the leprosy hospital in

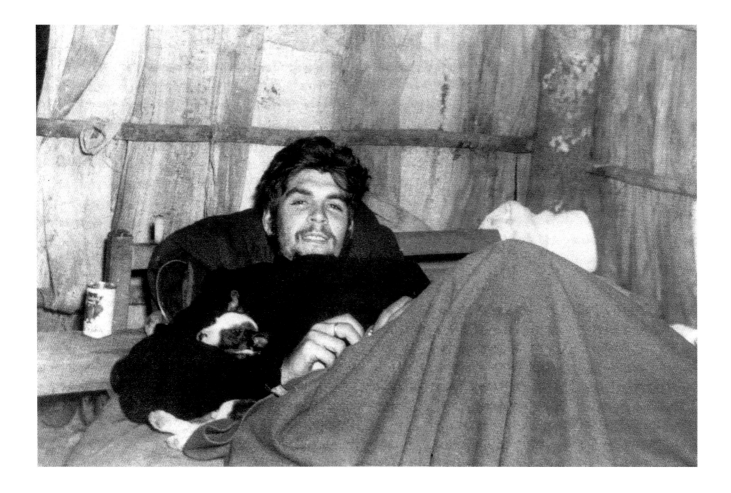

Ernesto Guevara
with his dog
Comeback, which
accompanied
him for the first
few days of his
journey and also
fell off the bike
several times—
fortunately
without injury.

San Francisco de Chañar. As Guevara put it, they were living "a dog's life."[3]

A born militant, Alberto viewed the journey as an opportunity to contact oppressed people, and he would hand out anti-imperialist pamphlets from the back of their Norton 500, which they nicknamed "La Poderosa II" (The Mighty One II). Ernesto, on the other hand, was thinking of all the French authors he would read—Jules Verne, Alexandre Dumas, Rimbaud, Baudelaire—and saw the trip rather as a bid for freedom—his own, that is. Together, they would discover "new horizons" and "roam the highways and waterways of the world forever."[4] Guevara's aims were as yet a long way short of his future revolutionary ideals, to say the least. Throughout the journey, he would be content with seducing women, chasing chickens, and thieving. His attitude was similar to that of T. E. Lawrence, who owned no fewer than eight Brough Superiors and cursed "the

horrible boredom of having nothing to do."[5] Many years later, in *The Motorcycle Diaries*, he would subconsciously transform the experience of an improbable journey on an unsuitable machine, and the resulting disasters, into the dawning realization that he was a man with a mission, destined to lead an unconventional life.

THE NORTON 500 "HOBBLES ALONG"

Despite having thousands of miles ahead of them and only a vague idea of where they were going, they had few exciting adventures, as Guevara acknowledged in his later account. With no money, he and Alberto could afford neither trains nor planes, but had to rely entirely on The Mighty One. Why that name? Why not The Work Horse, since it was more like Don Quixote's faithful but decrepit mount La Rocinante (*rocín* means "work horse"). Indeed, the age of their already vintage Norton 500 has

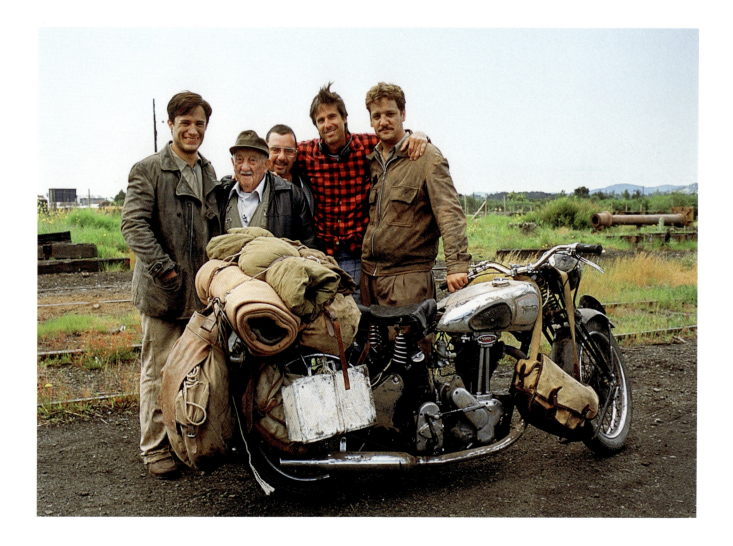

been the subject of some debate. Some say it was built in 1939, others in 1947. And yet they managed to cover more than 6,000 miles on it. The first 600, although ostensibly the most straightforward, must have felt like a ride on a bucking bronco: "The bike is very difficult to control because of all the weight on the rack at the back, which is way behind the balance point. The slightest bump in the road makes it rear up and catapult us into the air,"[6] wrote Guevara. Once, when he was riding, the bike ended up on its side in the sand nine times in a single day. Hardly a Paris–Dakar rally winner in the making! Angry and agitated, he anticipated neither the vagaries of the road—sudden bends and encroaching vegetation—nor the unpredictable behavior of the aging machine. Nevertheless, he commented, "the air seemed lighter and we seemed to breathe more freely

there. Perhaps it was the air of adventure, as distant lands, heroic deeds, and beautiful women filled our excited imaginations."[7]

The Norton "hobbled along," leaked like a sieve, and was held together with pieces of wire—on the advice of a young mechanic: "Given a choice of wire or a screw, I know which I'd trust."[8] One morning, they discovered that the crash bar was cracked, and punctures became more and more frequent, so that in the end they had to jettison not only the little baggage they were carrying (a small suitcase containing two pairs of trousers, three pairs of underpants, a pair of socks, two sweaters, and a toilet bag, plus a tent, some blankets, and an automatic pistol) that were weighing the Norton down, but also the aforementioned wires, which slowed down any necessary repairs. Guevara, who

From left to right: Gael García Bernal, Alberto Granado, Alberto Granado, Jr., Walter Salles (Director), and Rodrigo de la Serna during the filming of *The Motorcycle Diaries* in 2004.

"My soaring dreams were curiously at odds with the rhythm of water being pumped out of the bilges."

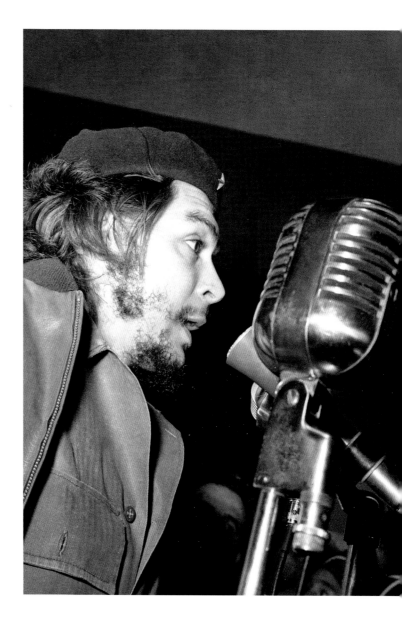

had only 15 years left to live. He wrote in his diary: "Maybe one day, when I'm tired of running around the world, I'll come back to this corner of Argentina—maybe not for ever, but to take a breath before I set off again in search of a different world."[9]

THE NORTON EXPIRES

With puncture after puncture, they were down to an average speed of 2 mph—the Norton having been designed for roads softened by English drizzle rather than the stony and treacherous tracks of Argentina. When they got to Chile, they boarded a leaking boat: "My soaring dreams were curiously at odds with the rhythm of water being pumped out of the bilges."[10] On another occasion, after yet another crash, one of the front forks broke and the gearbox fell to pieces. The brake discs wore out and the handbrake failed. In the end, it seemed, the Norton had had enough of the hills, and the next descent could prove fatal—for them as well as for the bike. Having begun at Córdoba in Argentina on December 29th, 1951, the bike tour ended at Santiago in Chile on March 1st, 1952. That day, as Guevara recalled, he and Granado ceased to be "motorized vagabonds" and became "non-motorized vagabonds."[11] Their odyssey finally came to an end in July of that year in Caracas, Venezuela.

The end of the road: Che as a full-time revolutionary haranguing the crowd on his way to his greatest achievement—bringing down Cuba's dictator.

Ernesto Guevara, now known as Che, was executed at age 39 by a soldier with a semi-automatic on October 8th, 1967, on the orders of the Bolivian President René Barrientos. Che's great adversary, Batista, died of a heart attack in 1973, at the age of 72, near Marbella in Spain. Alberto Granado, who, after the Cuban revolution, founded the Santiago de Cuba Medical School, lived until he was 88 and died in his bed. As for La Poderosa, its name lives on thanks to Che Guevara's son Ernesto, who has set up a company offering "La Poderosa Tours" of Cuba. The bikes it uses are Harley-Davidsons—archetypal emblems of the capitalism Che and his comrades so passionately fought against.

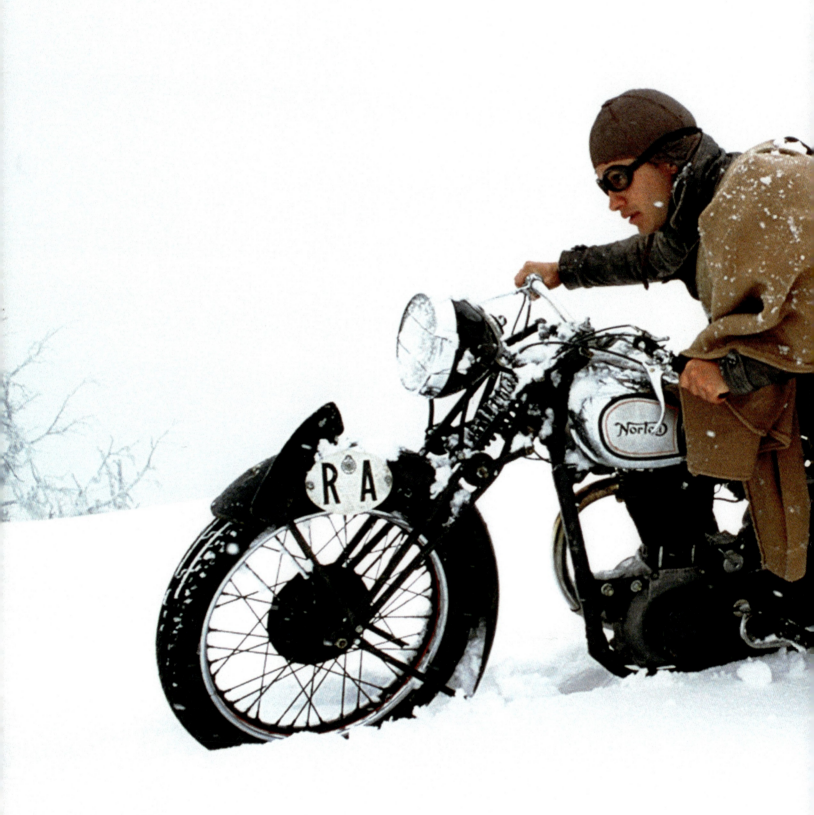

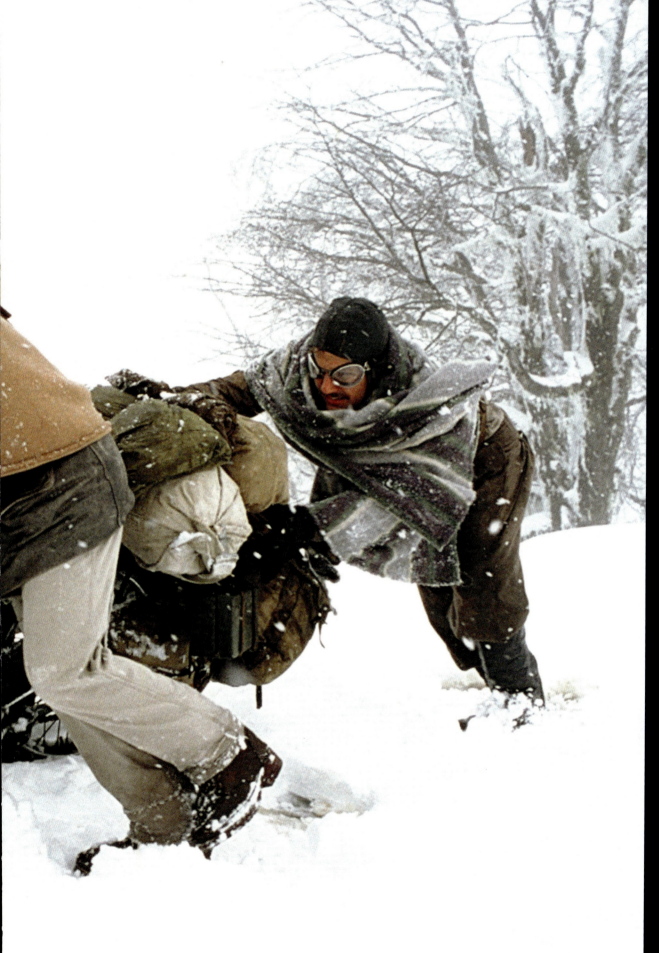

A still from the 2004 movie The Motorcycle Diaries, directed by Walter Salles, who went on to make an adaptation of Jack Kerouac's On the Road in 2012.

JACK KEROUAC— BEAT GENERATION GURU

In the same year as Che's motorcycle adventure, a writer in North America punched a hole in the literary landscape with his book *On the Road*, which became the manifesto of the Beat Generation and the subsequent hippie movement.

In his journal, on August 23rd, 1948, Jack Kerouac wrote: *"I have another novel in mind—'On the Road'—which I keep thinking about: two guys hitchhiking to California in search of something they don't really find, and losing themselves on the road, coming all the way back hopeful of something else."*[12] As such, *On the Road* is a kind of precursor to *Easy Rider* and its many imitations.

Jack Kerouac, known as Ti Jean (which in French means "Little John"), was born in Lowell, Massachusetts, on March 12th, 1922. He was descended from Urbain-François le Bihan, a landowner in Kervoach in Brittany, France, who settled in Quebec in the late 19th century. A fervent writer, Kerouac was proud of his bilingual ancestry: Pointing out that English was "not my own," he explained that he must refashion it "to fit French images.[13] Kerouac did not own a motorcycle—it is even unlikely that he had any kind of driver's license—but he was obsessed with movement, with individual liberty, and, of course, with the road. He

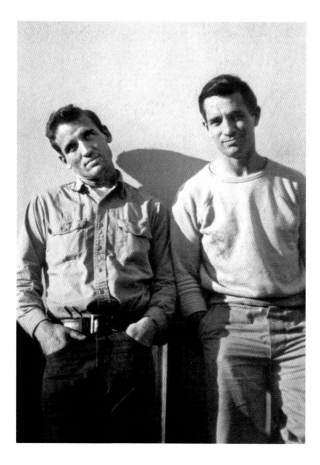

Jack Kerouac (right) with his "brother" Neal Cassady, who fixed in his mind the idea that "the road is life."

dedicated thousands of pages to this principal theme—from *Where the Road Begins* (a four-page essay) to *On the Road* itself, in which he expressed his famous mantra: "The road is life."

Kerouac moved to New York ("THE" city) in 1939 and won a football scholarship to Columbia University, where an injury in only his second game destroyed his hopes of becoming a professional football player. Dropping out of Columbia, he joined the U.S. Navy, but was discharged on psychiatric grounds. Back on terra firma, he met two future legends of the Beat Generation, Allen Ginsberg and William S. Burroughs. Both men loved to shock: Ginsberg's poem *Howl* would later be banned for obscenity, and Burroughs would kill his wife while supposedly re-enacting the story of William Tell.

"WENT FAST BECAUSE ROAD IS FAST"

1947 was a pivotal year in Kerouac's life: it was the year he met Neal Cassady, his fictional and surrogate brother. (As a child, Kerouac had lost

his beloved older brother Gerard.) Cassady—an athletic and boastful petty criminal and womanizer—seemed to be the incarnation of Kerouac's alter ego and became his mentor. Like Cassady, Kerouac could not stay still. The following year, he embarked on his first road trip, a six-month odyssey from New York to Los Angeles, via Denver and San Francisco, among other places.

Back in the Big Apple, Kerouac wrote to Cassady on May 22nd, 1951—not long before Che Guevara took to the road on his Norton 500: "Went fast because road is fast [... It's about] you and me and the road [... I] rolled it out on floor and it looks like a road."[14]

The "scroll" of *On the Road* was typed in 21 days, but it could not be printed as such. When his publisher rejected it, Kerouac is said to have exclaimed: "It was dictated by the Holy Spirit! It doesn't need editing!" Eventually, Kerouac submitted two other versions, in a more traditional format. In one of them, it is not *On the Road* that appears on the title page, but *The Beat Generation*. The expression "Beat Generation" had been coined by a *New York Times* columnist John Clellon Holmes and referred to the lost generation of writers such as Ernest Hemingway who had lived through the First World War. Did the term "beat" come from the slang for "worn out"—(dead) beat—or from the beat of jazz music? In an interview with the critic Joyce Johnson, Kerouac insisted that beat was connected to *beatific*.

Although the publishers Kerouac approached could tell that they were looking at a work that epitomized the Beat Generation, they were afraid of being prosecuted for obscenity.

Finally, on September 5th, 1957, *On the Road* was published by Viking Press. One conservative critic found it offensive and compared Kerouac to Marlon Brando and James Dean, whose movies *The Wild One* (1953) and *Rebel without a Cause* (1955) had horrified right-wing Americans everywhere. The writer in question railed against young men who were all brawn and no brain, for whom violence was the default reaction to the slightest provocation.[15] Kerouac responded that he had wanted to write a book about two rebellious young men and the affection that existed between them.[16] This was the time when Lee Strasberg was training actors at his ground-breaking Actors Studio to express themselves through their emotions; when pop art was exploding in the U.S. and the U.K. with artists such as Jackson Pollock and Robert Rauschenberg; when singers like Bob Dylan and Jim Morrison were taking the music world by storm. When Dylan admitted that "On the Road [...] changed my life like it changed everyone else's"[17] and Morrison set out on his own journey of discovery after reading *On the Road*, Kerouac realized that he had unwittingly become a preacher, even an icon, of a new way of thinking, acting, writing, and protesting—one

Kerouac realized that he had become an icon of a new way of thinking, acting, writing, and protesting.

that, by the early 1960s, would develop into a counterculture.

THE ROAD TO 1968

Kerouac's novel soon became a best-seller, and he wrote to Marlon Brando with an idea for a movie version: Kerouac would write the screenplay and play himself, and Brando would be the Dean Moriarty/Neal Cassady character. He received no reply. Novelists have always had an uneasy relationship with Hollywood.

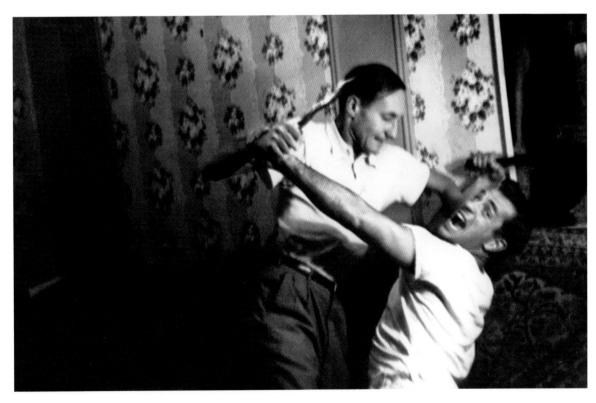

Is William S. Burroughs, writer and doyen of the Beat Generation, really attacking Kerouac with a wrench? After all, he did shoot his own wife in the head...

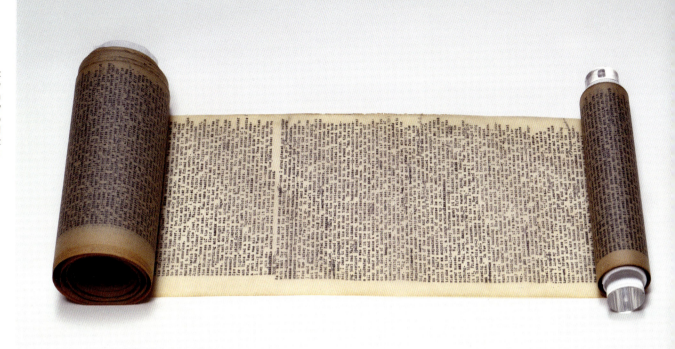

The original 120-ft long scroll of *On the Road*, which Kerouac initially refused to allow to be edited, fetched $2.4 million at auction in 2001.

The fervor caused by the publication of *On the Road* soon subsided, and Kerouac went on to publish other books—while destroying himself with alcohol. On October 21st, 1967, he died of an internal hemorrhage. In 2001, the scroll of *On the Road*—multiple sheets of tracing paper taped together for which Kerouac had paid $3— was bought at auction by Jim Irsay, owner of the Indianapolis Colts, for $2.4 million. Six years later, on the 50th anniversary of its first publication, Viking produced a complete and unexpurgated edition. And in 2012, Brazilian filmmaker Walter Salles followed his adaptation of Che Guevara's *Motorcycle Diaries* with a screen version of *On the Road*.

By the mid-1950s, using nothing but their energy and imagination, Kerouac and the other drivers of the Beat Generation had lit fuses that would blow both the cultural and social establishment sky high. The global protest movement of 1968 was still a long way off, but this was its beginning. After the Beat Generation, youth culture adopted a new term: being "hip" or a "hipster" came to mean flouting social conventions and standards, and the trend was accelerated by a movie, an actor, and a small-town story. The Korean War had just ended, and the thousands of young soldiers returning to civilian life were facing a painful lack of recognition from their government and struggling to adapt to so-called normality. With Eisenhower's new Republican administration claiming to be both conservative and energetically progressive, the average American felt complacent rather than rebellious, believing, as Charles Wilson, President of General Motors and Secretary of Defense, famously did not say: "What's good for General Motors is good for the country."

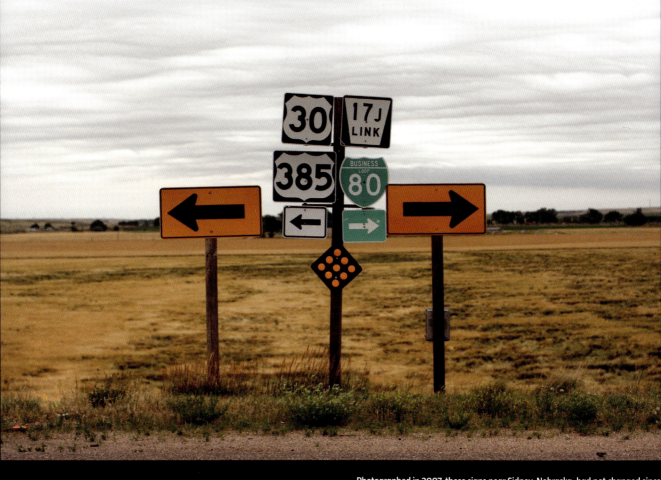

Photographed in 2007, these signs near Sidney, Nebraska, had not changed since Jack Kerouac saw them—as if to indicate that his dreams remain part of "the road."

THE BIKER
AS BAD BOY

László Benedek's 1953 movie *The Wild One* created a new genre: the biker movie. And Marlon Brando, *alias* Johnny Strabler, and his Triumph Thunderbird 6T became icons for a whole generation of young people brought up amid war—The Second World War and then the Korean War. For them, it would soon be time to rebel ...

In 1953, when *The Wild One* was released, Brando was 29. He was already a star thanks to his portrayal of Stanley Kowalski in Tennessee Williams' play *A Streetcar Named Desire*—both on stage and in its 1951 movie adaptation by Elia Kazan, who described his favorite actor as malicious, ambitious, and suspicious ... but really a nice, well-educated guy.[18] His hypnotizing looks, his catlike movement, and his glistening torso were enough to make men and women swoon. Brando was perhaps the first of the new heroes of the silver screen: alongside James Dean, Dennis Hopper, Paul Newman, and Robert Redford. He acted according to his instincts—which was the only way he knew how.

Stanley Kramer, who may have been a poor director but was a visionary producer who gravitated toward screenplays that laid American society bare, saw in Brando a rare creature—one that was already rebelling against Hollywood itself. As for director László Benedek, a sophisticated writer and photographer that history has largely forgotten, he brought his own personal vision to the movie.

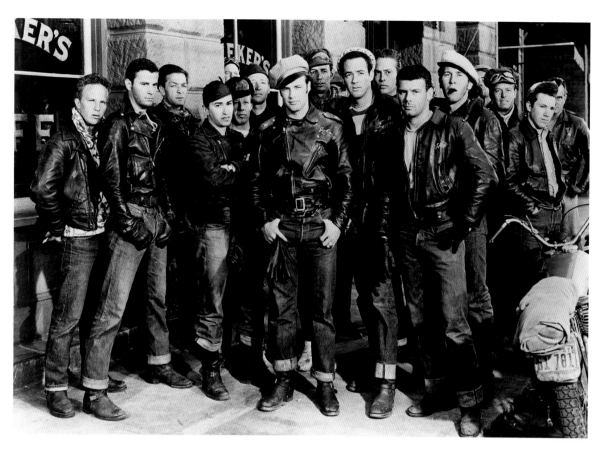

Marlon Brando (center) as "The Wild One." Both he and the movie rapidly acquired a cult following and marked an entire generation.

THE BIKER—FAITHLESS AND LAWLESS

The Wild One was based on fact—or what was reported as fact. The movie presents comfortable middle-class Americans whose lives are disrupted by the clash between two biker gangs: the Black Rebels, led by Johnny (Brando), and the Beetles, led by Chino (Lee Marvin). Drinking and racing along the main street, they terrorize the town and torment the local police.

In their book *L'Assaut des motards*, French writers Henri Lœvenbruck and William Thoury point out that the movie was an adaptation of a story called "The Cyclists' Raid" by Frank Rooney, published by *Harper's Magazine* in January 1951. Rooney based the story on an event that had taken place in Hollister, 90 miles from San Francisco, on July 4th, 1947, but both the local and national press had "massaged" the facts to appeal to a public greedy for sensationalism. It was enough to create a scandal and give bikers the bad name that would stick to them for decades to come. From then on, anyone on a motorcycle was someone to be

feared, a faithless outlaw, a threat to social order. (The movie was banned for 17 years in Britain, for fear that it would incite young people to violence.) Bikers were no longer simply "men on bikes," but "dangerous gangsters," as the title of Benedek's movie suggested.

Here was a movie starring young actors on motorcycles that was a million miles away from the melodramas and epic fantasies Hollywood also released that year. Johnny Strabler became an instant hero, and Brando's outfit—jeans, T-shirt, Chippewa Engineers, and Perfecto jacket (a previously unknown brand)—caught people's imagination like a #1 hit. Emblazoned on the back of the jacket was "BRMC" (Black Rebels Motorcycle Club) and, beneath, a skull and crossed pistons—an obvious reference to the pirate flag.

In the opening scene of the movie, bikers sweep into the town like a tidal wave, the titles declaring: "This is a shocking story. [...] It is a public challenge not to let it happen again." The principal character, Johnny Stabler—who, like Brando in real life, is something of a loner—is

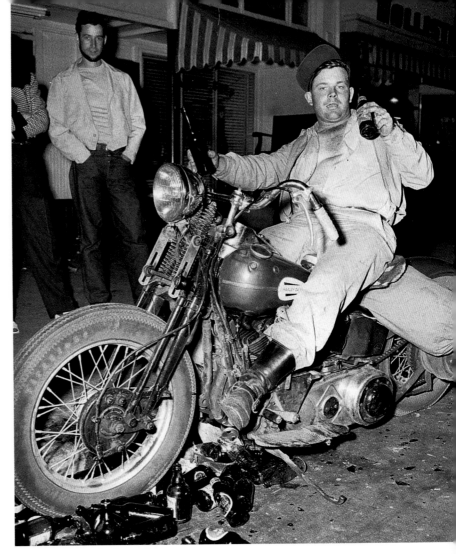

Thanks to this photograph, the apparently affable Eddie Davenport found himself transformed into the archetypal lawless biker.

an ambiguous hero: sneering, violent, and ... soft-hearted. Even his choice of bike—a British Triumph Thunderbird 6T, rather than a Harley-Davidson—indicates that Johnny rejects his own country's values, its industrial pride. It is light and fast, and his assault on the Beetles and their heavy Harleys is a metaphorical attack on America itself.

"HAVOC IN HOLLISTER"

The "Hollister riot" is one of the worst examples of 20th-century media hype. Since the 1930s, Hollister, a Californian town of 4,500 people, had hosted a motorcycle rally as part of the Gypsy Tour, a nationwide gathering of motorcycle clubs organized by the highly respectable American Motorcyclist Association. The AMA's rigid and restrictive regulations prevented certain clubs from participating, including recently formed clubs and—typically at the time—Black American clubs. The Boozefighters MC, Galloping Goose MC, Market Street Commandos, and the Pissed Off Bastards of Bloomington were among the 13 "rebel" groups that were excluded.

1947 was no ordinary year for the Gypsy Tour, which had been suspended since 1941 because of the War. With fine weather that summer, Hollister's population swelled with the arrival of some 700 riders from the surrounding area. While the AMA-approved clubs took part in organized races on a standard dirt track, the banned bikers took over the main street.

Inevitably, the latter got out of hand, and some 50 of them were arrested for drunkenness, reckless driving, and disturbing the peace. The only really dramatic incident, however, was when Hollister's tiny jail was besieged in an attempt to liberate one of the men who had been incarcerated. A few people sustained minor injuries, but the only broken bones were those of racers on the official track. Order was soon restored with the arrival of 32 officers of the Highway Patrol, and Bert Kirk, a member of the City Council, reported to the press that "there appears to be no serious damage."

But the press knew that the American public was beginning to fear the growing rebelliousness of the younger generation—and came out with all guns blazing. The opening salvo was fired by the *San Francisco Chronicle*, whose first article, under the headline "Havoc in Hollister," described the virtual devastation of the town. Naturally, the national press was only too eager to take up the story, and on July 21st,

MOTORBIKES AND COUNTERCULTURE

Life magazine published this photograph alongside an article headed "Cyclist's Holiday: He and Friends Terrorize Town." According to this, 4,000 bikers, not 700, flooded into Hollister, racing madly up and down the main street and smashing store windows, and it was only the intervention of armed police that brought them under control. After four years of war coverage, the press was well aware of the power of images, and it wanted the Hollister story to have a big impact. It therefore needed a striking photograph that would catch the attention of people all across America and teach those big, bad bikers a lesson. The chosen victim was Eddie Davenport, a native of Tulare, California, and a member of the Tulare Raiders MC. With his vacant stare and his beer belly, the hapless Davenport was set up, in what amounted to blatant propaganda, as the personification of the modern "highwayman," who no longer held up carriages but spread terror and destruction on his mechanical steed. Along with Marlon Brando and his screen persona Johnny Strabler, he has since come to personify the iconoclasm of the time.

The press knew that the American public was beginning to fear the growing rebelliousness of the younger generation.

But this picture of Eddie Davenport lounging on his "bob-job," beer bottles in hand, was no chance snapshot; it was deliberately posed. The smiling young man in the background, Gus Deserpa, a Hollister resident, recalled: "I saw two guys scraping all these bottles together, that had been lying in the street. Then they positioned a motorcycle in the middle of the pile. After a while this drunk guy comes staggering out of the bar, and they got him to sit on the motorcycle, and started to take his picture."[19] All that remained was to add the "terror" headline…

From that moment on, Hollister was a byword for anarchy and violence. The movie and the town became inseparably linked, and life in America would never be the same again. Bikers were the new scourge, the ultimate in human degradation.

"I'M A HEARTLESS BRUTE"

Although the movie had catapulted Marlon Brando to stardom as "the wild one" of Hollywood, the actor did not defend the way it portrayed bikers: "In my opinion," he is reported to have said, "it's a dead end. We started out with the intention of making something meaningful, something that tried to reveal the motivations behind these tough young guys' behavior. But along the way, we somehow lost the thread. Instead of showing what prompts young people to form these groups and express themselves through vio-

A TRIUMPH IN THE U.S.!

By 1953, the British-made Triumph motorcycle was already a formidable competitor to the American Harley-Davidson, as Edward Turner, Triumph's boss since 1936, had decided early on to target the U.S. market.

The Thunderbird, which took its name from a motel Edward Turner once stayed at while traveling in the U.S., was launched in 1947 and was an immediate success. Turner appointed Bill Johnson, founder of Johnson Motors, official importer, and by the time *The Wild One* was shot, more than half of Triumph's production was being exported to the States. Nevertheless, Turner is reported to have refused to supply bikes for the movie (Brando had to use his own) and was shocked by the image it portrayed of Triumph bikes.

Today, *The Wild One* is a time machine that "projects" viewers into the past, where they can (re)discover the "bob-jobs" ridden by Chino and his Beetles. The term bob-job derived from "bobbed," meaning shortened or cut down. In the 1950s, rebellious riders stripped their machines of everything that could slow them down in order to distinguish themselves from the fat cats who could afford bikes gleaming with chrome accessories. It was a time of austerity, and real riders rarely patronized their local dealer; they visited army surplus stores instead.

According to *Freeway* magazine, the term bob-job also derived from the felt disc used to polish metal, known as a "bob," since riders would individualize their machines with elaborate paint jobs. In the late 1990s, the bob-job evolved into the "bobber" and in 2017, Triumph unveiled the "Bobber Black," a deliberately retro bike evoking the spirit of the 1950s.

Bob-jobs are back: Triumph unveils its 1,200 cc Bonneville Bobber and subsequently the slightly more sophisticated Bobber Black.

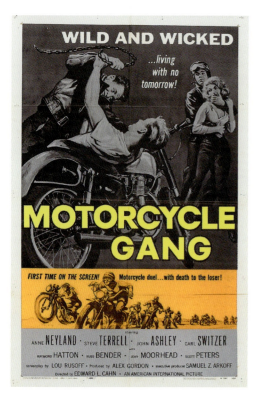

Edward L. Cahn, director of the 1957 movie *Motorcycle Gang*, had no compunction about making Z movies about bikers—and believed they would eventually make him famous…

lence, we ended up just showing different types of violence." Always ready with a bon mot to sum up the characters he played, Brando is said to have quipped: "Even before they meet me, people think they know me. Wherever I go, I'm the guy on the motorcycle in a black jacket with crossbones painted on the back. I'm a heartless brute. When I'm old, people will still ask me where I keep my club."[20]

László Benedek had a rather better understanding of the contemporary atmosphere—and the movie's "message." It was, he felt, a wake-up call to the youth of the day: "Its theme was not juvenile delinquency, but the lack of ideals and goals among young people, who didn't know what to do with their enormous potential. In it, he said, he tried to show that responding to violence with violence is doomed to fail; that aggression is futile and sooner or later creates an even bigger problem. The movie doesn't only show thugs on motorcycles; it also shows ordinary citizens, shopkeepers,

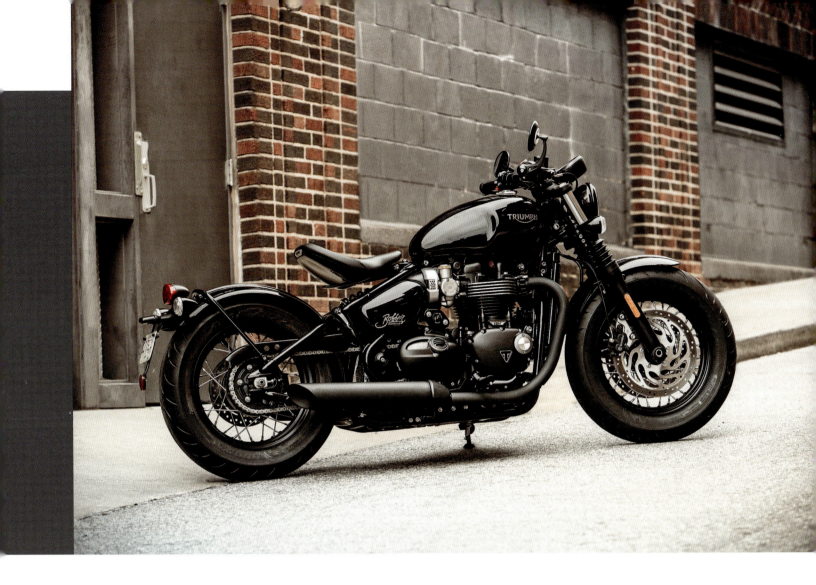

and policemen, whose behavior is just as misguided—and the dangers that can result from a reactionary mentality."[21]

A POSSE OF PALE IMITATIONS

The Wild One made the mold for all the biker films that followed, transforming the humble "motorcyclist" into the rebellious young man, marginalized by a society that had only recently emerged from the traumas of WW2 and the Korean War. The immediate postwar period was conservative rather than forward-looking. True, its priority was reconstruction, but on the foundation of the standards and beliefs of the 1940s. Like *Easy Rider* 15 years later, *The Wild One* was a cultural marker, revealing the moral tone of the age through a fictionalized story. Unfortunately, it also gave birth to a spate of B movies—and even Z movies—on the same theme, which Steve McQueen believed had set riding back "a thousand years."

Among the ambitious, but less than inspired, directors who jumped on the bandwagon, which László Benedek had set into motion, were Wolf Rilla with *The Black Rider* (1954)—a haunting tale of a gang of bikers who pretend to be ghosts—and Edward L. Cahn with *Motorcycle Gang* (1957). After churning out a succession of low-budget Westerns and thrillers with bizarre titles such as *Creature with the Atom Brain*, Cahn decided to grapple with the biker genre at the age of 58. The result was a drama that Quentin Tarantino included in his personal movie pantheon, along with *The Great Escape*, *Easy Rider*, and a number of New Wave movies.

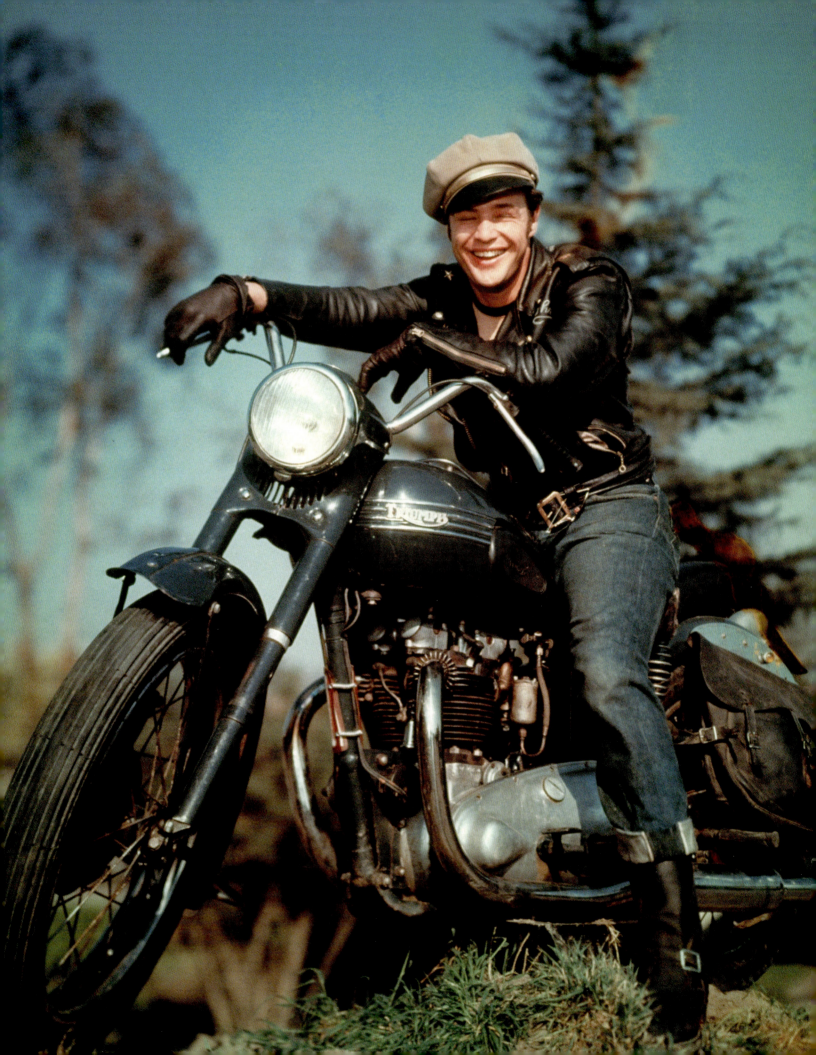

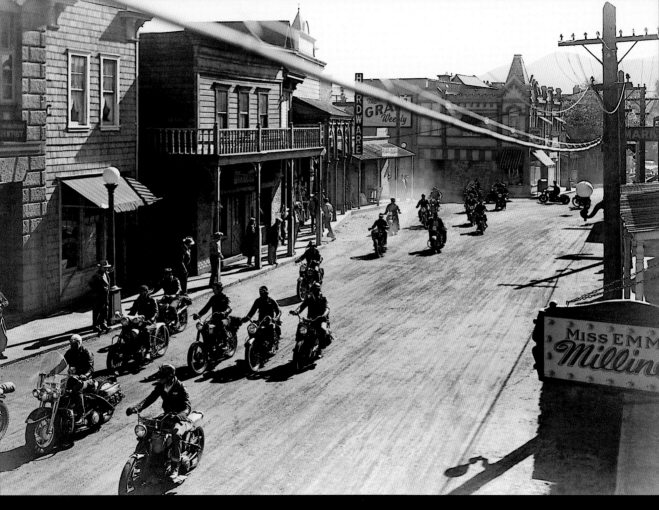

In *The Wild One*, László Benedek employs all the conventions of the classic Western—except that the outlaws are no longer on horseback, but on bikes.

STEVE MCQUEEN— GREAT ESCAPE TO STARDOM

When the insurers of *The Great Escape* forbade Steve McQueen to perform any dangerous stunts, he asked stuntman Bud Ekins, who had become his motorcycle mentor, to undertake the legendary leap over the barbed-wire fence. And so the concept of "the oddball biker buddies" was born.

The Great Escape, which was released in 1963, confirmed Steve McQueen's star status. In it, McQueen plays Captain Virgil Hilts, nicknamed "The Cooler King" on account of the amount of time he spends in solitary confinement. The screenplay is based on a true story of 76 prisoners who escaped from a German POW camp—Stalag Luft III in Lower Silesia (now Poland)—during WW2. Director John Sturges, one of the masters of the Western, carried over themes of wide open spaces and cavalcades, and the yearning for (lost) freedom. In fact, *The Great Escape* is a motorized Western, which suited McQueen perfectly.

The climax of the action is a 70-foot jump, 12 feet in the air, over a barbed-wire fence on a German army motorbike. Although McQueen did most of his own stunts, both the producers and the film's insurers considered this a leap too far, and it was performed by stuntman Bud Ekins.

THE BMW WON'T STAND UP TO THE STUNT

Like McQueen, Ekins was born in 1930. Built like John Wayne, he was the kind of guy who speaks his mind. When Rin Tanaka interviewed him for his book 40 Summers Ago, Ekins said that if there was anything about his life he wished he could change, it was that he hadn't sold Hondas ... and the sound of a Harley engine, which he hated. Talk about honesty!

In the 1950s, Ekins was a regular winner of the Baja, a 73-mile bike race through the desert from southern California to New Mexico. He was also the first non-European rider to take part in enduro events in the U.K. (American race organizers being especially parsimonious with their prize money). Ekins also became the top Triumph salesman in the States—hence his bad-mouthing of Harley-Davidsons. He was particularly successful with the Triumph Bonneville, the classic big bike of the time. Between 1958 and 1965, more than 50,000 Triumphs were sold in the U.S., which was 70% of total production.

In the early 1960s, McQueen bought a Bonneville owned by actor Norman Powell from Bud Ekins's garage, and it was Ekins who was responsible for McQueen's initiation into desert racing. In January 1962, McQueen wrote Ekins to tell him that he was to star in The Great Escape and that in one scene he had to steal a German sidecar. Soon after, Ekins flew to Germany, not yet knowing that he would become McQueen's official stuntman in several movies.

For movie buffs, what would The Great Escape be without the motorcycle chase in which the hero ends up entangled in barbed wire (actually coils of string and rubber)? An ordinary action film such as those that Hollywood reeled out after the Western era. Nothing more.

By 1963, Steve McQueen was already an avid rider. During the chase scene, Bud Ekins remembered that the Germans were supposed to catch up with him, but he was riding so fast that they couldn't—and McQueen couldn't be persuaded to slow down. So in the end, they

John Sturges (behind the camera) and Steve McQueen during the shooting of *The Great Escape*. They previously collaborated on the legendary film *The Magnificent Seven*.

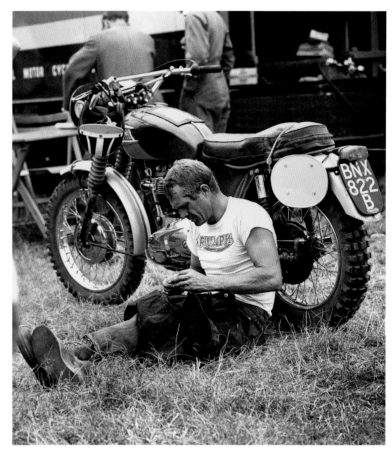

Steve McQueen photographed on September 7th, 1964, in his famous Johnson Motors T-shirt with the blue Triumph logo.

dressed him in a German uniform and "he chased himself"[22] But the main stunt, a 70-foot jump over a barbed-wire fence, made him think twice, and it was Ekins who immortalized the scene in a single take, neither the producers nor the insurers having allowed for a second one. McQueen gave credit where credit was due: "I always felt a little guilty about that. A lot of people thought it was me making that jump, but I've never tried to hide the truth about it."[23].

The German army used BMWs, which were generally excellent machines, but the designers in Munich hadn't intended them to fly through the air. When Ekins pointed out that they were neither robust nor rapid enough for the stunt, a 650 cc Triumph TT Special was drafted in as a double. Painted khaki and fitted with a rear baggage rack and an old saddle, it just about passed its audition. The standard shock absorbers were retained, and the only modification was a lighter front wheel.

STEVE MCQUEEN STANDS TRIAL

During the shooting of *The Great Escape*, Bud Ekins took part in the International Six Days Trial (ISDT) in Czechoslovakia. Inaugurated in 1913, the race took place in a different European country each year. In terms of length, difficulty, and prestige, it was, and still is, considered "the Olympics of motorcycling." When

Ekins won it, Steve McQueen decided that he would take part the following year. Designed for desert racing, with a raised exhaust pipe and shortened fenders, as well as a kick-start rather than a battery, the Triumph TR6 SC, nicknamed the "Desert Sled," was a favorite race bike in America. It might not prove so popular after six days in European mud…

The 1964 ISDT was to be held in Erfurt, East Germany, so even before they tackled the terrain of the course, the Americans would have to cross not only the Atlantic but also the Iron Curtain—an even bigger leap than in The Great Escape! In the course of a single night, August 12/13th, 1961, East Germany's capital of Berlin had been split in two by the erection of the 100-mile-long "Wall of Shame," on the pretext that the Communist zone needed to be protected from "Fascist aggression." The Berlin Wall had since become a striking symbol of the clash between two world views: Western individualism vs. Eastern collectivism. Elvis Presley, who had been stationed in West

After a second crash, McQueen is on the verge of being eliminated.

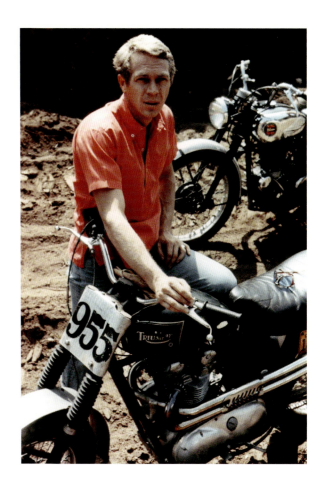

Germany in 1958, was now regarded in the East as Public Enemy No. 1.

The ISDT took place in an ostensibly relaxed, but in reality highly tense, atmosphere. The park where the riders assembled was guarded by armed soldiers. McQueen—who became the flag-bearer for the first U.S. team ever to compete on Communist soil—and his colleagues had to sleep in a high-rise dormitory. The race itself was a test not only of speed, but also of consistency over the six days, with check points at regular intervals around the course. With McQueen trusting in his Triumph, the team were aiming to win the Silver Vase Team—the competition's "Holy Grail," awarded to the top team not riding bikes made in their own country.

McQueen, on a 650 cc TR6 SC, was in the 750 cc class, while Ekins, with his T100 SC, was in the 500. That September, Erfurt suffered torrential rain. Water off a duck's back to the British team, but on Day 2, the Americans were level with them when McQueen tried to slither round a bend he hadn't seen coming—he was using the treetops as marker posts—and careened into a cart. A cut on his face and a crushed exhaust pipe—miraculously repaired with an axe courtesy of a woodcutter who happened to wander onto the track—failed to dampen the actor's optimism for the

Steve McQueen and his "Desert Sled," the default accessory for any rider emulating "The King of Cool." Note also the classic Persol 714s on the saddle.

following stage. On Day 3, the sun came out and the water evaporated, but the 300 competitors faced a 260-mile mud bath. For the Americans, it would prove to be their last gasp. Bud Ekins broke his ankle when he hit the side of a bridge, and after a second crash, McQueen was on the verge of being eliminated. In a last-ditch attempt to cross the line within the time limit, he swerved to avoid a spectator and had another bad fall. The Triumph's front forks crumpled—and with them the actor's dream of lifting the Silver Vase.

Undaunted, McQueen planned to enter the ISDT again in 1965, when it was to be held on the Isle of Man, but it clashed with filming, and he had to entrust his precious Triumph to Ed Kretz, Jr.

It was Sean Kelly—the nostalgia-mad designer that took over Johnson Motors in the 2000s—who tracked down the only one of the five Erfurt Triumphs still in existence. It happened to be Steve McQueen's. Its last owner, Frank

Danielson, had raced it several times in the Baja—after fitting it with a sidecar. A pardonable sin?

ON ANY SUNDAY— A TRIBUTE TO PROS AND AMATEURS

After *The Wild One* (1953), it seemed that every biker movie title had to be "wild" something: *The Wild Angels* (Roger Corman, 1966), *The Wild Rebels* (William Grefé, 1967), *Wild Riders* (Richard Kanter, 1971)… But for most people, there was another word that encapsulated the notion of utopian freedom: summer.

If the Summer of Love was a fleeting experience, summer could also be "eternal," as in Bruce Brown's *The Endless Summer* (1966), a documentary-style film that followed two young Californian surfers on their odyssey—from Senegal to Ghana, from Tahiti to South Africa—to find the perfect wave.

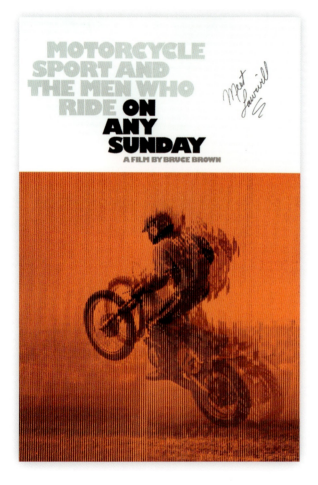

It was Steve McQueen who had the idea of getting Brown to make a two-wheeled version of *The Endless Summer.*

In search of a wave, in search of a dream… *The Endless Summer* was to surfing what *Easy Rider* would be to biking a few years later: a "quest" movie—albeit gentler and less violent, its heroes tanned rather than tough-skinned. And in terms of budgets and receipts, the two movies would have remarkably similar fortunes. After countless rejections, Brown found a studio willing to make *The Endless Summer*; it cost $50,000 and made $30 million. *Easy Rider* cost around $350,000 and grossed upwards of $40 million.

It was Steve McQueen who had the idea of getting Brown to make a two-wheeled version of *The Endless Summer*. The result was *On Any Sunday*, released in 1971. Its original title, *Motorcycle Sport and the Men Who Ride on Any Sunday*, evokes the weekly "worship" of bike racing, when hundreds of helmeted "crusaders" blast their way across 100 miles of desert, over dunes and rocks that dash their dreams, blinded by the relentless sun in their search for "the promised land"—aka the finish line.

A homage to riders both professional and amateur, the movie centers on Mert Lawwill—145 pounds but only 5ft 5in (168 cm) tall—who won the ultimate accolade of becoming the AMA's #1 ranked rider in 1969. Whether racing off-road or on the track, on his Harley-Davidson 750, Lawwill liked to be right at the top of the podium. Lawwill's "co-star" is Malcolm Smith—slim, with boy-next-door looks—who specialized in the Baja, an endurance race through the dust of the Californian desert, where even the cacti seem to cower beneath the sun. *On*

Although directed by Bruce Brown, *On Any Sunday* is probably Steve McQueen's most personal film, expressing his own philosophy on riding.

Every Sunday, people from all walks of life, experts and novices, come together to race their bikes across the Californian desert. That was what McQueen loved!

Any Sunday also features McQueen himself, although he makes only a fleeting appearance—not surprisingly, since by this time he was able to command a million dollars per movie. He is seen riding a Husqvarna 400 in the 1970 Elsinore Grand Prix—an off-road race "interrupted" by a stage in the streets of Elsinore, Utah, where the average age of the inhabitants (other than on the day of the race itself) is not less than 60. Competing against 1,500 other riders—including 200 pros—in front of 50,000 spectators, McQueen, who is used to playing leading roles, pulls off an overall 8th place (or possibly 10th; the archivists disagree).

The final scene of the movie shows Lawwill, Smith, and McQueen—two on Husqvarnas and one on a Greeves Challenger—churning up water as they speed around in circles.

In terms of its glorification of "coolness," *On Any Sunday* is another take on "the endless summer"—a period of rebellion and heroism that would come to an end on November 7th, 1980, the day Steve McQueen died. Never a great talker, he once wrote with reference to the movie: "Every time I start thinking the world is all bad, then I start seeing people out there having a good time on motorcycles [and] it makes me take another look."[24]

THE DESERT IS A RUTHLESS RACETRACK

Born to be wild, Steve McQueen was addicted to off-road racing, and the bike he chose to carry him over sand and scree was a Rickman Metisse.

Off-road, off limits, off the beaten track... at heart, "The King of Cool" was more desert fox than road runner—completely at home in the empty expanses of the desert. Before his ISDT attempt, he would compete in the annual Greenhorn Enduro—a race through the Mojave, which stretches across southern California, Nevada, and Arizona. On race days (Sundays, as *On Any Sunday*) he adopted the name Harvey Mushman. His trusty Triumph TR6 was already showing its age (McQueen himself described it as a "brutal machine") and would soon be added to the actor's impressive collection of motorized museum pieces. His preference was for a "Husky" (Husqvarna) 400, which he nicknamed "The 405." The third of his trio of bikes built for mud and sand was the Honda CR250M Elsinore.

THE FIRST DESERT SLEDS

It was a time of innovation and icono-clasm. Makers such as Bultaco, Montesa ("an up-and-coming name," according to McQueen), and Honda—with its CR250M Elsinore, named after the famous race—were beginning to design bikes specifically for off-road racing. But even they could hardly have imagined that the major races of the 1970s would be epic challenges such as the Paris–Dakar. There was nothing for it but to improvise. McQueen sat under a cactus in the Mojave thinking.
A new concept was emerging: the desert sled—as well designed for skipping over sand as a sled is for gliding over snow.

Bill Bryant of chopcult.com explains how it happened: "Early desert sleds were built by a rider concerned with only himself and his ability to finish a race. [...] These bikes could have been Harleys, Indians, or any type of home-built contraption that a rider

> ## "EARLY DESERT SLEDS WERE BUILT BY A RIDER CONCERNED WITH ONLY HIMSELF AND HIS ABILITY TO FINISH A RACE."

could piece together."[24] McQueen broke the concept down into its component parts—a street bike of at least 650 cc, spiked tires, a protection bar, narrow handlebars, a race number plate, and a raised exhaust pipe—using his Triumph as a starting point. The chassis had to be a Rickman.
British brothers Don and Derek Rickman were young and dynamic. Although already expert motocross riders, they were dissat-isfied with the machines they rode, finding them sluggish, and began to experiment. They took a BSA Gold Star chassis and bolted on parts from other bikes: Norton forks, a 500 cc Triumph T100 engine, a BSA gearbox... All the young wizards needed was a suitably magical name for their cre-ation. "Bitsa"? "Mongrel"? No, they wouldn't do at all. It was Derek's wife who trawled the dictionary and came up with Metisse, from the French *métisse*, meaning "mixed heritage"—and it stuck.

The Rickman brothers in their motocross days, before they created the magical Rickman Metisse.

THE STEVE MCQUEEN DESERT RACER

But the brothers still weren't satisfied. They dreamed of the perfect chassis—one that would accommodate the single-cylinder engine from a Matchless G80, the bike described by Baja competitors as a "bruiser." In 1962, their masterpiece was finally unveiled: a chrome frame with copper-plated Reynolds tubing designed to accommodate the oil reservoir behind the steering stem—a weighty piece of gear. When the Rickman brothers went into other areas, their motorcycle business was taken over first by Pat French and later by Gerry Lisi, who signed a contract in 2009 with Steve McQueen's son Chad to produce 300 replicas of the Rickman Metisse branded "The Steve McQueen Desert Racer." Its gray Porsche oil reservoir is a throwback to 1966, the year in which the actor purchased his first Metisse. "The King of Cool" is still in the race…

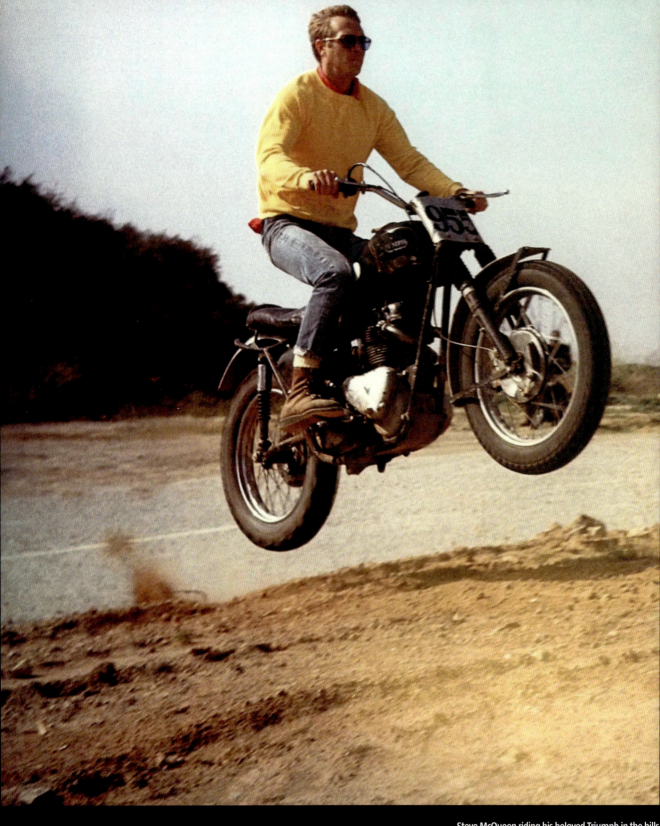

Steve McQueen riding his beloved Triumph in the hills above Hollywood, not far from his home.

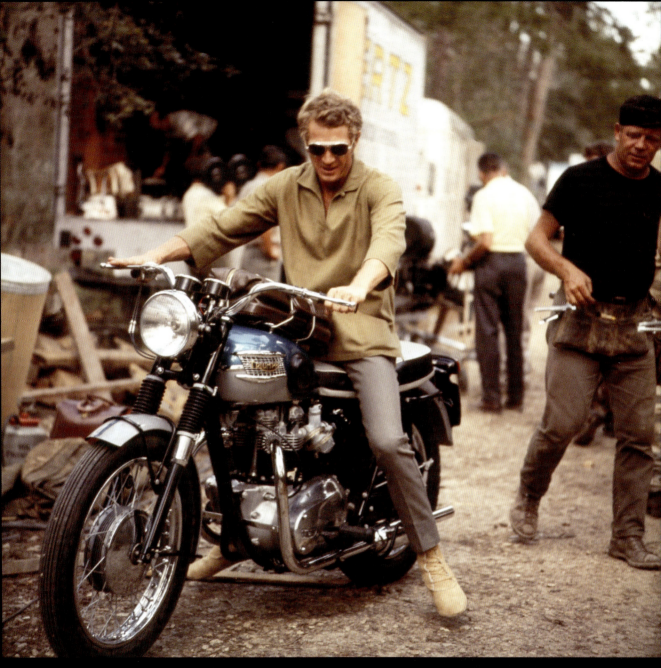

Even away from the camera (here, on the set of *The Great Escape*), McQueen wouldn't part with his Triumph Bonneville.

FOLLOWING PAGES:
Throughout the 1960s, McQueen took
every opportunity to compete in the
Southern California desert.

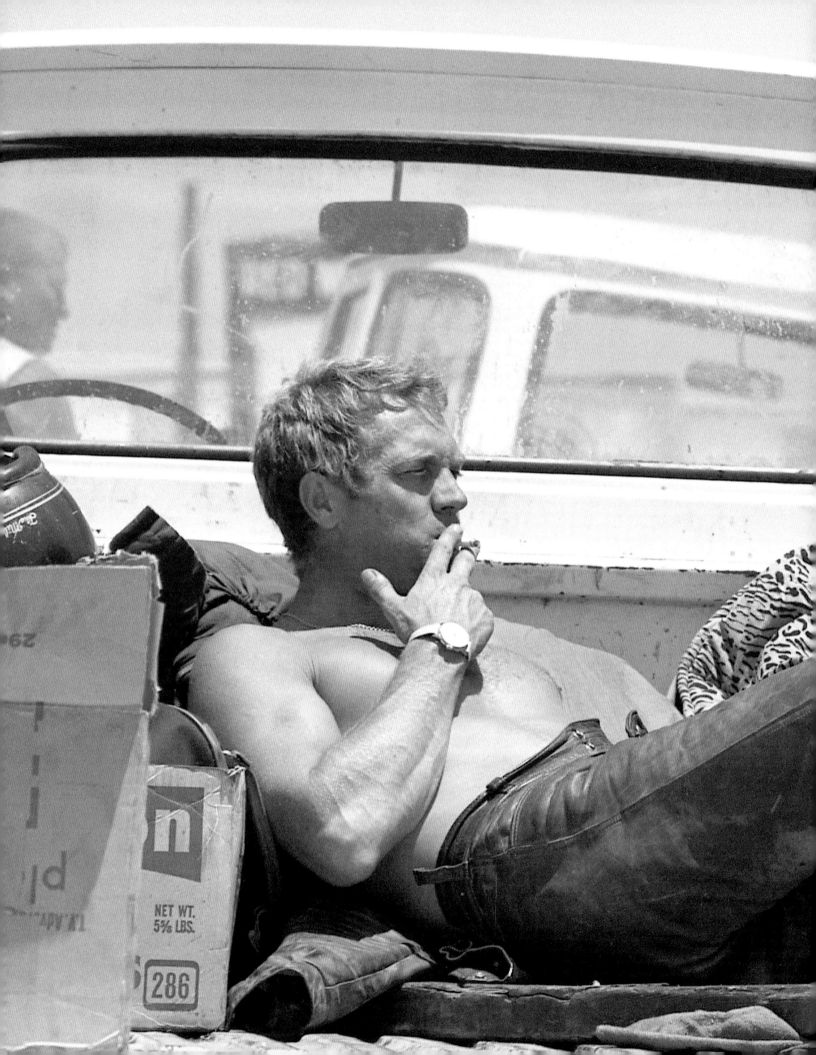

A LIFE ON THE LIMIT...
BETWEEN FANTASY AND REALITY

**Steve McQueen, who died in 1980, remains the quintessence of cool...
and the definitive rider. As much a commercial as a cultural phenomenon,
"The King of Cool" still dominates the world of motorcycling.**

Today, Steve McQueen continues to appear in articles and books, while the captains of industry continue to reap rewards from replicas of his trademark clothes and favorite motorcycles. Almost 40 years after his death, these are still sought after by fans and nostalgia buffs—as if acquiring parts of McQueen's life means buying a share in his immortality, riding with him on an eternal "great escape"... He looked just as good in the city suit he donned for *The Thomas Crown Affair* as he did in jeans. And in *Bullitt*—involving the most famous car chase in movie history—he could hardly have been more laid-back as he defied the law of gravity at the intersection of San Francisco's Taylor and Filbert Street. What an outfit for a city cop chasing bad guys—his Mustang GT Fastback vs. their Dodge Charger: blue turtleneck, gray pants, suede jacket and shoes (no doubt Sanders Hi-Top Snuffs). Astride a bike, McQueen was just as stylish: classic chinos, Clarks shoes, Baracuta jacket... the epitome of cool.

A LOVE OF SPEED... AND OF BEAUTY

When racing—whether in the California desert or the Erfurt mud at the 1964 ISDT—McQueen was equally meticulous about his appearance, which would impress even today's fashionistas: Barbour jacket and Bell 500-TX helmet (manufactured between 1959 and 1969), hand-painted by Kenneth "Von Dutch" Howard himself, with McQueen's first name "signed" on the back. The gloves he wore are less easy to identify, since there were no gloves specifically designed for enduro racing in the mid-60s. Riders tended to wear lightweight cycling or golf gloves. For the ISDT, McQueen probably used a

ACQUIRING PARTS OF MCQUEEN'S LIFE MEANS BUYING A SHARE IN HIS IMMORTALITY, RIDING WITH HIM ON AN ETERNAL "GREAT ESCAPE"

heavier pair originally intended for something else altogether. His sunglasses were from Lewis Leathers, suppliers to the Royal Air Force, and his boots Red Wings or Chippewas. And finally, a glance at his watch: a German Army Hanhart, highly prized by Luftwaffe pilots...
This examination of Steve McQueen's wardrobe is not just for fun. His "look" was part and parcel of his timeless appeal, the fascination he continues to hold even for people with no interest in bikes or cars. The current "retro" revival surely owes a lot to him. But McQueen's aesthetic sense went way beyond clothing. Competing in the Baja, he would try to spot the perfectly formed sand dune; at the 12 Hours of Sebring, to find the ideal racing line. Being an actor is OK, he once said, but it's racing that I love—for the speed, for the incredible beauty of it.

Steve McQueen in his iconic Bell 500-TX helmet at the 1964 ISDT. In the background, his riding buddy, Bud Ekins.

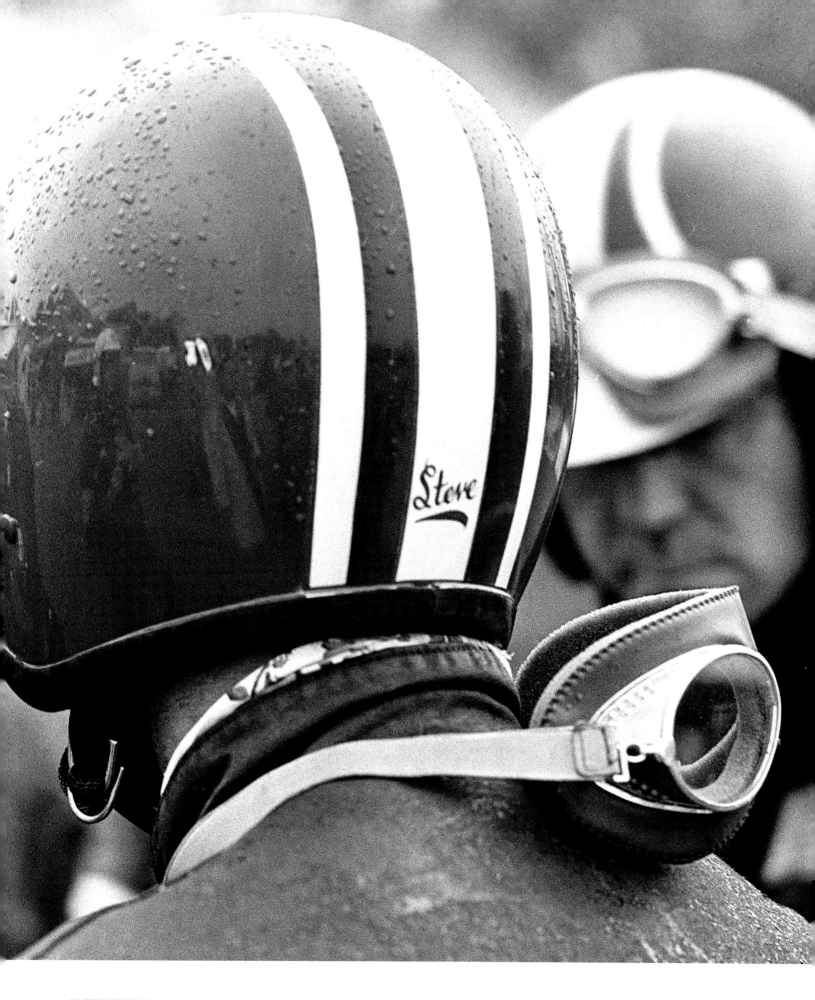

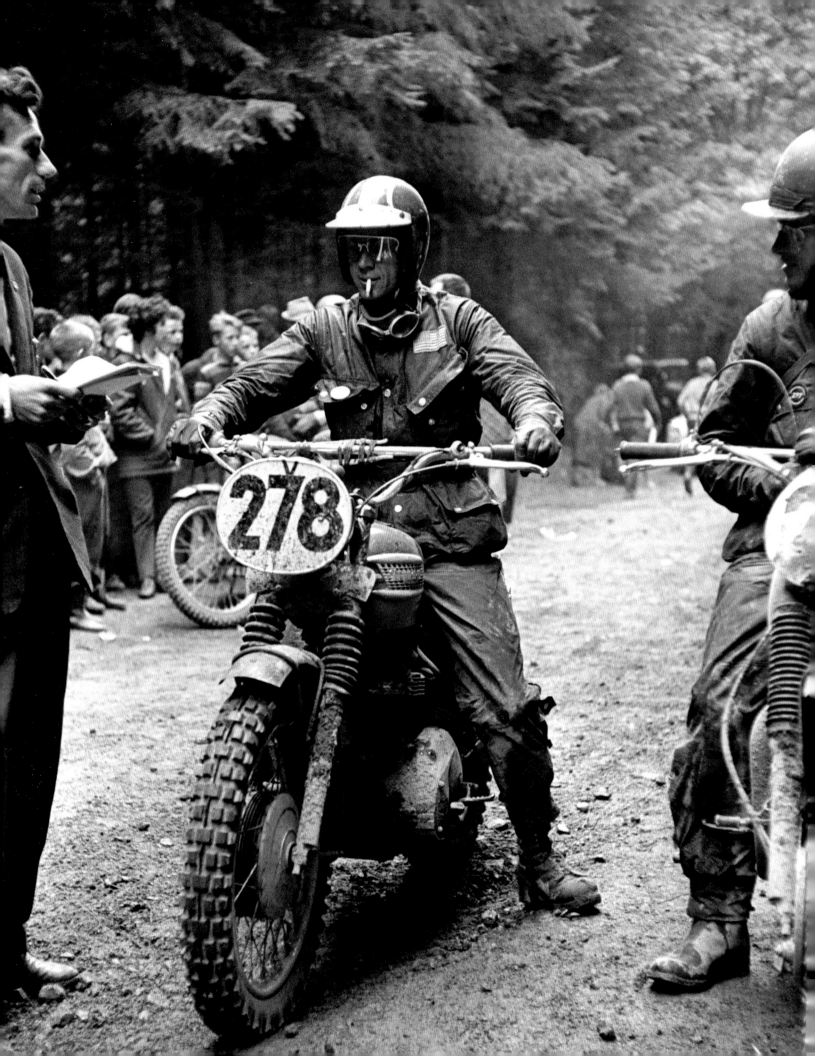

September 1964, the ISDT in Erfurt,
East Germany. After a promising start,
McQueen pulls out of the race on Day 3.

"BURN, BABY, BURN!"

The mid-1960s were characterized by the erosion of America's superpower status following Kennedy's assassination and the eruption of the Vietnam War. It was a time of disillusionment, of shattered dreams. And the motorcycle became a major symbol of the search for freedom.

In the mid-1960s, the world was divided by the so-called Cold War—an invisible war shrouded in the mist of conflicting ideologies. America was still reeling from the assassination of John Fitzgerald Kennedy on November 22nd, 1963, at the age of 46. Losses in Korea and Indochina paled into insignificance as the country fell into an even more terrible bloodbath, the Vietnam War, the first U.S. troops arriving in Da Nang in March 1965.

In that year, 40% of Americans were under the age of 20. Some had to go and fight; others joined peace movements. Slogans were bandied about, such as Free Speech Movement leader Jack Weinberg's "Don't trust anyone over 30." In Los Angeles, the Watts riots of August 1965 left 34 people dead and 1,100 injured, not to mention $35 million worth of damage. After setting fire to buildings, rioters taunted the police with cries of "Burn, baby, burn!"

Bob Dylan was among those who joined the fight for civil rights led by Martin Luther King, who himself would be murdered in 1968. The black boxer Cassius Clay, who had converted to Islam and changed his name to Muhammad Ali, as a protest against the Vietnam War, refused to enlist, asserting that "No Vietnamese ever called me nigger." The controversial phrase would be taken up by the Harlem peace marchers in 1967.

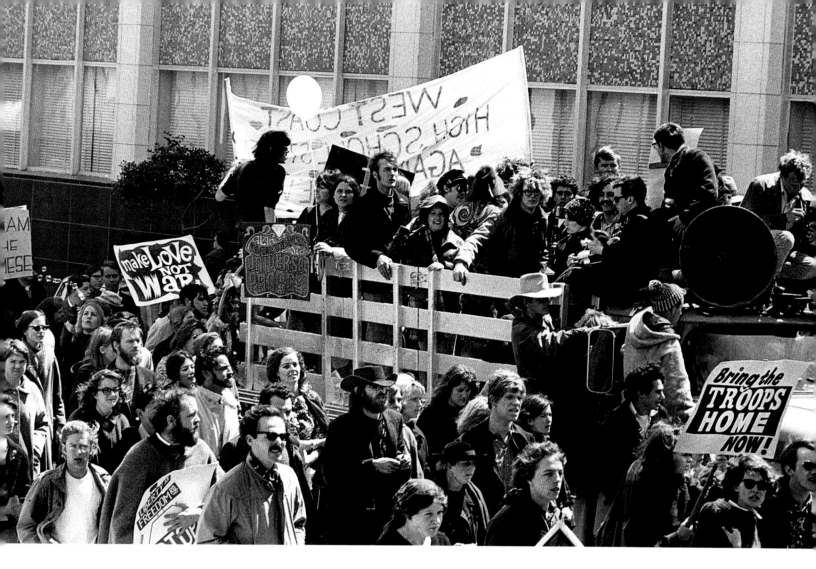

Peace and love in San Francisco in the 1960s. Students and other young people protest against the Vietnam War.

"CAN YOU PASS THE ACID TEST?"

The beatniks of the Beat Generation had spawned imitators. Enter the hippies. Allen Ginsberg, William S. Burroughs, and Gregory Corso had kept the memory of Jack Kerouac alive, making counterculture part of the social landscape. *Time Magazine*'s Man of the Year for 1966 was not an individual, but everyone under 25, and San Francisco became a hot-bed of student protest, thanks to the nearby University of California, Berkeley. In January 1967, the Summer of Love began in the Haight-Ashbury neighborhood, and the 14th saw the first great hippie gathering, dubbed the "Human Be-In," in Golden Gate Park. Harvard doctor of psychology Timothy Leary advocated psychedelic experiences, and acid test parties became the defining rite of a movement that oscillated between pacifism, violence, and angst.

Surprisingly, the Hells Angels happily took part in a party organized by a hippie group calling itself the Merry Pranksters, who handed out leaflets in the street asking, "Can you pass the acid test?" For two days, Angels and hippies shared a variety of substances, including acid and bathfuls of beer—though this didn't stop the former from indulging in some "Commie bashing" at a protest by Berkeley students.

The word "free" was on everyone's lips. It was pronounced at political meetings and sung at concerts. It became the keyword of a genera-tion that wanted nothing other than freedom: the Free Speech Movement, free concerts, even free food and free stores—instigated by the San Francisco Diggers, a radical group that saw themselves as urban "Robin Hoods." But the altruism was short-lived; by the end of the Sixties, the Summer of Love had given way to a decidedly chilly winter.

Taking the acid test—the rite of passage for true Californian hippies.

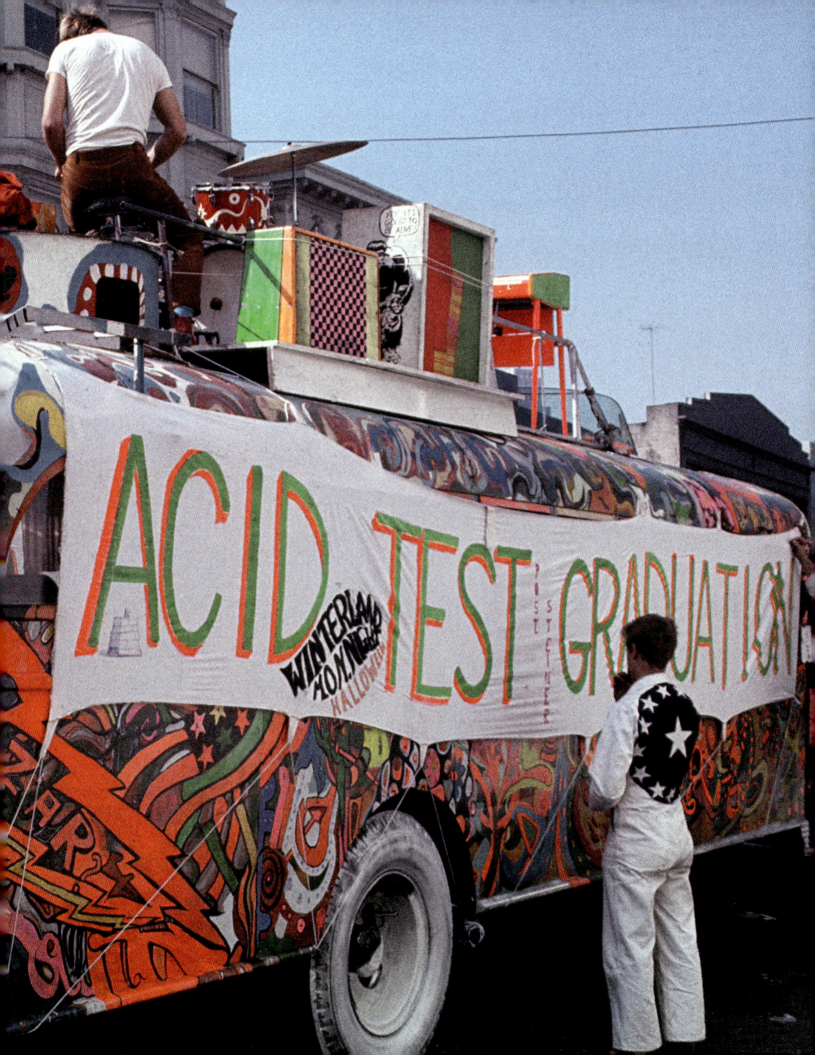

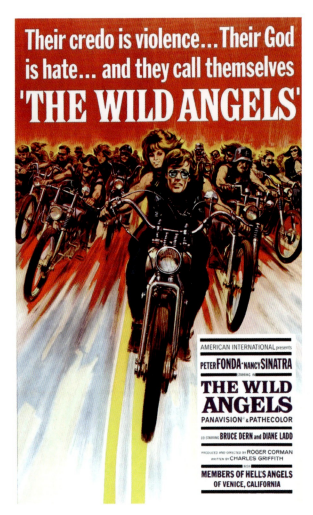

Their credo is violence... Their God is hate... and they call themselves 'THE WILD ANGELS'

AMERICAN INTERNATIONAL presents

PETER FONDA · NANCY SINATRA

STARRING IN

THE WILD ANGELS

PANAVISION® & PATHECOLOR

CO STARRING BRUCE DERN and DIANE LADD

PRODUCED AND DIRECTED BY ROGER CORMAN
WRITTEN BY CHARLES GRIFFITH

WITH

MEMBERS OF HELL'S ANGELS
OF VENICE, CALIFORNIA

Roger Corman's *The Wild Angels* (1966) starred Peter Fonda, but also launched Jack Nicholson's career and paved the way for *Easy Rider*.

An article in the British *Sunday Mirror* poured scorn on the movement, claiming that the hippies had managed to combine into a single entity the fashion sense of the Hindus, the drug-taking practices of the Chinese, the business acumen of the Australian Aborigines, the altruism of the Early Christians, and the sexual habits of rabbits.[24]

"FREE TO RIDE OUR MACHINES"

Veteran film connoisseurs won't have forgotten the flood of "biker" movies that appeared in the 1960s, as studios attempted to cash in on the new genre. Russ Meyer, the first American director to shoot a soft-core porn movie, even believed that breasts and bikers and could work together with his 1965 sexploitation movie *Motorpsycho*. But it was maverick director Roger Corman, a Hollywood outsider, who was to hit the jackpot. Corman made around 50

features, mostly B and Z movies, and produced at least 400. Early in his career, he co-wrote *The Fast and the Furious* (1955) and then the cult movie *The Little Shop of Horrors* (1960), in which a young actor Corman had taken under his wing made one of his first screen appearances: Jack Nicholson. Corman, who was to become the mentor of New Hollywood filmmakers such as Martin Scorsese, Ron Howard, Francis Ford Coppola, and Peter Bogdanovich, went on to make two more movies—*The Wild Angels* (1966) and *The Trip* (1967). In these, he would bring together the *Easy Rider* "dream team:" Peter Fonda, Jack Nicholson, and Dennis Hopper.

A discursive tale of a stolen motorcycle, *The Wild Angels* boasted an impressive cast: Peter Fonda, Nancy Sinatra, and Bruce Dern. In it, Fonda, as Heavenly Blues, delivers a message

"We want to be free to ride! We want to be free to ride our machines without being hassled by the Man."

Peter Fonda, who would later play Dennis Hopper's alter ego, was the first to realize that the ultimate biker film had yet to be made.

that was to echo down the years: We want to be free! We want to be free to do what we want to do! We want to be free to ride! We want to be free to ride our machines without being hassled by the Man. And we want to get loaded. And we want to have a good time. And that's what we're gonna do. We're gonna have a good time. We're gonna have a party.

The Trip, which was banned in the U.K. until 2003, is not about a motorcycle journey, but the effects of LSD as imagined by Jack Nicholson, who, before starring in *Easy Rider*, wanted to be a screenwriter rather than an actor.

Roger Corman's last contribution to the biker genre was *The Wild Racers* (1968), co-directed by Francis Ford Coppola (although his name doesn't appear in the credits). Corman boasted that in his entire career as a producer he never lost so much as $100 on a movie. Like László

Benedek—although without his hang-ups—Corman captured the spirit of the time, characterized by the rise of "a culture of biker gangs based on drugs, sex, and sadistic violence," as he himself put it. Quite a claim! But a very different concept was taking shape in Peter Fonda's mind. He imagined a more grown-up kind of biker movie—one that would reflect the aesthetics of the age. The two main actors would be Dennis Hopper and Jack Nicholson. All he needed was a title, the money, and the bikes. Action!

FREEDOM AT ANY PRICE

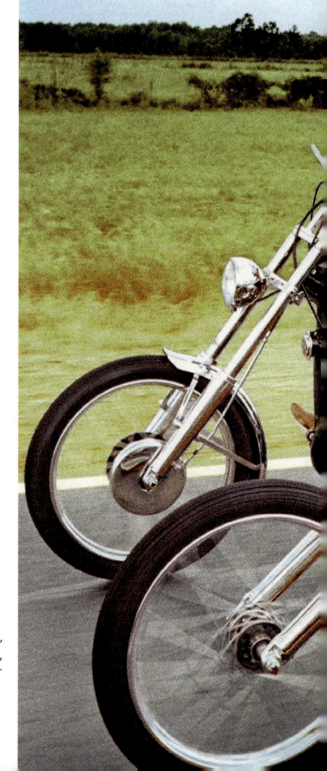

By the end of the 1960s, the dream of a better world had taken root. Libertarian ideas had spread through the movies, music, and literature, all clashing and converging. As the rioting and protesting diminished, the motorcycle came to symbolize the search for a world in which freedom came first. And the epitome of this new mythology was *Easy Rider*.

The infamous trio of "easy riders:" Dennis Hopper (left), Peter Fonda, and Jack Nicholson.

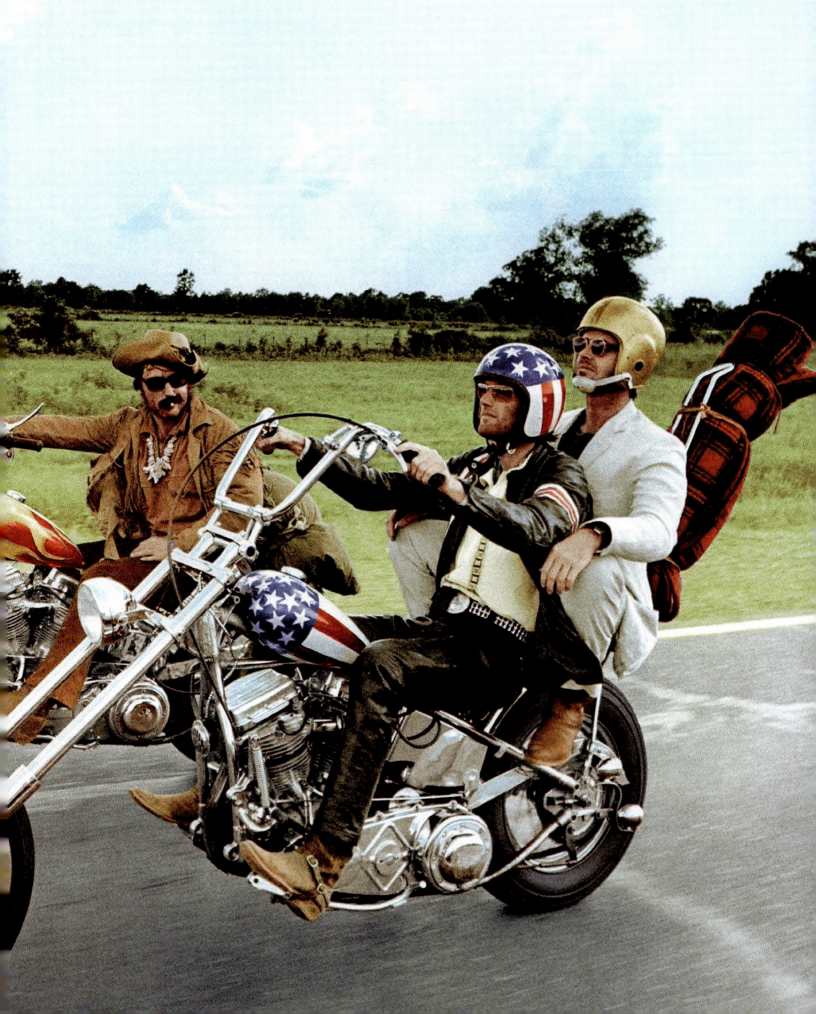

EASY RIDER—
NOT SO EASY

**It was a chaotic story of actors getting stoned on the set, bikes being bought for $400 and then becoming the world's most valuable choppers, of inspired customization turning into tired standardization ...
It was the story of one of the major films of the second half of the 20th century: *Easy Rider*.**

In 1967, the beat was Kerouac's—as in "beatific." And no one was more so than actor, photographer, and soon-to-be director Dennis Hopper. In mid-June of that year, he had been to the Monterey Pop Festival, the progenitor of a belief that alternative values, such as peace and love, would spread and could be built into a new world. Monterey was the first great music festival, predating and prefiguring Woodstock. Here was the perfect communion between performers and public, both glorying in their youth and blowing their minds.

According to Hopper, Monterey was the purest, most beautiful moment of the whole '60s trip. It seemed like everything had come to that moment. It was a magical, pure moment in time.[1]

Hopper had spent the last two years working on an idea for a movie about outlaws, about freedom, about people finding their own path. He already had two actors in mind—friends that, like him, were into biker B movies: Peter Fonda (*The Wild Angels*) and Jack Nicholson (*Hells Angels on Wheels*). Years later, Hopper would confess: to having been "half pop, half

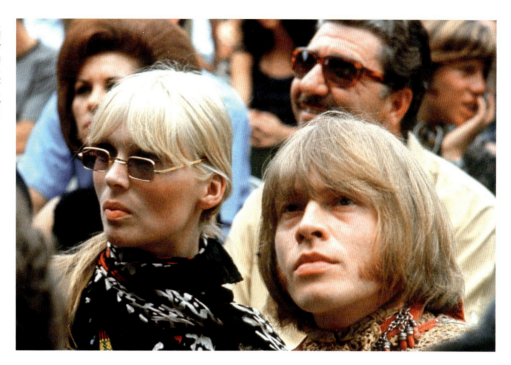

Brian Jones, founder and long-time leader of the Rolling Stones, and Nico, from The Velvet Underground, at the Monterey Festival in 1967.

hippie. But I was never a biker, even if, as I see things, a motorcycle is a symbol of freedom. Riding is a little like being a modern cowboy."[2]

A DIVIDED AMERICA

As it happened, Hopper, Fonda, and Nicholson would soon find themselves making a ride to end all rides, which would revolutionize not only the way movies were made, but also the way people behaved: *Easy Rider*. The movie posters included a quotation from Jack Kerouac: "A man went looking for America and couldn't find it anywhere."[3]

Easy Rider is one of those movies that "sum up the time," as the French movie critic Serge Daney once said; "an instant piece of history"[4], according to another observer, Charlie Chaplin (did he mean movie history or world history?). *Easy Rider* chronicles a divided America—on the one hand reactionary and racist, with rednecks bent on hippie-bashing, and on the other visionary and utopian, with advocates of Free Love and a "thinking earth."

In time, Dennis Hopper would come to see the movie as a meditation on freedom: Above all,

it's about freedom, and the responsibility that freedom implies. In a nutshell, about how not to screw up your own freedom. At the time, the country was a mess: the Vietnam War, the Black Panthers ... It was a tricky time; there were riots all over the United States.[5]

FLASHBACK

Back in 1955, the new youth idol was 24-year-old James Dean. Having appeared in a few stock movies where he wasn't even credited, Dean had shot to stardom with Elia Kazan's *East of Eden* and Nicholas Ray's *Rebel without a Cause*. The latter was a kind of "moral sequel" to *The Wild One*, made two years earlier. Both movies were about the angst of young Americans stifled by the conformism of society. James Dean would die in September that same year, when he smashed his Porsche 550 Spyder into another vehicle at an intersection on Route 466 as he headed toward Salinas. Amid the utter state of shock and horror among his many fans at his passing, there was turmoil in Hollywood, where Dean had just been nominated for an Oscar for his role in *Rebel without a Cause*. His last movie, *Giant*, which wasn't released until 1956, was also a box-office hit.

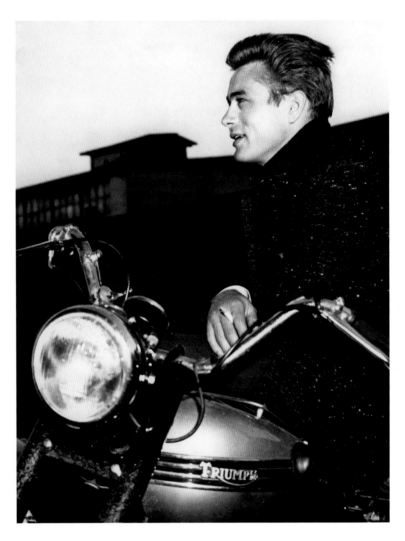

James Dean, who owned a Triumph Tiger 110 and later a TR5 Trophy, enjoyed riding, but he died at the wheel of a Porsche 500 Spyder in 1955.

Who would take over from James Dean? Where was the actor with the same "marginal" persona? From among the young bloods waiting in the wings, only one name stood out: Dennis Hopper. He was 20 years old.

"THE SIXTIES WAS JUST ONE BIG DRUG PARTY"

Indeed, Hopper's success could almost be said to have been due to mistaken identity. As he kept saying to interviewers, "Please don't call me 'the new James Dean'." Hopper found the label suffocating. He was his own man—one of the first to collect pop art, then in its infancy, buying works by Andy Warhol, Jasper Johns, and Roy Lichtenstein. He loved L.A. and all its galleries, and he socialized with painters, photographers, and sculptors. To Hopper, Hollywood was a cultural desert. And before he could feel at ease there, he had to metaphorically murder James Dean. When the President of Colombia Pictures, Harry Cohn, came looking for him, Hopper told him to "fuck off." This was ironic, since Columbia would co-produce *Easy Rider* just a few years later. But for the time being, Hopper forgot about Hollywood and returned to the art world—the underground. He made an "Art" movie for Warhol and increasingly got stoned. "The Sixties was just one big drug party,"[6] he remembered. Finally, he got to play the leader of a biker gang called the Black Souls in Anthony Lanza's *The Glory Stompers* (1967).

"I need a road," he confessed to Stewart Stern, one of the screenwriters on *Rebel without a Cause*. By this time, Hopper, like a bottle of good wine, had reached maturity and was ready to take on *Easy Rider*. All he needed was an alter ego to help him find his way. The man for the job was Peter Fonda.

Son of movie legend Henry Fonda, who had worked with all the great directors between 1930 and 1970, Peter was born in New York—a long way from Hopper's Dodge City. His sister Jane was also a star, thanks to the scandal caused by *Barbarella* (1968), an erotic space adventure based on a comic strip by Frenchman Jean-Claude Forest. *Barbarella*'s screenwriter was Terry Southern, who would also script *Easy Rider*. All the loose ends were now tied.

Peter Fonda made a career out of playing outlaws and bikers—starting with his portrayal of Heavenly Blues in Roger Corman's *The Wild Angels* (1966), which grossed $10 million on

Hopper, like a bottle of good wine, had reached maturity and was ready to take on *Easy Rider*.

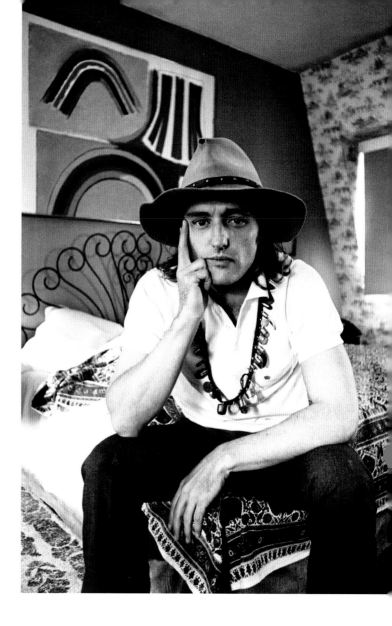

a budget of $360,000. He was one of the very few actors to make a name for himself in such roles, and learned a valuable lesson from it: to make a successful movie, combine a few motorcycles with a screenplay aimed at an audience already hooked on biker stories, and shoot for as few weeks as possible.

RECIPE FOR A CULT FILM: NO MONEY AND TOTAL CHAOS

Although independent producers were well aware of the huge profits that could be made from biker movies, the big Hollywood studios were still dubious, despite the success of *The Wild One* a full 15 years earlier. Nor did they know what to make of the odd couple that came to see them: a guy who looked like he'd just stepped off a surfboard (Fonda) and another who might have been a tramp (Hopper). It was Jack Nicholson who rescued the situation by introducing them to the director Bob Rafelson and his associate Bert Schneider, who had recently founded Raybert Productions. Raybert, which (as BBS Productions) would produce a number of independent movies in the 1970s, advanced $40,000 for location scouting. Hopper was confident that they would need only $12,000...

The first dailies meet with a damning verdict: "A big pile of shit," says one of Raybert's co-producers. But for some reason Bert Schneider gives Hopper et al. the benefit of the doubt. They can start shooting—provided they find themselves a screenwriter. A real one. Fonda's preference is for Terry Southern, who recently won an Oscar nomination for Stanley Kubrick's

Dennis Hopper on a promotional tour of London in 1969, after Easy Rider won the First Film Award at the Cannes Film Festival.

Dr. Strangelove. Operating on a diet of Martini cocktails, Southern churns out page after page of dialogue that Hopper doesn't even read. Somehow, despite the chaos and confusion, shooting progresses.

"It's a shitshow," say the crew. Schneider asks Nicholson to get things under control. No easy task: during a single scene, the three protagonists get through 155 joints! After just seven weeks of shooting, they have 32 hours of rushes and a first edit lasting four-and-a-half hours. Out of this jumble, with Hopper obsessing over every cut, emerges a movie that has the critics reaching for superlatives. *Easy Rider* is nominated for Best Original Screenplay and Jack Nicholson, who plays a drunk lawyer, receives the Film Academy's nomination for Best Actor in a Supporting Role. Even in Hollywood, times are changing...

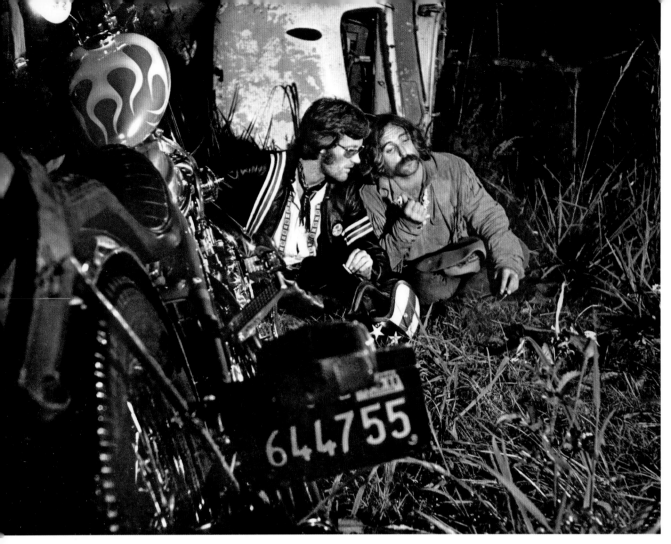

It's time to get stoned (again) for Dennis Hopper and Peter Fonda during the shooting of *Easy Rider*. Hopper would continue to do so for many years afterwards.

FONDA'S CHOPPER STARTS OUT AS A RETIRED POLICE BIKE

Peter Fonda had been seen on a chopper before, in *The Wild Rebels* (1967). Choppers were mostly Harley-Davidsons (Triumph's supremacy was on the wane by now), with greatly extended front forks and psychedelic paint jobs with flower power swirls.

The wizards who produced the *Easy Rider* choppers were African-Americans Clifford "Soney" Vaughs and Ben Hardy. A born biker and former marine, Vaughs had no qualms about riding his own chopper through Alabama. "I wanted to be a visible example to them; a free black man on my motorcycle,"[7] he said. In Arkansas, he was shot at by rednecks who couldn't bear to see a white woman on the back of his bike.

When he was contacted about *Easy Rider*, Vaughs had already finished making a documentary about the rise of the Black Panthers called *What Will the Harvest Be?* He teamed up with his mentor, Ben Hardy, the "King of Bikes," and charged him with finding suitable machines. Much like Triumph, who had refused to supply bikes for *The Wild One*, Harley-Davidson were unhappy about being associated with such a subversive script, so the four choppers it required were cobbled together especially for the movie. The chosen machines were 15-year-old Harley-Davidson Electra Glides, which Hardy picked up for $400 from a depot selling "retired" LAPD bikes.

Regarding the bikes as characters in their own right, Peter Fonda offered Hardy the "position" of co-producer—a promise he came nowhere near to keeping. For all his "cool biker" image,

Fonda was not prepared to flout institutionalized racism, and neither Vaughs' nor Hardy's name appeared in the closing credits! When shooting was over, a disillusioned Vaughs announced: "It's as if non-white chopper builders and riders didn't exist at all."[8]

EASY RIDER—AN UNEASY TITLE

Movies that "just happen" often have titles that are claimed by various people. This one was originally titled *The Loners*, and Peter Fonda is supposed to have dreamed up *Easy Rider* "just like that" one night after a few drinks…

But Terry Southern also lays claim to the idea. As screenwriter, he said, he was best placed to devise a suitable title. For him, *The Loners* was no good at all—a meaningless and unimaginative title. The term "easy rider," in current parlance, meant a hooker's boyfriend—not her pimp, but just a guy who wants … an easy ride. Fonda is reported to have told *Rolling Stone* magazine: It is a southern term for a whore's old man, not a pimp, but a dude who lives with a chick. Because he's got the easy ride. Well, that's what's happened to America, man.

Liberty's become a whore, and we're all taking an easy ride.[9] It is just the kind of comment that Fonda, who liked to play the rebel in front of the press, would make.

A third claimant to the title is Soney Vaughs. The first time he met Fonda and Hopper, at his home in West Hollywood, he says he gave them the title "on a plate." It came from the song *Easy Rider*, sung by Mae West in the movie *She Done Him Wrong* (1933). It includes the words: "I wonder where my easy rider's gone…"[10]

So was it Fonda, Southern, or Vaughs who first thought of the title? You pays your money …

BORN TO BE WILD—AN ODE TO FREEDOM

For the soundtrack, Peter Fonda suggested to Hopper that they use folk rock group Crosby, Stills, & Nash, whose gentle vocal harmonies were a world away from the psychedelic rock then in vogue. Hopper almost fell over! He thought he must have misheard, believing that "folkies" wouldn't get the movie at all. He then became aggressive and refused to allow the group anywhere near the studio.

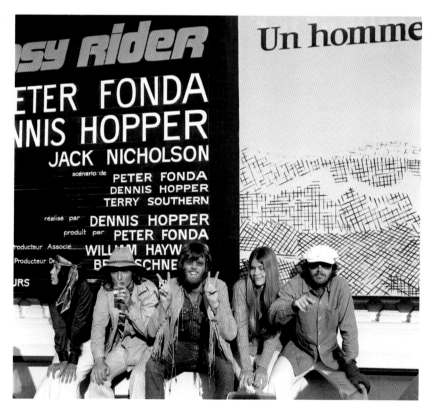

Easy Rider wins the First Film Award at the 1969 Cannes Film Festival.

Greatly
influenced by
Steve McQueen,
Peter Fonda was
responsible for
his "trendy rebel
biker" look.

As it turned out, he was right. The eventual soundtrack, an ode to freedom entitled *Born to be Wild* by Steppenwolf, transcended its time and became a classic. In the song, Steppenwolf sums up the message of the movie: "Get your motor runnin' / Head out on the highway / Lookin' for adventure / And whatever comes our way." An adventure whose ultimate goal is freedom. It is a quest that permeates the movie, as Jack Nicholson underlines: "They're not scared of you, they're scared of what you represent to 'em [...]. What you represent to them is freedom."[11] The freedom to make mountains of money. Columbia's Chief Executive, Leo Jaffe, put it succinctly: "I don't know what the fuck this picture means, but I know we're going to make a fuck of a lot of money."[12] He, too, was right. As for Dennis Hopper, *Life* magazine headlined him as "Hollywood's hottest director." He had finally become a (counter-)cultural icon; no need to be "the new James Dean" now.

Easy Rider was released in the U.S. on July 14th, 1969, with a PG 12 rating(!). Having cost just $350,000 to make, it grossed over $40 million. At the Cannes Film Festival the same year, it won Hopper the First Film Award. His next release, *The Last Movie* (1971), bombed so badly that he was virtually exiled from Hollywood for more than a decade.

EPILOGUE

June 3rd, 2010: San Francisco de Asis Church in Ranchos de Taos, New Mexico. Rumor has it that the Hells Angels are about to arrive. In fact, it was merely a lousy pretext for preventing Peter Fonda from attending his old friend's funeral. Hopper's so-called nearest and dearest had decided to make a clean break with the past—and particularly with the *Easy Rider* years. Fonda had to put away his chopper and climb back aboard his jet. Times had changed yet again—but not for the better. The two men had never been able to agree on one of the most important lines in the movie, spoken by Hopper's character, Billy, and repeated by Hopper himself in a real-life conversation with Fonda: "We blew it." Fonda never understood it. But one thing is for sure: Hopper blew his own funeral.

"They're scared of what you represent to 'em. What you represent to them is freedom."

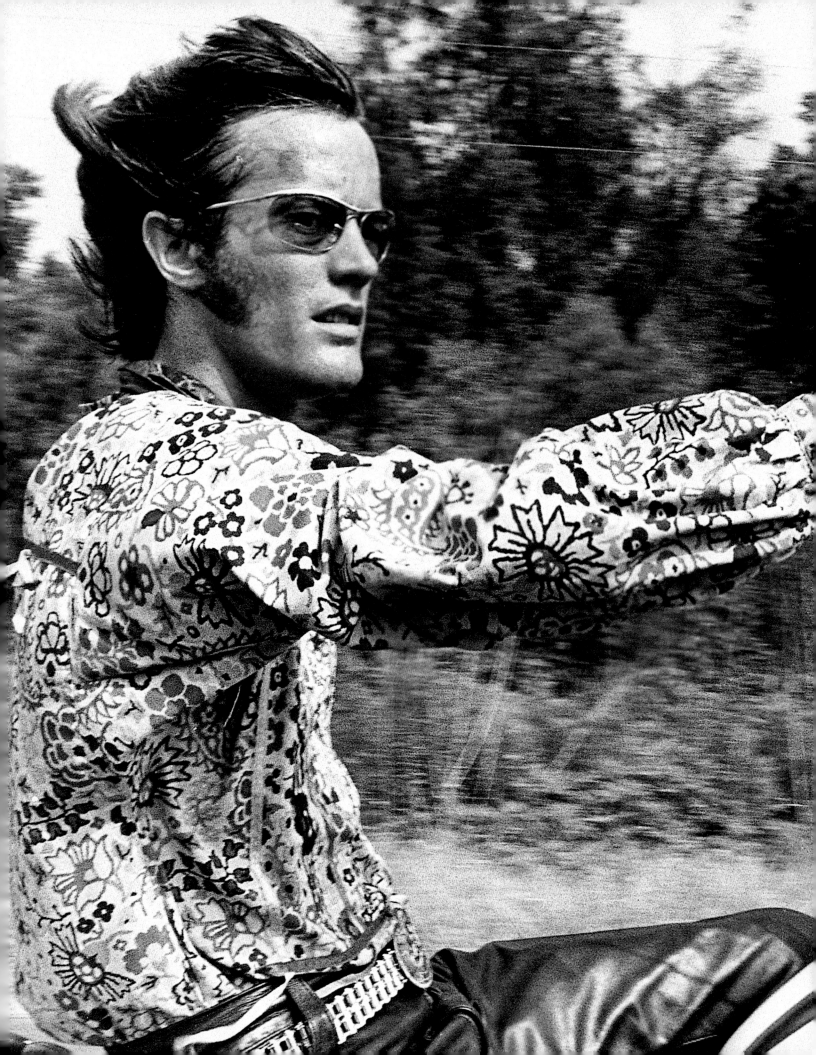

It was Peter Fonda who conceived the visual aspect of *Easy Rider* in every minute detail, from the design of the choppers to the actors' outfits. A true period piece!

CLIFFORD VAUGHS
MECHANIC AND POLITICIAN

Clifford A. "Soney" Vaughs, one of the two anonymous creators of the *Easy Rider* choppers (along with Ben Hardy), was also a civil rights activist—at a time of violent racial discrimination.

C lifford A. "Soney" Vaughs (1937–2016) will probably never earn his star on Hollywood Boulevard. Yet, along with Ben Hardy, he was the inspiration behind the chopper bikes with which Dennis Hopper and Peter Fonda challenged the complacency of 1960s America. In reality more rebellious than Hopper and Fonda put together, Vaughs, like Hardy, was omitted from the closing credits of *Easy Rider.* The two men received only belated recognition in 2009 for their role in creating bikes that became symbols of freedom for a whole generation. By then, Vaughs couldn't care less. He had long since quit the U.S. to spend the rest of his days quietly on a boat in the Gulf of Mexico. He had had quite enough "lives" already. Ben Hardy was always the black biker's guru, but Vaughs's career combined riding with politics. A dedicated biker, he also fought for black rights. He was committed to the cause, and not afraid to risk his life campaigning in the most violently racist states of America.

THE REVOLUTION STARTS HERE

A movie director and producer himself, and with no gripe against Peter Fonda, Vaughs made a short titled *Not So Easy* in 1972. In it, Fonda is seen on a conventional Harley-Davidson reciting standard safety advice for motorcyclists: to survive any outing in an urban environment, you should ride carefully and wear the appropriate equipment—helmet, goggles, gloves. This from a man who rode without even a helmet in *Easy Rider*...
As a young man, Clifford Vaughs had been a

member of the Student Nonviolent Coordinating Committee (SNCC), an organization that brought together students all over the north to protest against segregationist laws in the south. He took part in the first Freedom Ride in May 1961 and the Freedom Summer of 1964, which aimed to register

FOR CLIFFORD VAUGHS, RIDING AND POLITICS SHARED A COMMON GOAL: FREEDOM.

black voters in Mississippi. In that year, Vaughs hit the headlines thanks to a photograph taken by SNCC member Danny Lyon during a protest in Cambridge, Maryland. The picture showed Vaughs spread-eagled between six National Guard soldiers, with another SNCC member (and future leader of the organization) Stokely Carmichael hanging on to one of his legs—one of many photographs taken at the time that testified to the brutality inflicted on protesters. Danny Lyon was the first to make a photographic record of the activities of a biker gang. The Chicago Outlaws were part of the tiny minority of motorcycle clubs that openly used violence—and were proud of it. According to a police officer at the time, "99% of bikers are good people." In 1968, Lyon published a book called *The Bikeriders,* using the photos he had taken.
By then, at the instigation of Carmichael, the SNCC had radicalized, expelling all white members and adopting the slogan

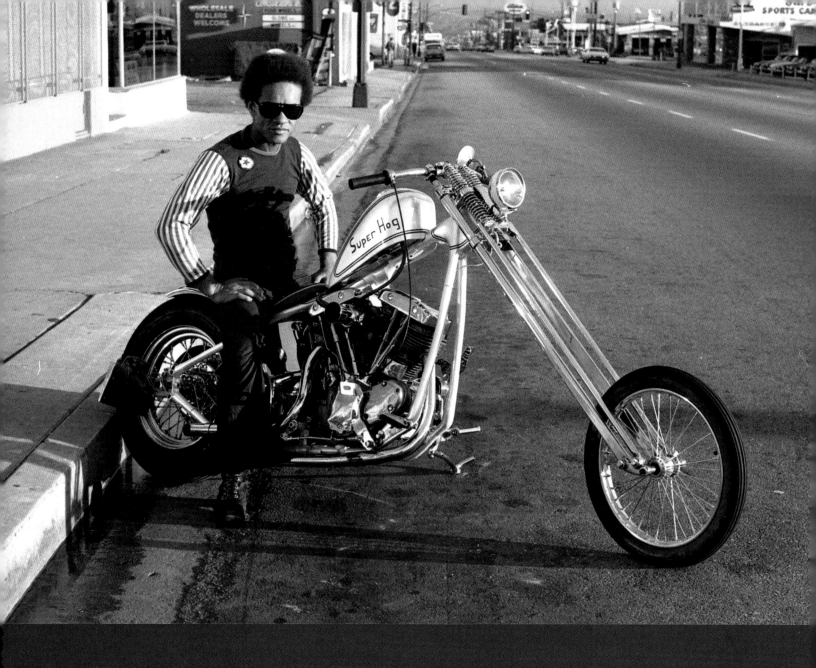

Vaughs in Los Angeles, on one of the choppers he designed. Not long after this photo was taken, he would create the bikes used in *Easy Rider*— and as soon be forgotten.

"Black Power." This was first used as such by another SNCC spokesperson, Willie Ricks, during a protest he had organized in 1966. That year also saw the foundation of the Black Panther Party for Self-Defense, which demanded official recognition of black rights—and was prepared to fight for it: "We want freedom. [...] We believe that Black and oppressed people will not be free until we are able to determine our destinies in our own communities."[12] Their battle cry was unequivocal: "The revolution has come! Off the pigs! Time to pick up the gun! Off the pigs!"[13] "Pigs" meaning not just police, but all whites. Among the Panthers' supporters at one time was Marlon Brando.

By the end of the decade, Vaughs had had enough of militancy and quit the SNCC, but not before he had made a documentary about the Black Panthers. For him, riding and politics shared a common goal: freedom. He would strap his chopper into the back of his pick-up, drive it to the states where racism was rife, and defend his right to ride around his own country, defying anyone to shoot him down.

FOLLOWING PAGES: The Chicago Outlaws in Wisconsin, photographed in 1966 by the legendary Danny Lyon.

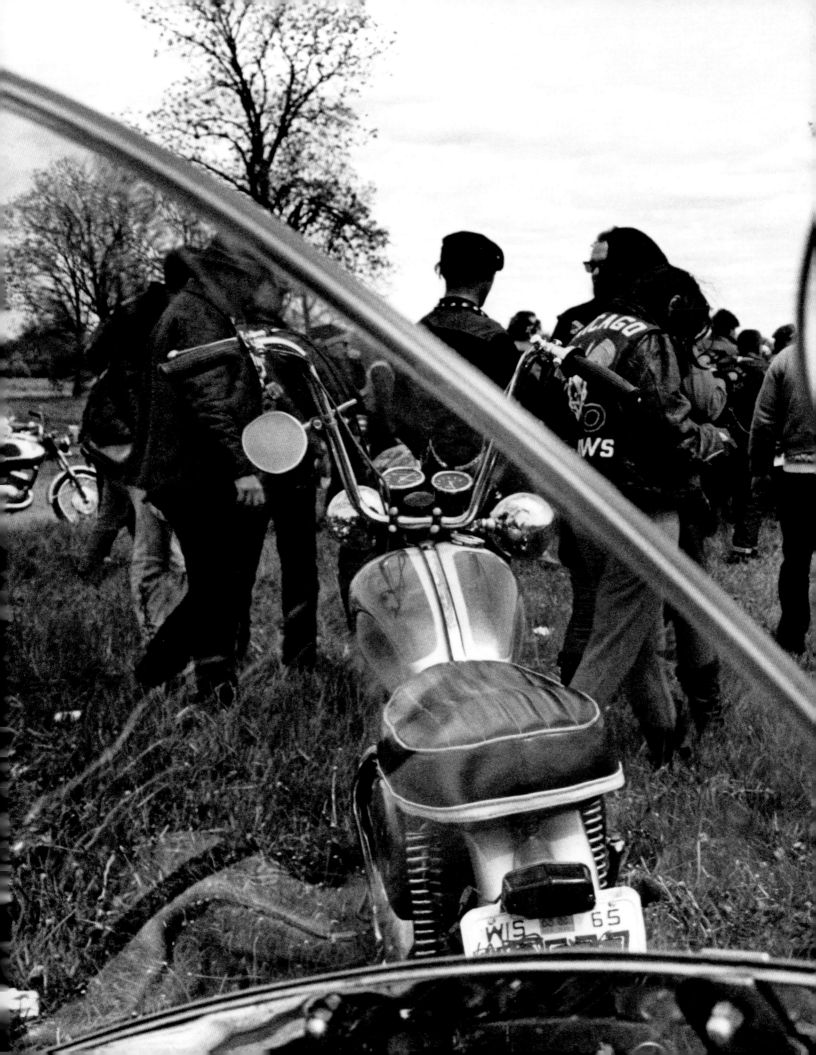

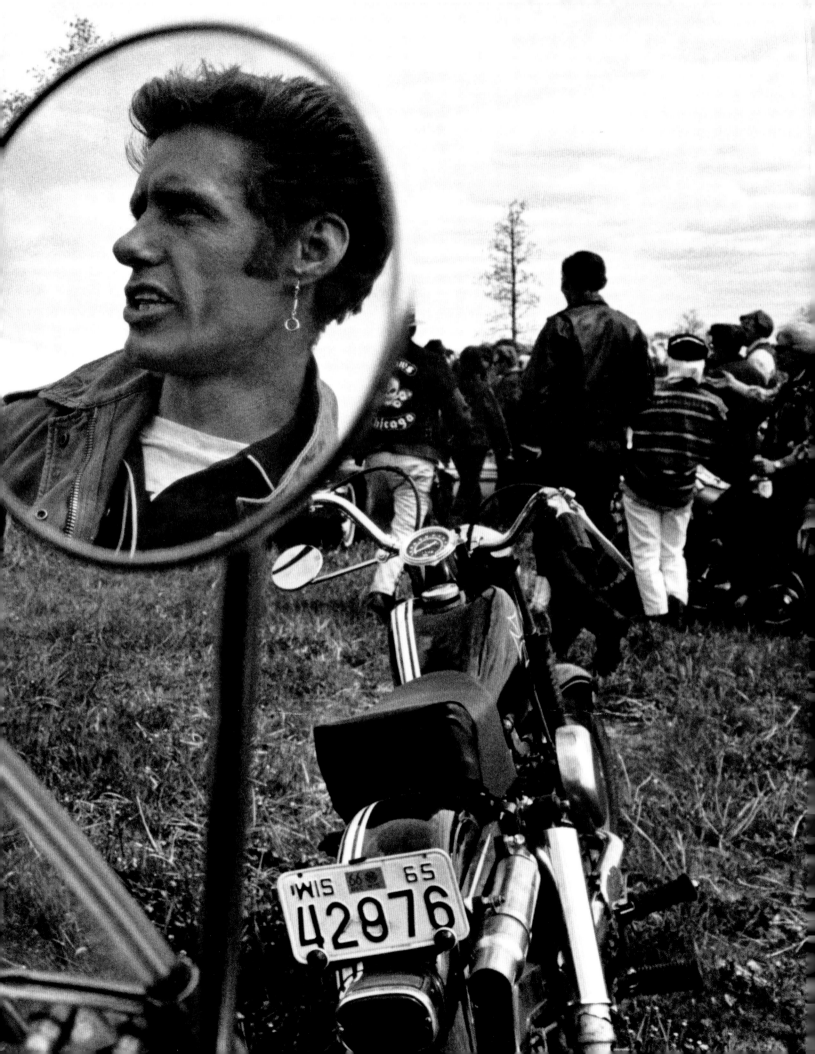

SIDEWALKS AND IMPORTS

The arrival in Europe of a flood of advanced Japanese bikes coincided with the rise of student unrest throughout the world—but especially in France. Both were signs that the old world was on the way out. But if the riots of May 1968 were soon over, Japanese domination of the motorcycle market was here to stay.

Six thousand miles east of Los Angeles, where *Easy Rider* had just begun filming, Pierre Viansson-Ponte, a journalist with the French paper *Le Monde*, was trying to think of a headline for an article due to appear on March 15th, 1968. American youth might be seething, but France ... was bored! That was it: "FRANCE IS BORED."

Viansson-Ponte wrote: "Public life in France is characterized by boredom. Our young people are bored. Students in Spain, Italy, and Japan are on the move, but all ours are concerned with is whether female students in Nanterre or Paris should be allowed into male students' dorms. Not exactly a major human rights issue." This apparently anodyne statement proved in fact to be one of the principal motivations behind the student strike at Nanterre University, organized by Daniel Cohn-Bendit and his "Movement of March 22nd."

It was the fuse that ignited the Paris riots of May 1968. But what did young people, and particularly students, want? Nothing in particular. They were simply protesting.

May 1968—a month of protest but not yet time for motorcycles. Women's rights protesters plead their cause from the saddle of a Mobylette.

After all, hadn't the radical literary group L'Internationale Situationniste just published a pamphlet entitled *Are Students Suffering?* Protesting against powerlessness—their own and their parents'—and against authority, which was then in the hands of a 78-year-old President, General de Gaulle. And yet the future they faced was hardly bleak. "Everything about their daily lives is branded with uncertainty. They are simultaneously free and fettered. [...] Free to push ahead and scramble up the career ladder and the social scale [...].[14] Free also to take their time," wrote Hervé Hamon and Patrick Rotman of the "'68 generation."

"BENEATH THE SIDEWALK THE BEACH"

The slogans that began to be daubed on walls in the capital set the tone: "Demand the impossible," "A life without obstacles," and, most famously, "Beneath the sidewalk, the beach." It was a movement that had been sparked in January by the Prague Spring, when the Czechoslovak Socialist Republic had attempted, and failed, to throw off the Soviet yoke, and subsequently spread to the United States, Mexico, and Japan.

May 1968 challenged the world's cultural, political, and social certainties, its most cherished values. And the world of motorcycling was not immune to the challenge; in fact, it underwent a radical change of direction. Jean Murit, a long-standing motorcycle dealer in Paris, still gets a lump in his throat when he recalls what happened, as he explained to the doyen of French motorcycling journalists, Jacques Bussillet: "May '68 changed everything for us. Suddenly, accepted family values were called into question, and teenagers and young people were asserting their freedom. Since they now had money to spend, well, that made it all possible. Before May '68, young people had to get their father's permission to buy a motorcycle, and that wasn't easy. Afterwards, they started turning up at the store on their own, without

either parent, saying, 'I want that one, nothing else.' They'd try to get a deal, but eventually paid the sticker price. Yes, May '68 made us rich!"[15]

BIKES ARE MADE IN JAPAN NOW

In Europe, British bikes had had their heyday, and the age of "market colonization" was almost over. The Land of the Rising Sun was raising the standard—in both senses—of motorcycling for the new generation.

Japanese bikes started arriving, almost furtively, in Europe in 1963. First came Honda, then, two years later, Yamaha and Suzuki. But the real invasion was signaled by the launch, in 1966, of the Honda CB450 "Black Bomber." This was a bike that looked British but had an engine with a double-overhead cam, a technical innovation that turned out to be a symptom of a far more radical change of thinking—a revolution in motorcycle design that put marketing and publicity first, and was aimed at making riding a more genteel, more "civilized" pastime.

Riding had not been for the faint-hearted, due to engines that leaked oil and drum brakes that performed anything but predictably.

Japan was no newcomer to motorcycle-making. Soichiro Honda had been planning to produce up-market bikes as far back as 1948, and by 1955 there were more than 70 Japanese companies making two- and three-wheelers. Two of the future world-market leaders had started out in quite different fields: Yamaha originally made keyboard instruments, and Suzuki built weaving looms.

By the mid-1960s, the Japanese market was saturated, and manufacturers started looking to export their products to other countries, starting with the USA. In 1965, 57% of Japanese bikes were exported, including models specifically designed for overseas markets, such as the Honda CB250 and 350, and, later, the Suzuki T500, launched in 1967. Curiously, though, the Honda CB450 and Yamaha XS 650, which were targeted at the American market, sold better in Europe.

If the Japanese initially modeled their bikes on existing European designs, they very quickly developed their own ideas for making motorcycles more comfortable and easier to ride.

Until then, riding had not been for the faint-hearted, due to engines that leaked oil, drum brakes that performed anything but predictably, and weight distribution that made "stability" a relative term. Thanks to Japanese ingenuity, the joys of riding were opened up to a whole new audience. Honda's publicity was aimed not at dyed-in-the-wool bikers, strapped into their Barbour jackets and peering like Crusaders

One of New York's first Honda dealers, in the early 1960s. The Japanese "invasion" of America had begun.

The Honda CB750 cut a swathe through the biking world, dividing the old from the new. From then on, nothing would ever be the same.

HONDA 750 FOUR

through a slit in their helmets. Instead, it promised hassle-free commuting through big-city traffic on, after all, modest machines of 50 or 125 cc. The modern rider was a go-getting executive in a blazer, hair flying in the wind on his way to a business meeting—or some other kind of rendezvous ... Brigitte Bardot, one of the biggest French movie stars of the 1960s, appeared on a Yamaha advert astride a 125 AT-1, leaving two admirers on Solexes trailing in her wake. The strapline, "Off the beaten track," implied that freedom could be found even in the city.

"THE HONDA CB750 EPITOMIZES EVERYTHING THAT'S GREAT ABOUT MODERN TECHNOLOGY"

If one bike could be said to have revolutionized riding, it was the Honda CB750 Four, which swept away all accepted ideas about what a motorcycle should be and made contemporary British bikes look like Stone Age relics. When it was unveiled in Paris in March 1969, the trade press rightly predicted that it would

be a winner. With a smooth, 67-horsepower, four-cylinder engine (which skeptics labeled a "gas-guzzler"), front disc brakes (yes!), and excellent stability, it promised long-distance comfort and a top speed of 120 mph. As if all of that weren't enough, the CB750 boasted a five-speed gearbox and an electric starter motor. Gilles Mallet, test rider for *Moto Revue*, summed up what was special about this two-wheeled flying machine: "The Honda CB750 epitomizes everything that's great about modern technology."

When he visited Japan in 1960, Triumph boss Edward Turner said that the Japanese were quite happy making small-engine machines and were no threat to the British big-engine market.[16] Not exactly a prophetic statement, as it turned out! Triumph continued to be reasonably successful, especially in the U.S. with the Bonneville, and they were optimistic about the 749 cc Trident T150, which they were sure would conquer new markets: its "three-cylinder engine will usher in a new era of motor-

Michel Rougerie, 19, refueling on his way to winning the 1969 Bol d'Or 24-hour race with Daniel Urdich on a Honda 750 modified by Japauto, Honda's principal French distributor then as now.

cycle design." How wrong they were! Much to their dismay, the Honda CB750, which enthusiasts were already dubbing "the bike of the century," rode off with the pot of gold, both in Europe and in America.

HONDA—COMPETING SINCE 1959

Motorcycle racing is a great opportunity to raise awareness of a new model, and demonstrate its capability—provided it wins.

In 1969, a Paris Honda dealer named Japauto made subtle modifications to a Honda CB750 (second front brake disc, 6.3-gallon (24 liter) aluminum fuel tank, single seat, and a slight increase in horsepower from the standard 67 to 72) and won the Bol d'Or 24-hour race. Taking turns aboard were Michel Rougerie (an up-and-coming rider of just 19) and Daniel Urdich. But it wasn't Honda's first competition success.

As far back as 1959, Honda had entered the Lightweight category of the Isle of Man Tourist Trophy (TT) with a 125 cc machine ridden by Naomi Taniguchi, who had achieved a respectable 6th place behind Mike Hailwood on a Ducati and winner Tarquinio Provini on an MV Agusta. In 1961, the company claimed its first victory on European soil by winning the Spanish Grand Prix in Barcelona, with Tom Phillis again on a 125 cc. Jim Redman, who would later ride the legendary Honda 6, finished third. Honda went on to snatch top places at most of the other European Grand Prix that year, using riders who had "defected" from rival camps, including Hailwood and Luigi Taveri, winners at 125 and 250 cc.

The final nail in the British-American coffin was Dick Mann's win on a Honda CB750R at the 1970 Daytona 200—a race that had been dominated by Harley-Davidson, Triumph, and Norton since its inception in 1937.

The starting grid at the 1970 Daytona 200. Dick Mann (#2), who had been chasing victory for 15 years, finally won it ... on a Honda CB750R. What a bombshell!

A Kawasaki Samurai 250 being refueled during the 1969 Bol d'Or, a 24-hour race which the Samurai was eligible to enter between 1967 and 1969.

An improvised pit lane for these 4-cylinder Honda 250s.
Any idea how we get back on the track?

FOLLOWING PAGES:
A rare sight: a woman riding a Jawa
Californian 350, whose gear shift lever
also functions as a kickstart.

FESTIVAL TIME

1969 may have been the end of the Sixties, but the decade wasn't finished yet. It was a year that oscillated between fanciful promises of a world without constraints and outright disillusionment. In their forgetfulness, people conjured the imaginary paradise of Woodstock in the wake of the Altamont inferno.

The Monterey Pop Festival in 1967 had left its mark on the popular imagination, and there was an urge to rekindle that "community spirit." Two young promoters, Michael Lang and Artie Kornfeld, decided to take the plunge and organized The Woodstock Music and Art Fair, subtitled "An Aquarian Exposition: 3 Days of Peace & Music," August 15–18, 1969. The festival was originally due to take place in Wallkill, a smart little town in New York, but the idea was vetoed by the residents, who included artists and "civilized" bohemians. That left the organizers with a week to move it to nearby White Lake, near Bethel, where Max Yagsur, a dairy farmer whose son was fighting in Vietnam, rented them his land for $50,000.

A factor influencing the choice of venue was that Bob Dylan lived nearby, and it was hoped he would come along. Dylan, a veteran protest singer with links to the civil rights movement, was, however, notoriously hard to pin down: He was never where you thought he would be. And sure enough, he avoided the festival, preferring to be top of the bill at the Isle of Wight Festival of Music in the U.K. at the end of the month.

A Woodstock attendee taking a nap on a handy Honda CL 160 Scrambler.

Politics wasn't Dylan's only interest; he also had a passion for motorcycles. When asked by journalists why so many of his songs included references to bikes, he replied that pretty much every guy loved bikes.[17]

After the success of *Blowin' in the Wind* (1963), Dylan bought himself a Triumph 650, but, Joan Baez, who was his girlfriend at the time, said it looked like he was sitting on a sack of flour.[18] After a riding accident in 1966, he "disappeared" for several weeks, causing consternation among his fans, who, like most Americans, feared the worst. In fact, he may never have had a crash at all, or used it as an excuse to take time out or detox ... It remains a mystery to this day.

HIPPIES NO LONGER WANT TO TAKE TO THE ROAD

Back at Woodstock, chaos. Three days of rain had transformed the field into a mud bath (some saw even this as a CIA conspiracy), the ticketing system was inadequate, there were virtually no bathrooms, and the expected 50,000 spectators turned into 500,000. Result: gigantic traffic jams, staff panic, and ultimately—since it proved impossible to control the flood of people—free admission for all. Financially, it was a disaster for the organizers, even though they had managed to persuade most of the bands (with the exception of Grateful Dead and The Who) to play for nothing and had sold some tickets in advance. As for the music itself, it was enjoyed more or less depending on the weather conditions, the quantity of illegal substances consumed, and the likelihood of being electrocuted ... Nevertheless, Woodstock was regarded as a triumph. The performances of the bands paled into insignificance compared with what the American and European press declared to be the birth of a new generation: the "Woodstock generation." The event was believed to have allayed at a stroke the anguish of a society exhausted by the Vietnam War,

MICHAEL LANG
MISTER WOODSTOCK

Michael Lang, a dealer in secondhand clothes from Coconut Grove in Miami, is largely unknown, but he was the principal organizer of the festival. Throughout the "Three Days of Peace & Music," he burned up the back roads of Woodstock on his BSA B44 Victor Special.

Michael Lang was born in Brooklyn in 1944. After running a clothing store in Coconut Grove, Miami, he decided to try his luck at organizing concerts. His first attempt, the Miami Pop Festival in May 1968, revealed the hand of a master, with 25,000 attendees and an exceptional line-up, including The Mothers of Invention, John Lee Hooker, and The Crazy World of Arthur Brown.

After that, Lang returned to New York State and made a home in Woodstock. His meeting with Artie Kornfeld, Vice-President of Capitol Records at just 20, was nothing less than historic: Together, the two men would organize a pop festival that has since acquired mythical status.

Tickets were supposed to cost $18, but the arrival of half a million people made it impossible to collect payment, and it took Lang and Kornfeld more than 20 years to

the continuing Cold War, the violent suppression of protests worldwide, and the assassination of political leaders. Woodstock came to be regarded as the creation of a new kind of community—a utopian one, needless to say—dedicated to hedonism.

Michael Wadleigh's 1970 documentary on the festival opened to the song *Going up the Country* by Canned Heat, which extols a life where "the water tastes like wine." From now on, hippies no longer want to take to the road. Only a year before, they had swarmed down the highways to Woodstock; now they wanted to put down roots, breathe fresh air, and live off the fat of the land. As if to compound the contradiction, Canned Heat's only other hit, in 1971, was *Harley-Davidson Blues*, which became the signature tune of American bikers!

STICKS AND STONES . . .

Free tickets ... a utopian idea promulgated by idealists who imagined that everything in the consumer world—from clothes to concert tickets—could be free, in both senses of the word. This romantic notion took hold after

Woodstock. It was like a recurring dream that eventually seemed real. But within a few months, after Altamont, it had proved to be a deadly nightmare.

Many were eager to jump on the Woodstock bandwagon, including Mick Jagger, lead singer of The Rolling Stones. The Stones hadn't toured America since 1966—in other words, for centuries. In that time, San Francisco had become the epicenter of the new craze for "psychedelic rock"—bands such as the Grateful Dead and Jefferson Airplane. There, free concerts had become the norm—almost a tradition. And Jagger was getting nervous. Led Zeppelin, a new band on the block, was attracting attention and he knew that, for The Stones' to assert their superiority, they would have to perform in the States again—and that meant a tour. But tickets to a Stones concert were expensive, and this didn't fit with the new trend in America. At press conferences, Jagger was repeatedly hounded on this point—and became increasingly evasive. But little by little, the idea percolated. Why not ... a free concert on the West Coast on the last day of the tour? (The Stones themselves are reported as saying: "Anything

Michael Lang, the man who made Woodstock happen, on his BSA B44 Victor Special.

repay the $1.6 million they owed, despite royalties from the *Woodstock* documentary helping to redress the balance. During the three days of the event, Michael Lang buzzed about the vast site on a BSA B44 Victor Special. His photo appeared in newspapers and magazines around the world. The Victor Special was a "civilized" version of the bike ridden by 1964 world motocross champion Jeff Smith. Built between 1968 and 1969 and aimed at the U.S. market, it was enormously successful. Unlike Europeans, Americans were avid off-roaders, and they found its "scrambler" looks irresistibly seductive.

we get out of this will either go to a charity or else directly back to the kids in San Francisco" and that any profits derived from the event would go to a Vietnamese orphans' fund.[19]) After all, The Stones had only recently given a free concert in London's Hyde Park—a tribute to Brian Jones, one of the band's founders, who had died on July 3rd. On that occasion, the British Hells Angels had provided the "security." As we now know, they were mere pussycats compared with the "real" American Angels. But no one had told Mick Jagger.

Free tickets ... a utopian idea promulgated by idealists who imagined that everything in the consumer world could be free.

Nowhere in the San Francisco Bay area would host the concert, given that Jagger, who abhorred the idea of a police presence, had stipulated in his contract that the forces of law and order should not come anywhere near it. Provocatively, he said that The Stones were prepared to play in the street. Instead, the Sears Point (now Sonoma) Raceway was chosen as a site that lent itself perfectly to crowd control. But the plan was thwarted when negotiations over rights to the movie that was to be made of the concert fell through. So what? Hadn't Woodstock changed venue a week before it started?

So finally, the event took place at the Altamont Raceway. Rising like a chimera from the dusty landscape at the intersection of two highways, Altamont was a pretty hellish place even before the concert started ...

"DO YOUR THING. EVERYTHING IS FREE"

Everyone wanted a piece of the action: producers (The Stones' *bête noire*), Mick Jagger's hangers-on ... and Emmett Grogan, leader of the San Francisco Diggers and prime mover

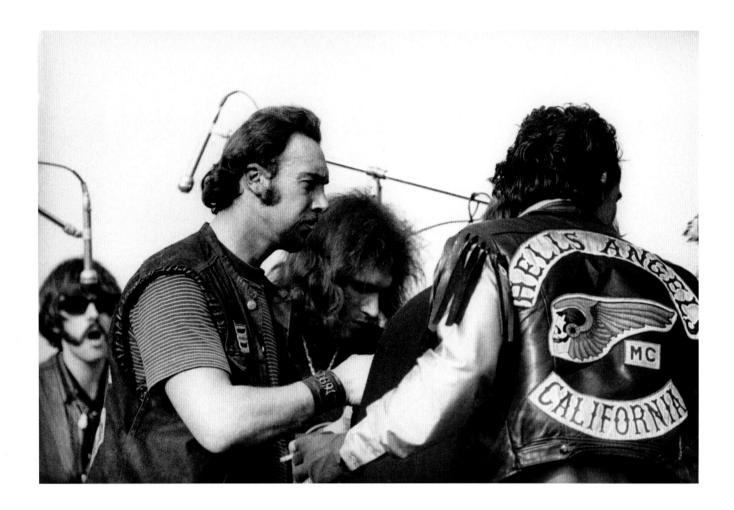

behind the city's obsession with free stores, free clinics—even free banks. A concert that was not only free but also advertised as such was right up his alley! Some time before, he had distanced himself from the hippie scene and counterculture generally, disappointed by their political and social apathy. His catch-phrase was "Do your thing. Everything is free," and he was convinced that the idea of getting the Hells Angels to provide security was a good one. However many people attended, no one would dare to cross them. He remembered the Summer of Love, when Angels and hippies had happily rubbed shoulders right there in Frisco. Haight-Ashbury was their home as much as it was Allen Ginsberg's or Timothy Leary's. Woodstock organizer Michael Lang was also enlisted to contribute his experience, though given the way that event had turned out, its relevance was open to question.

The date of the concert was fixed for December 6th, 1969, and The Rolling Stones would share top billing with Santana; Jefferson Airplane; Grateful Dead; Crosby, Stills, Nash & Young; and The Flying Burrito Brothers. At first, it was like Woodstock all over again: vast crowds, pro-digious traffic jams, bad trips-a-go-go among a certain element of the audience, and a token local law enforcement presence.

A few hours before Santana was due to kick off the festival, a young man drowned in an irrigation canal. A good start!

The San Jose Hells Angels terrorized both the public and the musicians. During the concert, a member of Jefferson Airplane was beaten up, and Stephen Stills sustained a leg injury. The atmosphere deteriorated fast. Faced with uncontrollable Angels, Grateful Dead simply

Security at Altamont was provided by Hells Angels, whose brutality was exacerbated by their apparent inability to discern between performers and spectators.

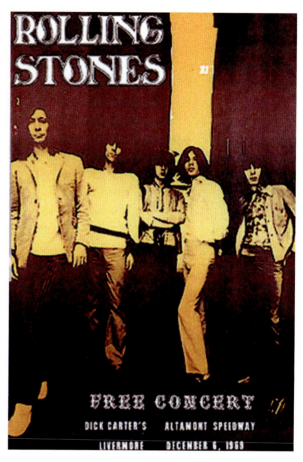

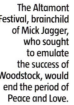

The Altamont Festival, brainchild of Mick Jagger, who sought to emulate the success of Woodstock, would end the period of Peace and Love.

packed their bags and left. Finally, The Rolling Stones made their appearance, but by this time it was clear even to them that what "must be hell" was right there in front of them.

"ROCK AND ROLL'S ALL-TIME WORST DAY"

Mick Jagger tried in vain to curb the murderous tendencies of the Hells Angels, who were attacking anyone and everyone who got in their way with pool cues. In a desperate, but lame, attempt to bring them under control, Jagger himself pleaded with the crowd: "Just be cool down in the front there. Don't push around." He might as well have asked them to make him a cup of tea. At this point, an 18-year-old black man named Meredith Hunter (known as "Murdock") entered the fray—thereby adding his name to this somber chapter in the history of rock and roll. When Hunter, as high as a kite, started climbing onto the stage, a Hells Angel grabbed him by the hair and punched him in the face. Hunter tried to escape into the crowd but was pursued by a four Angels, who attacked him. When a fifth, Alan (Al) Passaro, saw him draw a .22 caliber revolver from his jacket, he ran at Hunter and stabbed him repeatedly with a knife. The teenager died several hours later in an ambulance, after the organizer's chief medical officer had failed to commandeer a helicopter ... reserved for The Rolling Stones.

The concert went on. During the night, a guy who'd had a bad trip mowed down two spectators with a stolen car, and there was another drowning—bringing the death toll to four.

After their last song, *Honky Tonk Women*, The Stones took to their helicopter and were

gone. The following morning, the leader of the Oakland Hells Angels, Sonny Barger, who had attended only the last few hours of the concert, found himself facing questions from a presenter on local radio station KSAN-FM. His justification: Maybe you think we paid fifty dollars for our bikes or even stole them [...], but let me tell you, most of the guys who have a nice Harley chopper have spent thousands of dollars on it. No one kicks my bike over [...]. When you're there, keeping an eye on something that's your whole life, that you've invested everything in [...] and you see some guy ramming it with his boot, you know what kind of person you're dealing with [...]. And if you have to push past fifty people to get him, that's what you do. And you know what? We got 'em.[20] No comment....

Al Passaro, who ended Meredith Hunter's short life, was found not guilty of murder after a trial lasting 18 days. In 1985, he was found drowned, with $10,000 in cash in his pocket. He had probably been murdered.

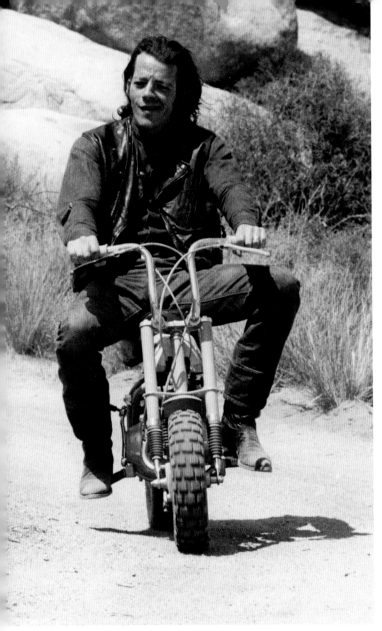

Emmett Grogan, a "peaceful activist" who nevertheless had ties to the Hells Angels, was a guiding spirit behind the Summer of Love...

"Death of the hippie, birth of the free man", according to Richard Brautigan, a leading U.S. writer of the 1960s.

Altamont became the subject of a documentary entitled *Gimme Shelter*, directed by the Maysles brothers. It was commissioned by Mick Jagger, who wanted to outdo *Woodstock*, the movie of the eponymous festival. This had been made by one of the kings of musical movie making, Michael Wadleigh, winner of a 1971 Oscar for Best Documentary Feature.

"DEATH OF THE HIPPIE, BIRTH OF THE FREE MAN"

Long after abandoning The Diggers, and having spent a while crisscrossing the West Coast on his motorcycle, Emmett Grogan confessed to the *New York Post*: "It was my fault because I stupidly left San Francisco and went back to L.A., where I got everyone hooked on this 'free farewell concert to thank you all' idea. [...] It's my fault that the California Hells Angels thought they were there to drink beer and have a good time with their mates, like they'd always done, and found themselves having to fight to stop people invading the stage, to protect a homo [Jagger] who got off on strutting his stuff in front of people, winding them up, and send-

Despite the dreadful events at Altamont, the press—including the usually sober *New York Times*—remained upbeat. It had been a "celebration of rock, with an audience of over 300,000."

It would take the investigative spirit of another publication, the magazine *Rolling Stone*, which had emerged from the underground music scene, to put the story straight and draw the public's attention to the true facts with an article headed "Rock and Roll's All-time Worst Day." In 1971, Stones guitarist Keith Richards told Robert Greenfield: "Altamont, it could only happen to the Stones, man. Let's face it. It wouldn't happen to the Bee Gees and it wouldn't happen to Crosby, Stills and Nash."

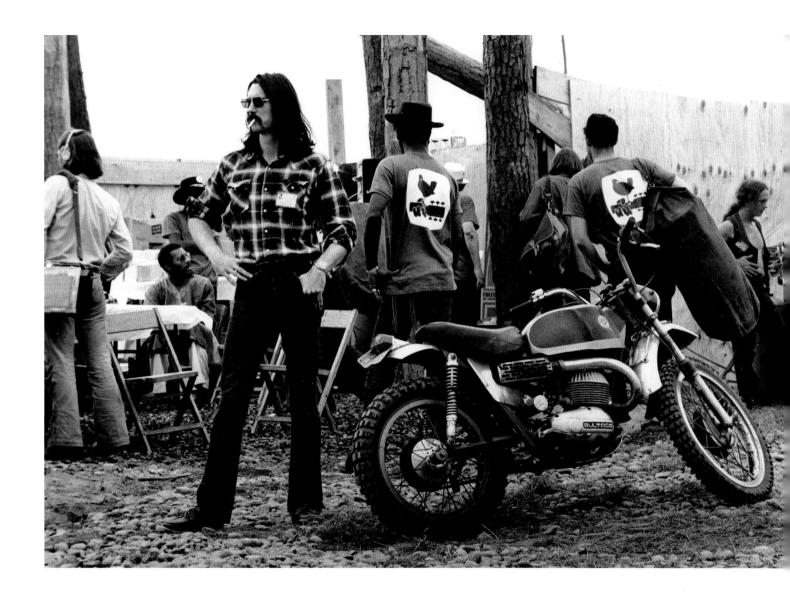

A Bultaco
backstage at
Woodstock.
Seated to the left
is Richie Havens,
whose set opened
the festival.
He traveled by
helicopter—to
beat the traffic!

ing them into some kind of puerile, hysterical trance—who thought he was playing to a bunch of excited flower-power teenagers instead of in front of 400,000 normal people old enough to know that flowers don't last that long, even when they have thorns."[21]

Above all, Altamont marked the end of the hippie dream: a utopia where everything was free. Richard Brautigan, a celebrated writer and friend of Emmett Grogan, summed it up when he wrote that the hippies were dead; long live the free man. Maybe it was a price that had to be paid? In the fiction of *Easy Rider*, Billy and Wyatt are killed on the road as they search for that same freedom. In reality, Meredith Hunter is killed for believing he has the free-

dom to defy the Hells Angels and The Rolling Stones. But rock and roll rode on into the new decade—albeit more doleful and embittered than before. As for the motorcycle, it was no longer something to be feared; it had become mainstream. Riding was now open to all. New heroes would appear, and the chopper would be nothing but a museum piece.

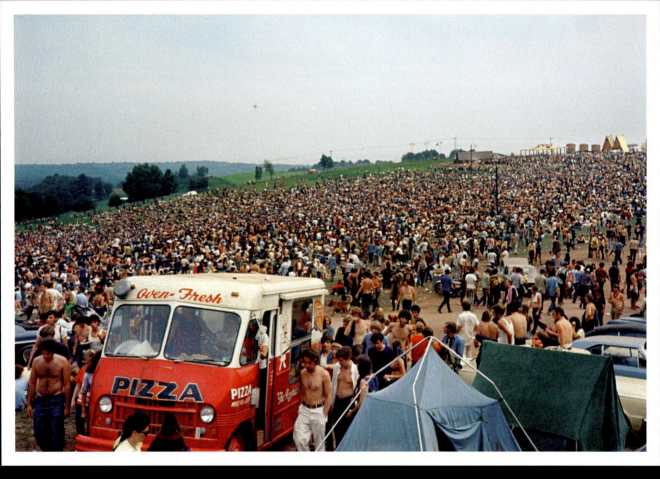

The organizers of the Woodstock festival expected 50,000 people; more than 500,000 flooded into Max Yagsur's fields.

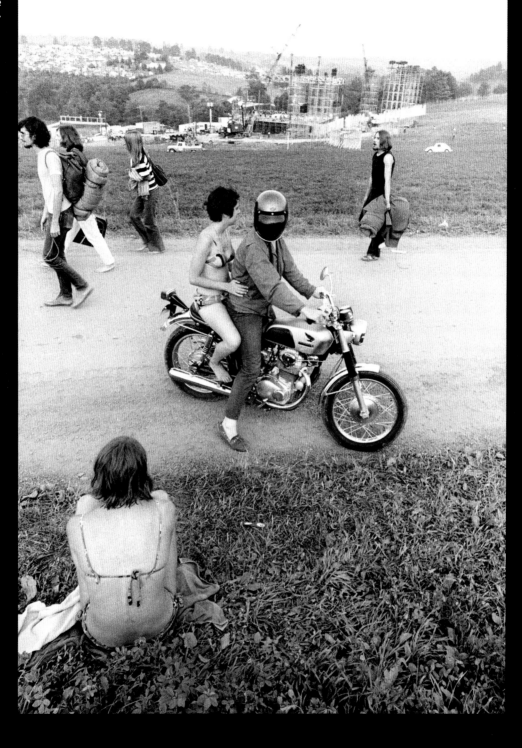

A Honda 250 or 350 at the Woodstock site. In the background, preparations for the festival are underway.

FOLLOWING PAGES: One of the few, if not the only, Harley-Davidson *not* converted into a chopper amid the mud and mess of Woodstock.

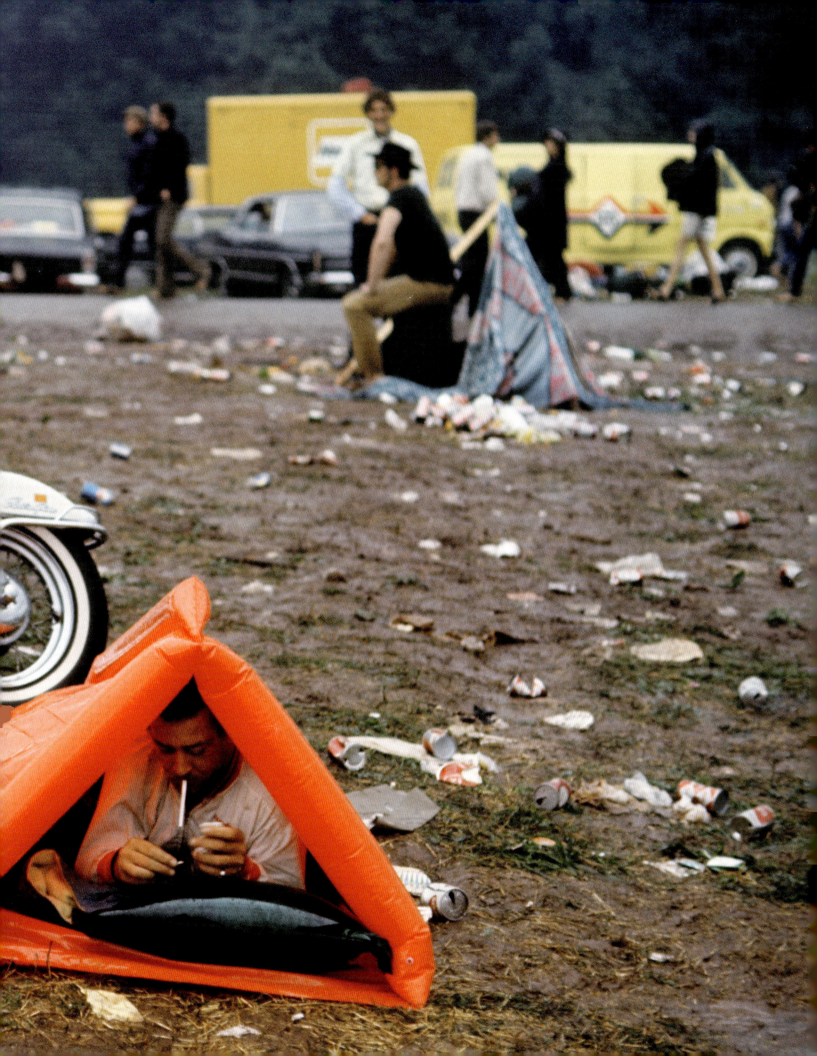

CONTINENTAL CIRCUS

When the motorcycle Grand Prix turns into a symbolic "class" struggle between factory team riders and "privateers," the circuit becomes a circus—both in reality and on screen.

1978: British bikers take the ferry to the Isle of Man for the Tourist Trophy. What, no saddle bags? Those were the days!

RIDERS ROCK AND ROLL

The Sixties and Seventies saw the emergence of radical political, cultural, and social movements— the foundations of counterculture. It was no coincidence that motorcycle riding— itself an expression of the desire to be free, to live on the margins of society—experienced its Golden Age during the same decades.

Motorcycle riding was not yet subject to the restrictions our safety-conscious age imposes on it: no speed limits, no requirement to wear a helmet, not even a motorcycle license. All these were in the future— and licensing would become as complex as the amendments to the Constitution! Competitive riding also had an element of rebellion about it—not to say, revolt. Victor Palomo was a Spanish racer who took part in Grands Prix between 1972 and 1982. In 1976, he confessed to Bruno Gillet in an article for *Moto Journal*: "I was born in Barcelona. My father was a good middle-class citizen. He had a garage for his car and plenty of money [...]. I started studying to be a lawyer. For me, it was a matter of principle: I wanted to help the weak and oppressed. At the time, I was living in a very left-wing area of Barcelona, and I had to abandon the idea of a career in law because I realized how corrupt the profession was. Motorcycle racing was a way of escaping all that.

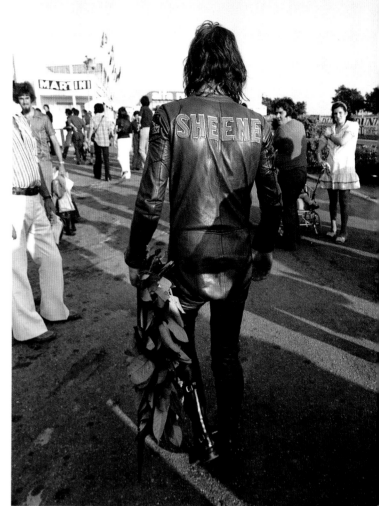

Barry Sheene, winner of the Trophée du Million at Magny-Cours, looking like a rock star.

I'd get into my camper with my bike on the back When I left Barcelona in the spring of 1972, I felt as if I'd been reborn. My father took it pretty badly. He cut me off. He simply couldn't understand why I would choose not to play the leading part that was cut out for me—in terms of prestige, as well as money. I remember one time in England; it was so cold, my mechanic and I slept in the shower cubicle of the camper with the hot water running all night to keep us warm."

CIRCUS PERFORMERS

Competitive riding in the Sixties and Seventies was a fringe event, and the championship circuit was a world apart, a wild world with its own practices and customs. Racers were nomads, traveling from track to track during the competition season, itinerant performers on a perpetual high-wire act—and often paying the price with their lives. The continental circuit had become a continental circus. Mike Hailwood himself once said that motorcycle racing was "a circus where the clowns pay to perform."

The motorcycling World Championship circuit was created in 1949 and by the late Sixties consisted of 12 Grands Prix, all of them in Europe—after unsuccessful attempts to hold events in Argentina (1962 and 1963), Japan (1963–1967), and the U.S. (Florida in 1964). From 1980 onwards, it was progressively "tamed:" races on the dangerous Finnish (Imatra) and Czech (Brno) tracks were stopped in 1982, and only purpose-built circuits were retained; running starts were abandoned in 1984; and a profes-

sional organizing body, the International Road Racing Teams Association (IRTA), was formed in 1986.

Before it became standardized and "professionalized," the circus had its stock characters—the perfect hero, the Latin lover, the outsider, the traitor, the handsome rebel, the giant-killer ... Each had his place on the starting grid, and the various roles were played by now legendary figures such as Giacomo Agostini, Jack Findlay, Phil Read, Bill Ivy, and Mike Hailwood. And each was chasing the same elusive goal: the World Championship—ideally in the 500 cc class, which had become the blue riband event.

The circus was absolutely in tune with the times. Riders and spectators were almost indistinguishable: black leather, Crusader helmets, long hair, cigarette hanging from the corner of the mouth (à la Barry Sheene), party spirit (especially on prize-giving nights, which were one big kegger, laundry hanging up to dry between battered old motor homes and trail-

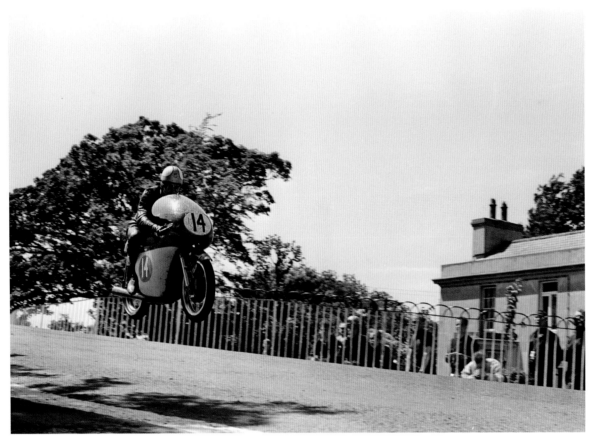

Mike Hailwood flying over Ballaugh Bridge on his MV Agusta 350 Three during the 1965 Junior TT in the Isle of Man.

ers, ready to be packed up the next morning to take riders, wives, and sometimes children across country to the next venue. It was often a hand-to-mouth existence: "Sometimes, we were so broke that we were running on empty. The trick was to have just enough gas to get you to the next circuit."[2] People have always paid a high price for freedom—especially the poor.

There was no clear distinction between the track and the pits. It was all part of the same scene, like a theater stage, and each actor knew his role: the predictable winner, the glorious loser, the unlucky runner-up, the survivor... The riders were a troupe, united despite their differences and their rivalries, touring the continent of Europe. Only the stopwatch separated them and reminded them that a race was a trial, with sentences meted out on the podium: victory, breakdown, accident, joy, tragedy...

HEROES LIVING ONLY IN THE PRESENT

The continental circus was about men more than machines. Admittedly, Agostini's MV Agusta, Hailwood's Honda 6, and Read's Yamahas weren't without their attractions—far from it—but it was the riders rather than the bikes (or the team managers) that had the all-important charisma. Each spectator, journalist, writer, and movie director had their own hero. And heroes they were, in this life-and-death struggle where the present meant more than the future. Several races took place on ordinary roads, whose obstacles made danger unavoidable: level crossings, narrow streets (on the Isle of Man), tracks zigzagging through trees (at Imatra in Finland)... There were only cursory safety precautions. Hay bales were the only protection against high-speed crashes, marshals were untrained volunteers, and medical staff were notably thin on the ground—ingredients of an often deadly cocktail.

It was a case of capturing the fleeting image of your favorite rider as he sped past, since there was no guarantee he would reach the finish line alive.

Not that riders failed to realize the precariousness of the life that they had chosen. "Very few men, properly speaking, live at present, but are providing to live another time," wrote Jonathan Swift (1667–1745). But the men of the continental circus lived only "in the present." As Jim Redman, 250 cc and 350 cc World Champion in the 1960s, is reported to have said: "We were all under 30 and had all written our wills. We tried not to get too friendly with one another. What's the point in making friends with someone who's likely to disappear in front of you any minute?"[3] Often, riders met their deaths. At the 1972 TT, Gilberto Parlotti was bagged up after plowing his Morbidelli 125 into a post office. Sometimes, more than one died in the same race, on the same bend, after hitting the same patch of oil—like Jarno Saarinen and Renzo Pasolini at Monza (Italy) the following year.

Who knows what became of young widows like Soili Saarinen, or girlfriends like Santiago Herrero's, who lived in the wings, glimpsed only before the start or during a pit stop?

It was a case of capturing the fleeting image of your favorite rider as he sped past, since there was no guarantee he would reach the finish line alive.

WINNERS AND LOSERS

Posterity can be cruel, often remembering only the names of the greatest champions: Agostini, 15 times World Champion, and Hailwood, 9 times. Countless books, documentaries, and reminiscences have reminded us of their brilliance through the decades. The two men led quite different lives and had quite different destinies, yet both were driven by the same demons, on and off the track. Giacomo Agostini, who still makes regular appearances at vintage bike shows, is now a respectable septuagenarian; despite the passing of time, he has managed to retain his striking looks—and the lines on his face barely disguise the young heart-breaker he once was. If bike racing hadn't bitten him in the Sixties, he would probably have remained in Rome enjoying *la dolce vita*. Mike "the Bike" Hailwood, unstoppable on the track, was killed in a freak accident on a country road just a few hundred yards from his home. On their way back from buying fish and chips, he and his daughter were crushed by a truck that pulled out in front of them. Hailwood's son survived with only minor injuries.

We could fill several pages with lists of winners and losers, with stories of triumphs and Triumphs, of unreliable engines coughing and spluttering on the start line and breathing their last a few laps later, of the unsporting monopolization of the circuit by Japanese machines at the expense of British and Italian bikes (with the notable exception of the MV Agustas) ... But the essence of the continental circus in the 1960s was not the races themselves; it was the spirit of the men it immortalized—men who crashed into our memories and remained lodged there across the generations. And they had to crash in, because there was no time for them even to pose for photographs; death overtook them after too few seasons. Men who

Jarno Saarinen, the flying Finn, with his wife, Soili, shortly before he and Renzo Pasolini perished at Monza in May 1973.

had a *je ne sais quoi* all their own, whose skill on the track was matched by a magical ability to capture the attention of the crowd and the press with a simple word or gesture. Agostini, Hailwood, and Read might have climbed the podium more often, but these other men—a little more rebellious, perhaps—deserve our attention all the more for disappearing so soon.

THE "27 CLUB" OF MOTORCYCLE RACING

There are no unknown soldiers in this cemetery. Despite being struck down before the halfway point in their "races," they displayed a brilliance that brought them glory and showed that they, too, could one day oust their elders and eventually take over the continental circus. Their lives were cut off by their disregard for danger, by their overconfidence in their machines (was this genuine or just a show of bravado designed to calm their nerves before the start?), or by a seized engine or a bend straightened by a patch of oil.

Reading accounts of the circuit and sifting through old photographs reveals three names that recur like a refrain.

Jarno Saarinen—the flying Finn, the embodiment of elegance, multilingual, a qualified engineer, mad about architecture—was almost unbeatable and regularly snapped at the master's (Agostini's) heels. He swept all before him and took the checkered flag at the 1973 Daytona 200 and Imola 200—both on a Yamaha TZ 350 when most other riders were on 750s. With his unique style and inimitable cornering technique, he was well on his way to becoming World Champion that year when, at Monza on May 20th, tragedy struck.

Santiago Herrero, the Spanish "matador" (he had a striking resemblance to the famous

Sixties bullfighter El Cordobés), was destined for a different arena—and would never know the adulation of crowds of admirers. His life came to an end in Douglas on the Isle of Man, during the 1970 TT race, when he lost control of the Ossa 250 he thought so highly of. Like Saarinen, he joined the "27 Club," whose members already included Jimi Hendrix, Janis Joplin, Jim Morrison and ... Bill Ivy—all dead at 27. As the French art historian Paul Ardenne wrote: "Just as Captain Nemo died a proper submariner's death aboard his *Nautilus* (could he possibly, let alone decently, have died anywhere else?), it was only right that Santiago Herrero—like Ivy, Saarinen, Parlotti, and the others—should die aboard his motorcycle. He could, of course, have lived into old age, parading his Ossa in veterans' races or vintage events, signing autographs for fans who were as ancient as he was, collecting royalties on a career as an international star ... And it is not for us to presume that he would not have preferred such a comfortable retirement to a premature death on the racetrack. But I can't help feeling he must have sensed, the moment

before he died, that he had achieved something, and that such an end was neither futile nor in the least unjust."[4]

And what of Bill Ivy—the young man with the rock star looks? Having won the 1967 World Championship on a Yamaha 125, he found himself on the same team as Phil Read the following year, again on a Yamaha. In order to prevent a potentially fatal duel between the two men, their team "arranged" for Read to win the 125 cc class and "allow" Ivy to win the 250. "Little Billy" obeyed instructions; his teammate did not, winning both classes and leaving Ivy feeling betrayed by both Yamaha and Read.

But that was how the circus was: many sought freedom, but only a few achieved it. And hunting for the right race team and the right machine was like searching for a rich seam deep in a mine, while dreaming of the light at the end of the tunnel—of staying on a production bike for a whole race, or even a whole season. Tomorrow, a short hop might take you to the top of the podium ... but a breakage or a fall could dash all your hopes.

Later that year, Yamaha pulled out of the circuit, and a doubtless bitter Bill Ivy became a "privateer." The Czech manufacturer Jawa offered him a Jawa 4. After the discipline imposed by the Japanese, it was something of a leap in the dark, but the supercharged Jawa had nothing to fear from the fiery Latin MV Agusta. The only question was: Would it be reliable enough? It was the clash of two opposing worlds: the King of bikes from the West vs. the rival from the East, an impostor from behind the Iron Curtain. It was also a class struggle, between Count Vincenzo Agusta, proprietor of the Agusta factory, and, in effect, Karl Marx. But Marx would also betray Ivy: during practice on the Sachsenring near Karl-Marx-Stadt (modern Chemnitz), the Jawa's engine seized and Ivy was hurled into a wall. He died a few hours later. Rightly, he became a legend—and legend has it that at the moment the engine seized, Ivy was adjusting his goggles or tightening the strap on his helmet.

Was it Phil Read's betrayal that killed Bill Ivy, or Karl Marx's? Or was it simply a leather strap?

Bill Ivy pulls out of the Isle of Man TT in June 1965. That year, he would fail to score a single point on the Grand Prix circuit.

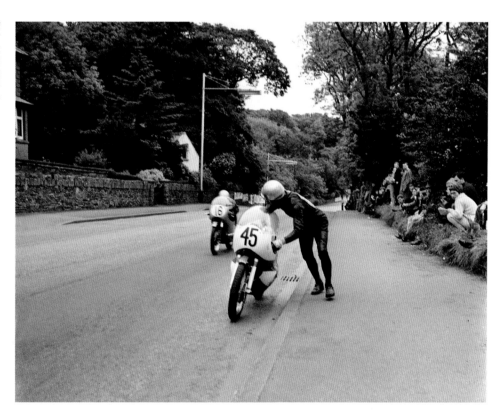

Glencrutchery Road, before the start of the 1973 TT.

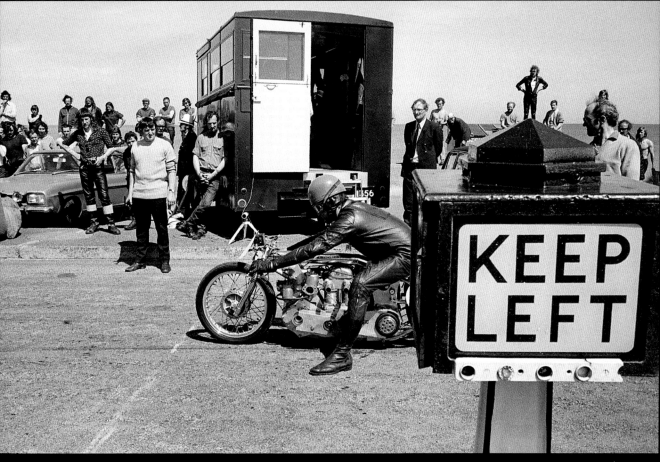

The Ramsey Streetfighter Challenge at the 1973 TT: a straight 400-yard (366 m) sprint along an improvised track on a bike powered by methanol.

FOLLOWING PAGES:
At the 1973 TT, Charlie Williams entered every class from 125 to 750 cc! He won the 250 Production and Lightweight trophies.

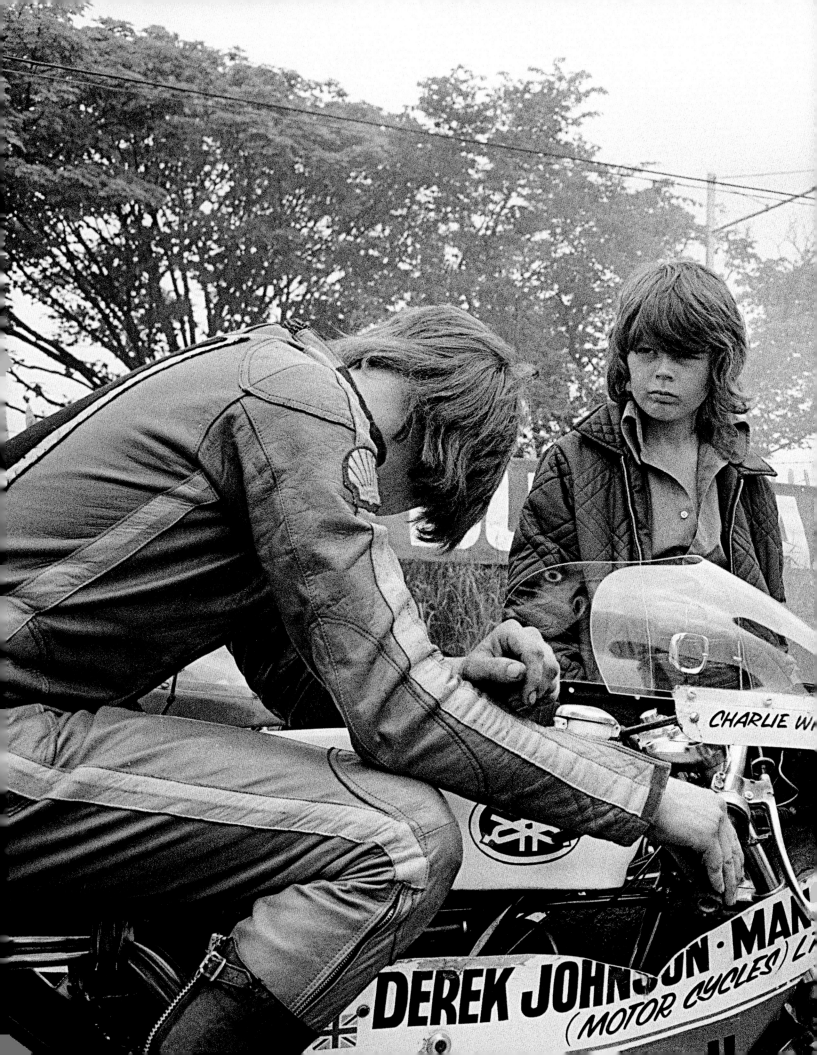

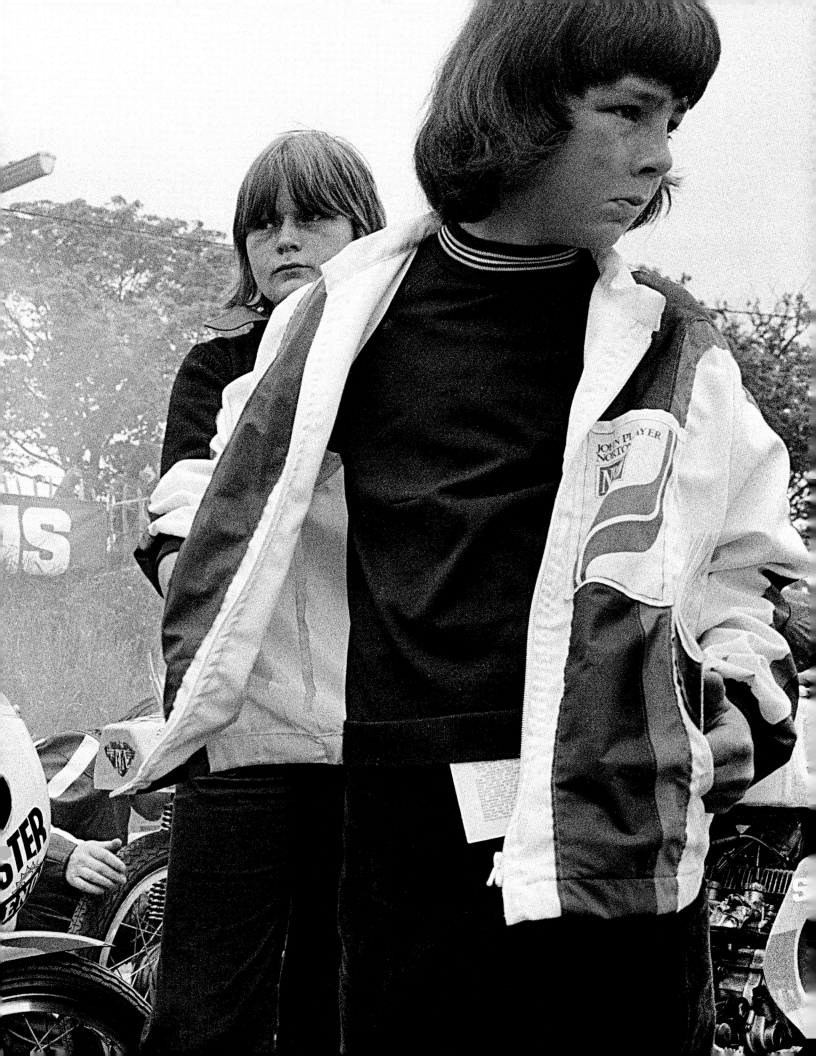

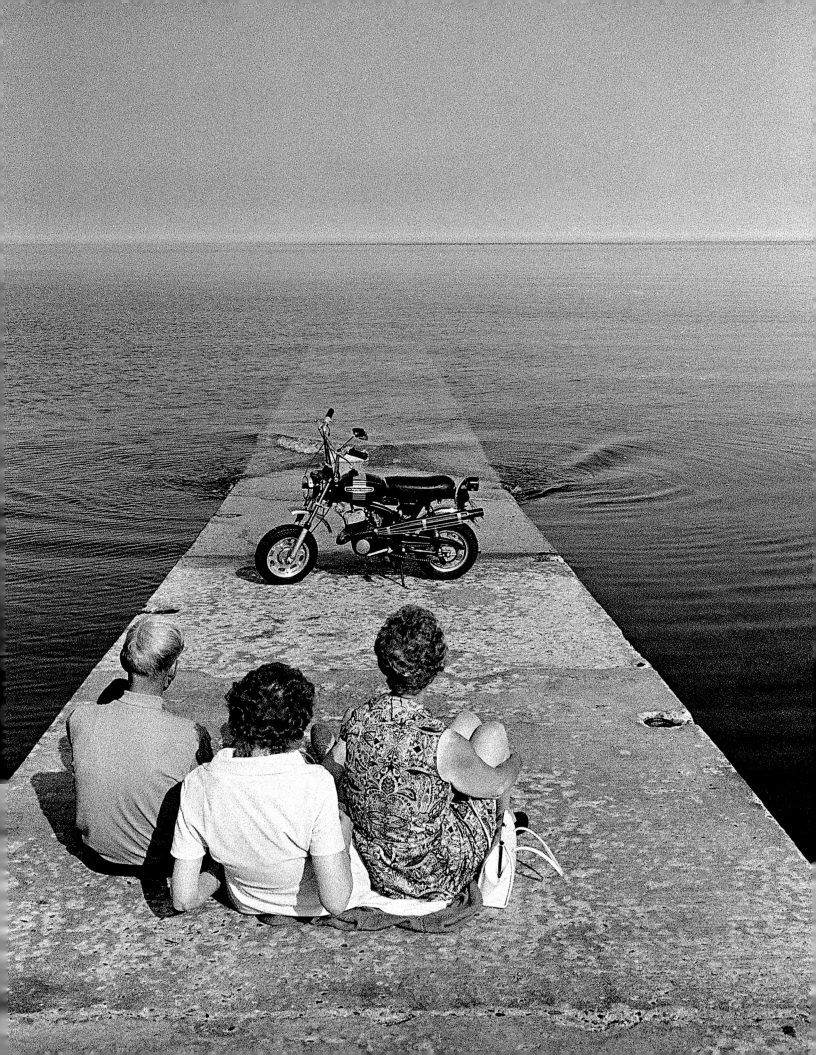

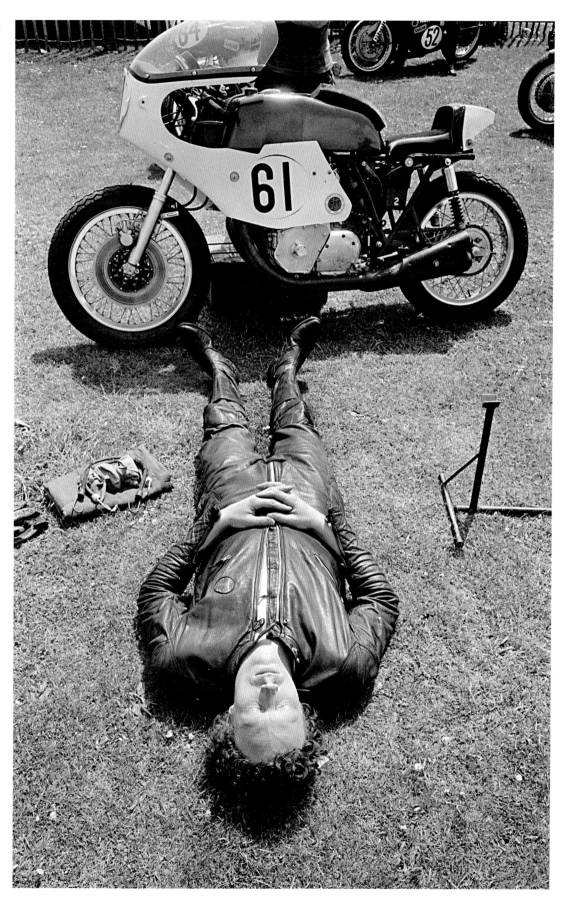

A competitor at the 1973 TT takes a well-earned nap. At his feet is a Honda. Yes, it is a Honda: The oil carter protector is the giveaway!

Are these vacationers at the 1973 TT 'seeing things', or has a mini-Harley-Davidson just come out of the Irish Sea?

CONTINENTAL CIRCUS AS A SOCIAL MICROCOSM

The continental circus was a microcosm inhabited by just a few hundred men, their families, and their machines. The magnificent documentary of the same name by the young French director Jérôme Laperrousaz reveals unexpected connections between the competitive circuit and society at the dawn of the Seventies.

The French documentary *Continental Circus*, which came out in 1972, hit audiences like a thunderbolt. It was a totally new type of movie-making: 16 mm format, unedited sequences, on-board cameras, and an intensely subjective approach, with full-frame close-ups of the riders' faces. Daevid Allen, whose influence David Bowie acknowledged, and his band Gong wrote the soundtrack, its repetitive rhythms blending with the hum of motorcycle engines.

Laperrousaz, then only 24, belonged to the "'68 Generation," which believed that everything was connected: music, movies, politics... One of the country's youngest directors, he made the first rock show to be shown on French TV, *Bouton Rouge* (1967–1968). He was also a habitué of Swinging London, where the Sixties were literally in full swing, and his friends included Eric Burdon of The Animals and Pete Townshend of The Who. *Continental Circus* was a product of France's innovative *cinéma vérité*, which evolved alongside Britain's New Wave—with directors such as Tony Richardson, Karel Reisz, and Lindsay Anderson. They wanted their work to be a

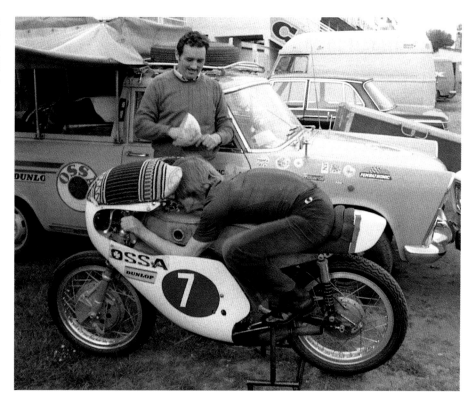

One of the most beguiling heroes of the circus, Santiago Herrero, on his ill-fated Ossa.

social commentary, and their characters were ordinary people—working-class heroes. The same applied to Laperrousaz's riders. They might have escaped life in a factory, but their reality was just the same: dry bread and a penniless future. In New York, Laperrousaz met up with Emmett Grogan of The Diggers (see page 82), who showed him his Hells Angels membership card and advised him against making a movie about that particular group of bikers.

A speed demon himself, Laperrousaz entered the Volant Shell, a car-racing competition held from 1964 to 1994 with the aim of identifying and training talented young drivers. He was also an avid reader and concertgoer; when he went to watch his first motorcycle Grand Prix, he was intending to make a movie adaptation of *Pylon*, a novel by William Faulkner. *Pylon* is the story of a group of pilots who, after the First World War, reject social conventions and take part in airplane races between pylons, which were highly popular in America at the time. Laperrousaz wanted to get inside the minds of these men, who lived on the fringes of society and chose to indulge in this strange, ritualized celebration of danger.

After three years of making notes, Laperrousaz abandoned the project in favor of another story about motorcycle riders, which he would eventually turn into a documentary. Nevertheless, his original theme remained more or less intact. He decided that his "cast" would include riders he knew—including Santiago Herrero, Giacomo Agostini, and Jack Findlay—and they themselves would be the stars of the movie. From them, he would seek answers to all the questions that preoccupied him: Why did they race week in, week out? Why, when they could visualize the entire circuit, were they still afraid of things going wrong, of crashing? The thrum of the engines and the throb of the music were in perfect harmony. The lyrics of the title track describe a dream Jack Findlay probably had before every race—even every night: "Can't you see me, Agostini / Comin' up behind you? / Gonna catch you later / I'm gonna be the fastest rider / Comin' up behind you." "If you look at Findlay riding and Hendrix playing guitar, you'll see the exactly same expression on their faces," commented Laperrousaz.

"A MOVIE ABOUT THE CLASS STRUGGLE"

For Laperrousaz, politics was never far away.

GRANDE DAME OF THE CONTINENTAL CIRCUS

In a sense, she ran the continental circus for almost three decades. Interpreter, negotiator (for an increase in prize money for the lower-order riders), and Jack Findlay's alter ego, she was known to the world as Nanou.

For a long time, the world of motorcycling wasn't exactly a utopia of sexual equality. Seventies bike ads invariably featured beauties in bikinis in lascivious poses designed to sell the manufacturer's latest model, and in the Eighties, scantily-clad grid girls would shield riders from the rain (or sun) as they waited for the start. Curiously, the continental circus seems to have been largely immune to this tendency. Maybe because a number of riders' partners (many of whom became widows) often attended races. It has to be said that their role in the proceedings was far from being a demonstration of female emancipation: washing, cleaning the camper, looking after children (if there were any), polishing chrome, and carrying their valiant partner's helmet. But, at the very least, their presence had a humanizing effect on the world of bike racing, at a time when many riders—when they weren't racing—were isolated and unsure of the future, exposed as they were to the often tragic consequences of unpredictable machines and improvised circuits.

1969—A DISASTROUS SEASON

In their midst, one woman stood out—a woman known to posterity only by her first name: Nanou. In *Continental Circus*, she is ever-present—whether laying a wreath on a dead rider's grave at the TT, cheering her man on to the finish, or considering the best course of action following a crash. Nanou was at one time both girlfriend and team manager to the taciturn Jack Findlay. If

Laperrousaz's documentary centers on the rivalry between Findlay and Agostini, Nanou is undoubtedly their co-star, her force of character exerting, and imposing, itself throughout. Riding is her *raison d'être*—and for "riding", read "freedom."
Marrying young to escape her parents, Nanou quickly divorced and remarried,

> "ALL THE RIDERS WANTED FREEDOM. IT COST US DEARLY, BUT IT WAS NO SACRIFICE; IT WAS OUR *RAISON D'ÊTRE.*"

going to live in New York. After returning to Paris, she discovered the world of bike racing and met Jacques Insermini, one of the first Frenchmen to join the circuit, soon becoming his girlfriend.
She met Jack Findlay in 1961, and for the next 15 years they suffered the torments of the continental circus together. She never doubted his talent, and in 1968 he was the season's top privateer. But the following year—the year in which Laperrousaz made *Continental Circus*—was the saddest and most disastrous of all. That season, "nine riders killed themselves," she later recalled. Nevertheless, with Findlay, she continued to chase the improbable dream of a World Championship title—all the while being sure to appear on the starting grid impeccably

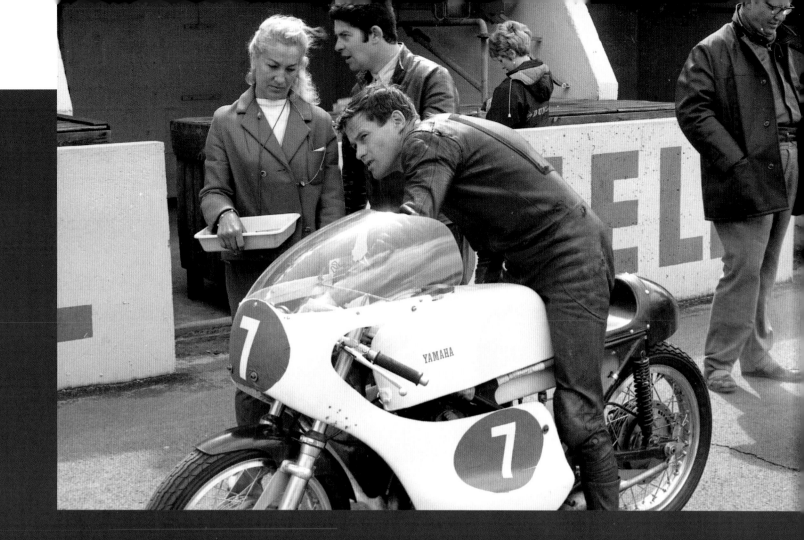

Nanou and Jack Findlay, the famous continental circus couple. After a season with Suzuki in 1975, Findlay reverted to being a privateer, on a Yamaha.

attired in the latest pop art fashions: "I liked being well dressed, but I didn't like being photographed. In fact, I haven't kept any photographs."[6]

Today, Nanou is a grand old lady. Although life did not treat her well after she left the circus in 1979, her memory and her assertive manner remain intact: "All the riders wanted freedom. It cost us dearly, but it was no sacrifice; it was our *raison d'être*."[7] As well as the sense of freedom, Nanou remembers the camaraderie and companionship of the period: "They would even lend each other parts. But that kind of cooperation disappeared with the arrival of the Japanese and their money ... and the sponsors! Ours asked Findlay to paint his camper black. Black! Can you imagine! How ghastly!"[8]

And what of Laperrousaz's documentary? She recalls it with some equivocation: "It isn't that I don't like it, but when it was shown at the Cannes Festival, it ran for 2 hours and 40 minutes. It was faithful to that feeling of solidarity that existed between us, along with all our day-to-day worries. But when it came out [the commercial release had been cut to 1 hour and 40 minutes], it had lost that feeling. Of course, there were tragedies, but the continental circus was more than that."[9]

Jack Findlay, who miraculously survived countless crashes, died in 2007, leaving Nanou as the only survivor of that remarkable duo, which had swung back and forth over the years between hope and disillusionment. In the end, their most trusted ally was not a motorcycle, but freedom itself. As for Nanou, she remains a female pioneer in a closed, macho world; it would be some years before women started competing in races themselves ... and riding solo around the world.

Giacomo Agostini, 15 times World Champion. Amid the chaos, he was consistently quick, on one of the world's fastest machines, the MV. Oh, and he was good-looking, too!

Although generally reserved, he confided in Philippe Canville of *Moto Heroes* magazine: "To me, *Continental Circus* is also a movie about the class struggle. I wanted to show the relationship between factory team riders and privateers. Agostini is the team man—an incredible rider, a great guy, and a genuine human being, whom I admire tremendously. But at the same time, he's cosseted by the MV Agusta team. Facing him is Jack Findlay, runner-up to Ago in the 1968 Championship—a guy who has nothing, who travels from track to track in a camper van, who survives on the meager payments made for starting and finishing a race, who has to borrow bikes or pay for them in installments. Alongside him is his girlfriend Nanou, a strong-minded woman. It's the relationship between those two worlds that I wanted to show. In the movies, the theme of the outsider has been explored by John Huston in *Fat City* and *The Misfits* and by Tony Richardson in *The Loneliness of the Long-Distance Runner*... Like them, I don't find that winners and people who have been blessed by the gods necessarily make the most dramatic subjects. Admittedly, Agostini hardly ever fell, but he had the best bike around and the top mechanics behind him—unlike the others, who spent most of their time struggling to keep up and to make ends meet. [...] I shot the movie during the 1969 season, but only starting with the Isle of Man TT—the first real challenge ... After that, it was on to Europe [...]. What I wanted to do was make *Continental Circus* a testament to a generation. It was just after 1968 [...]. The fact that it's still as popular today means that it speaks to the rebelliousness that riding symbolizes [...]. It's a movie that reminds us what was at stake in the Sixties—an age of upheaval that played a pivotal role in the development of our society."[10]

For the commercial release of *Continental Circus*, Laperrousaz had the backing of

André-Luc Appietto, the first French rider to take part in the Grand Prix circuit, who would kill himself in 1973 on the "natural" track at Bourg-en-Bresse in eastern France. A friend of Santiago Herrero and Bill Ivy, Laperrousaz managed to show all these "beautiful losers" (Leonard Cohen) as human beings rather than merely riders, using his camera to tease out of them their credo and purpose in life: "The movie is about what drives these men to live and die—men who choose not to follow a conventional course, working from 9 to 5 in an office or factory, but to follow their dreams,

A poster for the movie *Once Upon a Time, There Was a Continental Circus*, a personal view of the European circuit, directed by former Grand Prix rider Bernard Fau.

their obsessions. They are almost puritanical in their single-minded focus on getting to the next race [...]. The show must go on, whatever happens. The word 'circus' is entirely appropriate. It was a circus—and a very strange one at that... The performers were set apart from society. In the movie, someone says: 'When I started, it was worse than a drug. But I can stop whenever I want.' Except that they can't. They're still addicted! And death is always waiting for them."[11]

ONCE UPON A TIME, THERE WAS A CONTINENTAL CIRCUS

Continental Circus inspired several imitations. In 1975, Pierre-William Glenn made *Le Cheval de Fer*, which similarly documented a single competition season, starring a new generation of mainly French riders, including Michel Rougerie, Patrick Pons, and Olivier Chevallier. An even more explicit homage to Laperrousaz's movie was Bernard Fau's *Il Était une Fois le Continental Circus (Once Upon a Time, There Was a Continental Circus)* (2015), in which the 62-year-old celebrated his own part in the pursuit of freedom by a generation that regarded motorcycle racing as a road to self-discovery.

A man of the earth, Fau had decided to take up bike racing after watching *Continental Circus*, and had gone on to compete in several Grands Prix during the 1970s. He became the first Frenchman to win a leg of the British Championship, at Snetterton in 1977, where he had the honor of beating Barry Sheene and appearing in a list of "the world's greatest riders."

KENNY ROBERTS CRACKS THE WHIP

As if to prove that the continental circus was still in the Dark Ages, with little concern for the safety of its riders, a race was announced for October 1972 that would bring together the great and good of the sport. It was to be held in Rungis, a faceless suburb of Paris. Why Rungis? Why not? After all, numerous other unremarkable towns were transformed into racetracks for a weekend. But Rungis was a special case. In 1969, the 1,500-acre site had been chosen as a substitute for Paris's historic marketplace Les Halles, with its iconic wrought-iron pavilions. From then on, Rungis would be home to all the capital's wholesalers of fruit, vegetables, flowers, and fish. It needed all the publicity it could get! Seen by some as a bike festival and by others as an International Grand Prix, the event on October 22nd, 1972 offered spectators—who came in the tens of thousands—two 250 cc classes, an Open Class (350–750 cc), and a sidecar race. The big winners that day would be Renzo Pasolini, Barry Sheene, and Kent Andersson.

The track was laid out like a British Short Circuit: a series of bends, two straights, and a wide curve, dubbed "Jack Findlay corner," bordering a... drive-in movie theater! As for the

surface, there were places where the asphalt was coated in crushed vegetables or submerged under puddles of waste water or diesel fuel. Despite the inevitable crashes (including one by Agostini himself), there were no deaths that day. Hundreds of would-be riders had a chance to watch their idols perform, but the continental circus would never return to Rungis. Nevertheless, there were 18 fatalities on the circuit between 1974 and 1977, when the death of a girl by the name of Carole Le Fol caused the closure of the primitive track to all two-wheeled racing. In 1979, the department of Seine-Saint-Denis, north of Paris, opened the Circuit Carole at Tremblay-lès-Gonesse in her honor.

The age of "dueling" was coming to an end, as was the primacy of man over machine. At the end of the Seventies, riders went on strike. The arrival in Europe of the American rider Kenny Roberts turned the circus into a business—not without reason. Riders' outfits changed from black and white to color, and commercial sponsorship became the order of the day. In his book *The Golden Age of the Continental Circus*, Jacques Bussillet writes: "It obviously isn't possible to put a specific date to the end of the continental circus, but 1985 was certainly a watershed year: it was the last year in which riders could enter more than one class, and the first year in which it became impossible for a privateer to win the World Championship—or even a Grand Prix. From then on, the whole structure and organization of the Grand Prix circuit was controlled by teams."[12]

The "class struggle," too, was over—well, almost. Bill Ivy won a kind of posthumous victory over Karl Marx when capitalism took over. Everything was decided by the team managers. The new world of competitive riding had a new image and a new name: No one referred to the "continental circus" anymore (with its implication of riders trooping to their doom); now it was the MotoGP. Times had changed.

The "Paris International Grand Prix" parking lot on Oct. 22nd, 1972— a time before helmets became compulsory!

At the start of the "International Grand Prix" (or "Bike Festival") in Rungis, which was never part of the continental circus.

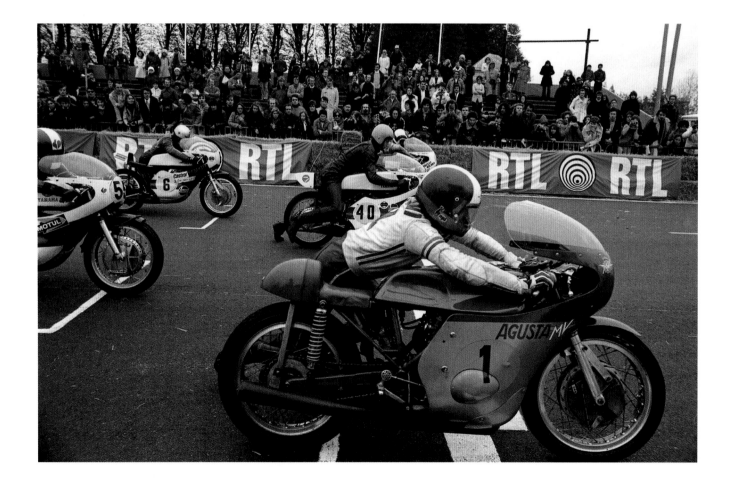

MOTORBIKES AND COUNTERCULTURE

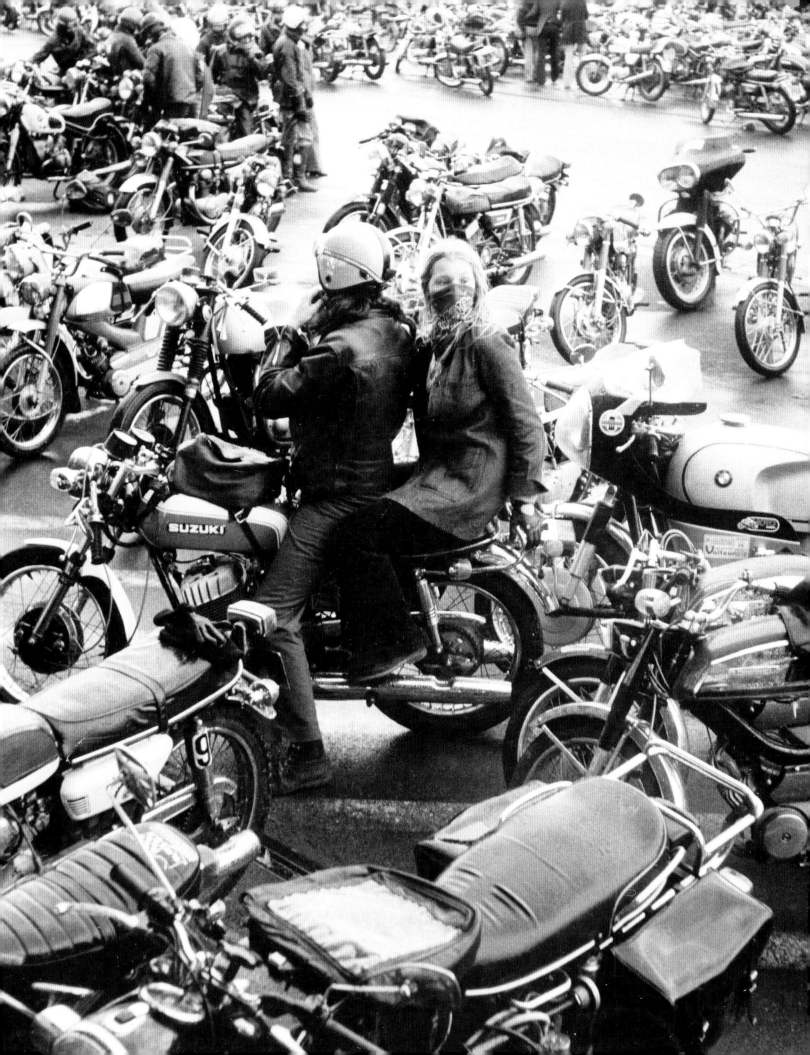

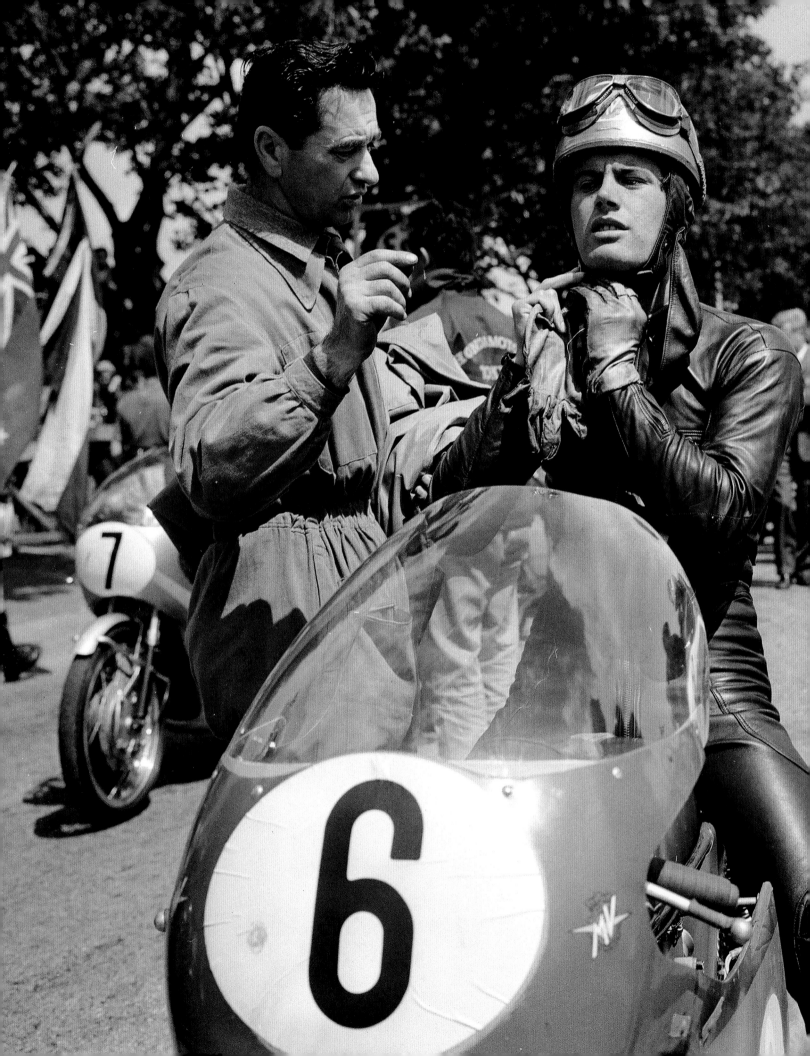

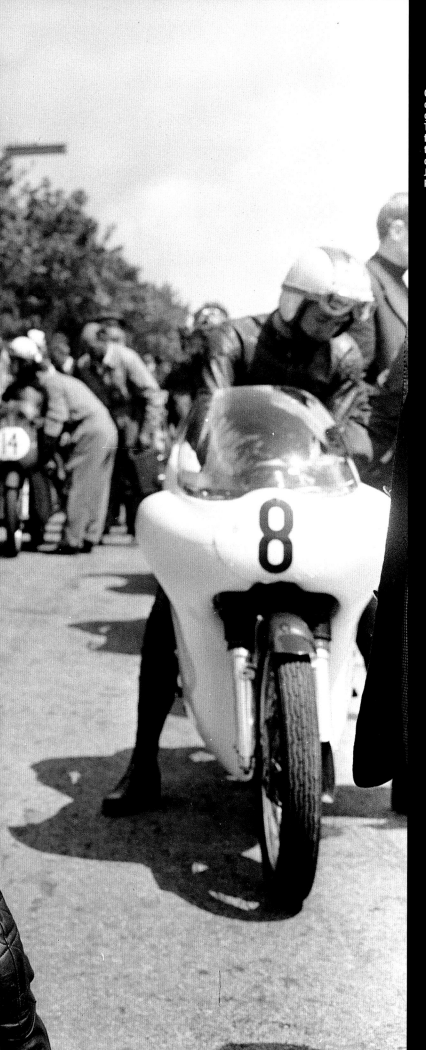

Giacomo Agostini on the starting grid at the 1965 TT, where he finished third in the 350 cc class, behind Jim Redman and Phil Read.

CHRISTIAN RAVEL SHOWS THE WAY

France's first "motorcycle hero," Christian Ravel, revolutionized the country's competitive riding scene by securing sponsorship for privateers. Media-savvy, Ravel had a simple aim: "to be the best."

Men's destinies are sometimes determined by geography. From the town of Saint-Germain-lès-Arpajon to the Autodrome at Montlhéry, just south of Paris, is 4 miles (6.4 km)—an ideal riding distance for a boy who is working out what he wants his life to be about: racing. At that point, it didn't matter to Christian Ravel whether it would be in a car or on a bike—so long as it involved speed.

Christian was a gifted child—already top of his class in elementary school—but he started work early to support his mother, who had been widowed. His passion for riding grew, until he finally attained "nirvana" with the acquisition of a Triumph T110. His elder brother Didier, who acted as Christian's mentor during their youth and tempered his competitive zeal, nevertheless kept pace with him in his pursuit of the perfect bike: Didier bought one of the first Honda CB750s to be imported into France.

In fact, it was Didier who was first off the grid with a Morini 50 cc, but 16 months of military service stalled his competitive ambitions. Like a good teammate, his brother—who, after all, was cut from the same cloth—took up the mantle. He started racing in 1964, at the age of 16,

Christian Ravel
early in his career,
photographed by
François Beau.

on a Yamaha YDS2—twin cylinder, 28 horse-power. It proved to be a good choice because, just a year later, he made the following careful note in his diary: "On May 30th, 1965, I took part in my first national-grade race and finished 4th. This result is extremely encouraging because my bike is completely unmodified." He then went from one bike to another—Ducati Mach 1, then Yamaha TD—in his quest for the Holy Grail, the French Championship, but in 1966, his performances were a mixture of podium finishes, breakdowns, and crashes.

"ALWAYS IMPATIENT"

After all the problems and "false starts," however, Ravel finally achieved his first goal. In September 1968, riding a single-cylinder Velocette, he won the 500 cc class at the Coupe du Salon in Montlhéry, beating two established French riders, Jean-Claude Costeux and Patrick Lefèvre. The victory marked the advent of a new generation of riders.

According to his brother, Ravel was an amazing young man, "always impatient." Frustrated with amateur competition, he wanted to move up a level and challenge the pros. Soon he set up his own racing "stable," Sonauto Yamaha, teaming up with another rising French star, Jean Auréal. For the Ravel brothers, 1969 was a vintage year. Didier started racing again, on a Yamaha TZ, and Christian became Sonauto Yamaha's No. 2 rider ... but not for long. That same year, he won the 600 mile (1,000 km) race at Le Mans with Pierre-Louis Tébec, on a Kawasaki Mach III. He also met Xavier Maugendre, Kawasaki importer and a key figure in the motorcycling world, who became Ravel's mentor.

KAWASAKI LAUNCHES THE LEGENDARY H1R

The "Little Prince" of the track, Ravel has the bearing, the diction, the education, and the fearlessness of a knight of old. He is no longer confined to the domain of amateurism. Nothing will stand in his way. Kawasaki has become his lord, and King Ago can prepare for battle.

1970 is the official birth date of "the legendary Christian Ravel." It is the year in which his true character emerged: the conquering hero—in his private and public life as well as on the track. Although the annals of competitive motorcycling list many other riders with more glittering careers than his, Ravel is the man who most successfully bridged the gap between the two worlds. He was France's first "motorcycle hero," admired as much for his behavior off the track (his eloquence, his determination to win, and his desire to push

Michel Rougerie (left) with Christian Ravel. From the same generation, they also shared the same fate: killed while racing, one ten years after the other.

back boundaries) as for his ability to defy the laws of gravity and physics. Although he was the youngest of the group, Ravel was looked up to by Michel Rougerie, Patrick Pons, Olivier Chevallier, Christian Sarron, and the rest. Most of them more frequently basked in glory, boasted similar or even superior talents on the track, and enjoyed greater media and public adulation; but it was Ravel who almost single-handedly brought French motorcycle racing into the spotlight.

1970 was also the year in which Kawasaki launched the legendary H1R: three cylinders, 500 cc, 70 horsepower. For Ravel: "It isn't a machine that's easy to control; it's like a poorly trained horse. It has a high center of gravity and is quite heavy. And its engine is much less smooth than the MV Agusta's. I noticed that when I rode alongside Agostini. It's a two-stroke and, if you're not careful, you can easily flood it."[13] But, he confessed to his brother, "it's a bike that will win races." And win he did—over and over again: At Montlhéry, at Le Mans, at Bourg-en-Bresse, and again in the inaugural race at the new Paul Ricard circuit near Marseille, he stepped up to the top of the podium. On the GP circuit, he fought for a second place behind Agostini at Spa-Francorchamps in Belgium—something no French rider had achieved since 1955—and in Finland the following month, he took Agostini on again, leading him for five laps before pulling out.

"THE BEST—EVEN AGAINST AGO"

After races, Ravel didn't get drunk and party all night like many of his peers, but he was something of a womanizer. He had a hypnotic

effect on people, and no one could say no to him—not even his brother. He never tired of expressing his views on the power of advertising, and he was the first to obtain sponsorship outside the sport. Danièle Baranne, who had given her name to a company making leather-care products, was unable to resist his (professional) advances. He also knew how to attract people from "showbiz" and radio presenters. Back then, France had only two TV channels, so radio was of prime importance as far as publicity was concerned, and Ravel would regularly get himself invited (or simply invite himself) to the studios of RTL or Europe n° 1, as it was called back then.

By now, he had another ambition: to be 500 cc World Champion—a title Agostini had held

The "Little Prince" of the track, Ravel has the bearing, the diction, the education, and the fearlessness of a knight of old.

since 1966. Like all kings, Ago was envied, feared, and detested. The Little Prince intended to usurp his throne. Having finally tamed his Kawasaki, he was ready to challenge the all-conquering MV Agusta.

At the start of the 1971 season, Agostini continued his total domination of the class. The Belgian Grand Prix, a race staged once again at Spa-Francorchamps, where Ravel had come in second the previous year, was on July 4th (the day after Jim Morrison, lead singer of The Doors, had been found dead in Paris, allegedly—and, in this connection, coincidentally—at the *Rock'n'Roll Circus*). It was a case of *déjà vu*, Ravel again just behind the relentless Agostini. Even with his head buried under the fairings, he couldn't keep up with the MV Agusta; it was simply too fast, always just out of reach. But Ravel was insistent that he wanted "to be the best, even against Ago"—a litany that had become an obsessive chant, Didier recalls. He was also obsessive about the Spa-Francorchamps circuit, which racing driver Dan Gurney succinctly described as "a track that separates the men from the boys." When his mechanics waved him in for refueling (the three-cylinder H1R was greedy on gas), Ravel ignored them. His teammate, Éric Offenstadt, tried to catch up with him, but on

the penultimate lap, heading into Stavelot at 150 mph (241 km/h), the Kawasaki suddenly froze; starved of fuel, the engine had seized, the central cylinder jammed inside its sleeve. The Little Prince would never be king. A year and 10 days later, he would have celebrated his 23rd birthday.

The inseparable brothers from Arpajon had been parted. Didier was now an only son. He would have plenty of time to remember his little brother: "Christian was like Ago, but without the experience. Count Agusta had his eye on him; they often spoke ..." After losing his brother, Didier decided to return to competition, believing that Christian would have wanted him to. He took up endurance racing. His experience and consistency made him a stalwart of the Kawasaki stable, and Xavier Maugendre became his mentor as he had been Christian's. "I was quick, but I rarely crashed. In the Bol d'Or, I often rode with younger riders from the Coupe Kawasaki that Xavier wanted me to bring on." In 1972, he won the 500 cc class of the Bol d'Or on a Kawasaki H1R—the bike proving to be as recalcitrant as ever.

Didier hung up his leathers for the last time in 1976, by which time Christian Ravel's name was already fading from memory. However, he had a decisive influence on motorcycle racing in France. He brought the sport into the modern era by challenging existing thinking and attracting the media to it. He had lifted the veil on a curse and allowed his compatriots to dream that one day, finally, a Frenchman would be World Champion. When Patrick Pons was on his way to the 1979 Formula 750 title, did he perhaps spare a thought for Christian Ravel?

1971, MOTORCYCLE HEART

Before his final race at Spa-Francorchamps, had Christian Ravel met the celebrated artist Niki de Saint Phalle? In an age when everyone knew everyone, it was certainly possible. The director Stéphanie Varela believes he did.

The 1970s saw a spate of "biker movies" aimed at dyed-in-the wool riders, and, of course, Jérôme Laperrousaz's 1972 documentary *Continental Circus*, but since then, motorcycle riding has hardly been a source of inspiration for imaginative directors. Until 2017, that is, when a young French director by the name of Stéphanie Varela sprang a surprise with her short film *1971, Motorcycle Heart*—part documentary, part fantasy, with real people in an imaginary setting. The protagonists are a man and a woman: rider Christian Ravel and artist Niki de Saint Phalle. Where did this young director, who is also a sculptor, get the idea of bringing these two unlikely but intriguing co-stars together? Well, the artist, de Saint Phalle, was fascinated by speed. Her partner, Jean Tinguely, created mechanical monsters, and the couple were friends with a number of Formula 1 drivers, including Jo Siffert, Jacky Ickx, and Niki Lauda. An eccentric aristocrat, de Saint Phalle achieved artistic immortality with *Nanas* (*Broads*, 1964–1973) and created a media sensation with *Les Tirs* (*The Shootings*, 1961)—works that she herself blew holes in with a rifle. Both as a person and as an artist, she became a heroine of counterculture, the very embodiment of the artistic freedom so many women sought.

And Christian Ravel? He, too, had an artistic temperament: creative on the track, sensitive off it. Legend has it that Ravel gave some of his trophies to the sculptor César Baldaccini (designer of the French "Oscar", the César) for him to "recycle." What could

be more noble than to transform victories into works of art?

There is one more thing the co-stars have in common: charisma. And this is where the director's imagination takes over, turning

DURING SHOOTING, ALL KINDS OF THINGS TURNED UP TO SUGGEST THAT NIKI DE SAINT PHALLE AND CHRISTIAN RAVEL COULD HAVE ACTUALLY MET.

the possible into a fictional reality: a chance meeting between Christian Ravel and Niki de Saint Phalle. In the movie, Ravel is near the artist's studio when he breaks a clutch cable on his Kawasaki H1; they meet, clash, and are attracted to each other ... Early the next morning, Ravel sets off for Spa-Francorchamps, where the sun is shining and he is convinced that he will beat Giacomo Agostini.

In reality, Ravel lost his life that day, July 4th, 1971; and a few days later, Niki de Saint Phalle married Jean Tinguely.

A POP ART MOVIE

Stéphanie Varela had wanted to make a movie about this remarkable woman for some time, but she needed a suitable man to spar with—a masculine alter ego. It was a press clipping that led her to Christian

Didier Ravel with his brother Christian's fictional doppelgänger Hugo Becker during the shooting of _1971, Motorcycle Heart_.

Ravel: "I fell in love with this character. He was only 23, but tremendously self-assured. He impressed me. He could have been 'champion' of almost anything."[14] This gave her the outline of the story. "They had a similar stature," she explains. And the meeting was credible: During shooting, all kinds of things turned up to suggest that Niki de Saint Phalle and Christian Ravel could have actually met.

By a strange coincidence, shooting started on the first anniversary of Ravel's death. His brother Didier found a Kawasaki that Christian had in fact ridden, for a promotional shoot. With its psychedelic colors and spontaneous acting from Anna Mouglaglis and Hugo Becker (who, according to Didier,

had just the same artistic sensibility as Christian), this short movie about the life of an artist, the desire for freedom, and the urge to break with the prevailing culture of the period is a homage to the 1970s. There was a final coincidence in the making of _1971, Motorcycle Heart_. In 1963, Niki de Saint Phalle herself had made a movie called _Motorcycle Heart_—a fact that Varela was unaware of when shooting started.

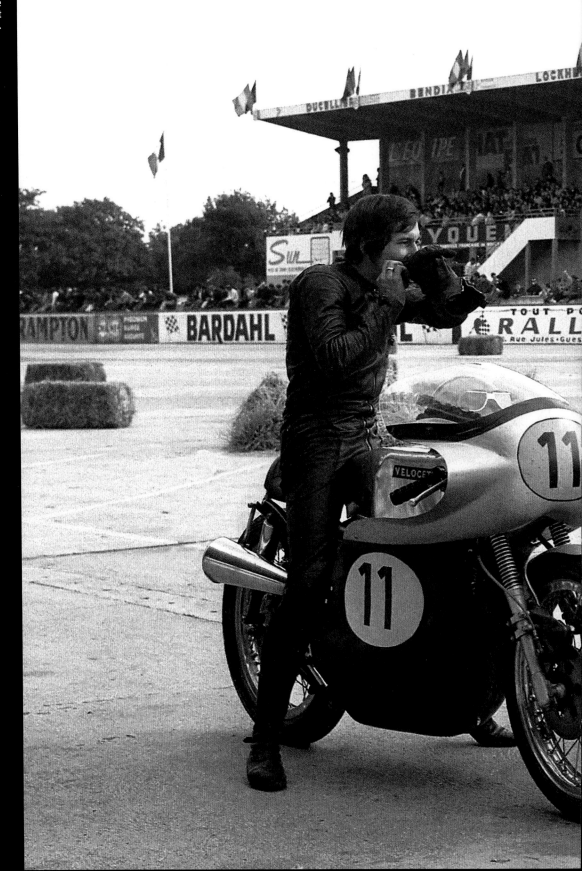

Symbolic moment: Christian Ravel on his Velocette 500 with Claude Costeux and Patrick Lefèvre, whom he beat in the 1968 Coupe du Salon at Montlhéry.

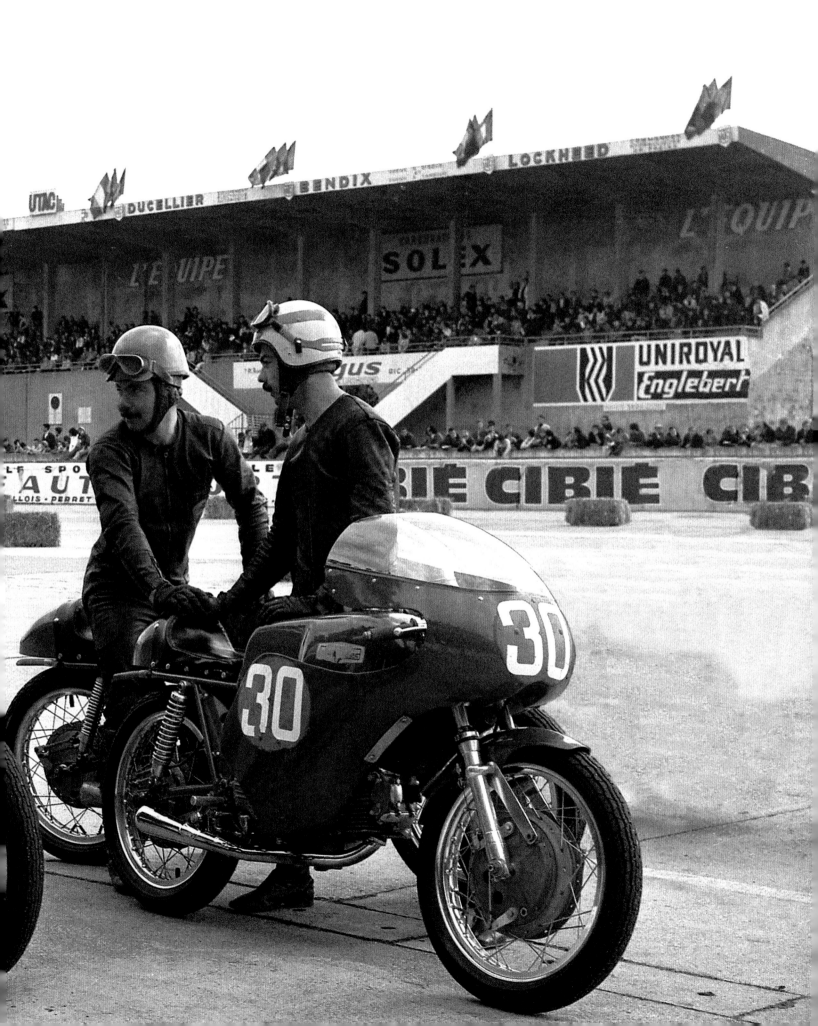

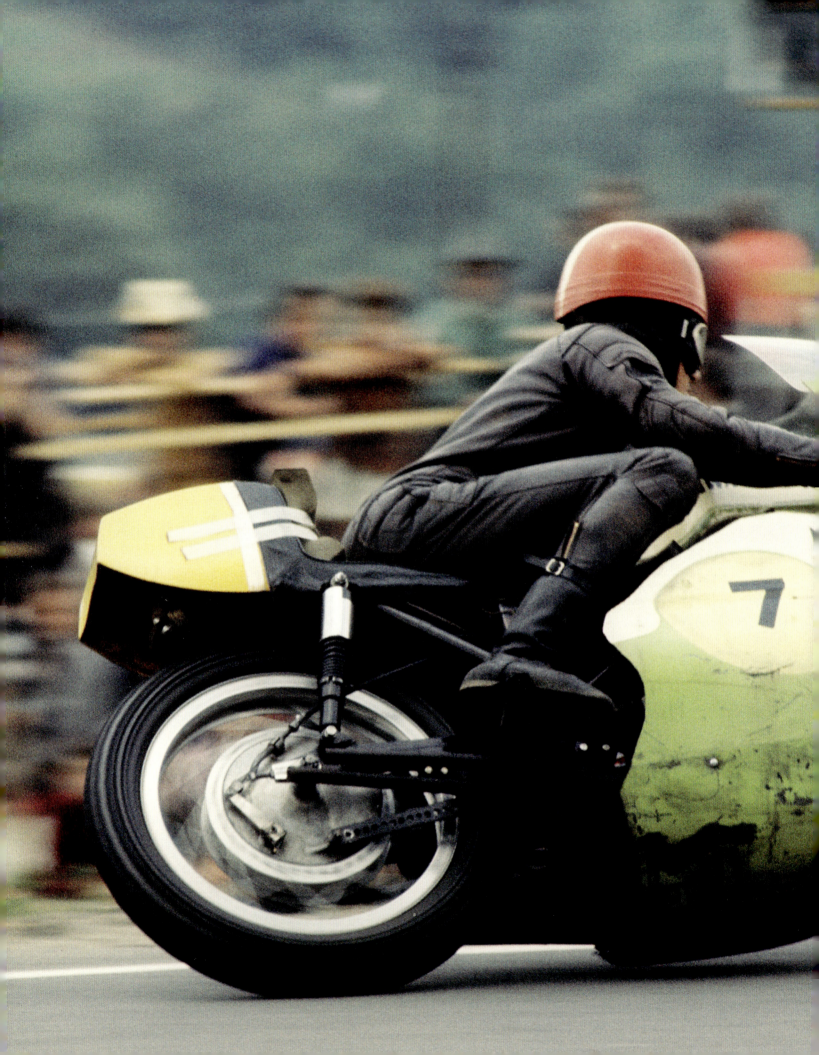

Christian Ravel
in action in
1970 on his
Barenne-branded
Kawasaki H1R—
one of the first
racing bikes to be
sponsored.

THE COUPE KAWASAKI

BATTLING IT OUT

The Coupe Kawasaki junior circuit was created just three years after the 1968 riots—and had a similar ambience: youthful, contentious, and uninhibited.

The early 1970s were still marked by the confrontational, chaotic spirit of the 1968 student protests—alternating between muscle-flexing and docility. Sex and rock 'n' roll had conquered new territories, and there was still a yearning "imagination to take over." There was the same atmosphere—give or take a few variations—in the world of racing, where the pursuit of freedom was still very much alive.

The Coupe Kawasaki, created in 1971 by Xavier Maugendre, the French importer of Kawasaki bikes, was modeled on the Coupe Gordini—a promotional event for cars. The Coupe Kawasaki aimed to promote young riders, who regarded it as a tournament in which pretenders to the crown battled it out to be king for a year. In 1975, there were 530 entrants for the "K Days," the first elimination stage. Jean-Patrick Vella, who won the Coupe in 1981, remembers that "there was even rivalry between guys from the north and guys from the south. [...] It was a great way to kick-start a racing career. 90% of the top riders came out of the Coupe Kawasaki."[15]

"RUN, COMRADE; THE OLD WORLD IS BEHIND YOU."

Motorcycle racing had been democratized; social distinctions were fading. Among France's top riders, Patrick Pons was from a wealthy family and Christian Sarron was a mailman! Anyone could enter the K Days with a standard bike—having removed unnecessary fittings such as the stand, license plates, and turn signals before the race. The same Kawasaki that was racing for first place that weekend could be driving along Main Street during the week. With hindsight, a question arises—an odd one, perhaps, but pertinent nonetheless: Was the Coupe Kawasaki a left-wing institution? Certainly, the famous May '68 slogan could be applied to its budding racers: "Run, comrade; the old world is behind you." The Coupe Kawasaki, which soon became

> ## "RACING THEN WAS STILL A MATTER OF MAKING IT UP AS YOU WENT ALONG. [...] WE TRIED TO OVERCOME OUR FEAR AND PUSH OURSELVES TO THE LIMIT."

known as the "Coupe Kawa," quickly established itself as a "champion factory." Before long, a new generation of French riders—including Patrick Pons, Christian Sarron, Éric Saul, and Bernard Fau—would be scooping up top prizes at International Grands Prix. It was a natural progression, according to Saul: "When I won the Coupe [in 1975], the prize was a Kawasaki 900 Z1, which I immediately swapped for a Yamaha TZ. I won the Post TT and finished third in the British Grand Prix at Silverstone. Most Grand Prix riders were on TZs; they were almost like promotional events."[16]

This new army of riders had no qualms about taking on the old enemy—the British—and beating them. Leading the way was a matchless competitor, Patrick Pons. France's answer to Dr. Jekyll and Mr. Hyde, Pons was a perfect gentleman away from

the circuit and a guided missile on the track. Jacques Bussillet, who watched his first races, fondly remembers that "early on, Pons came across as a head case, a maniac."[17]

Pons won the Coupe Kawa in 1972 at the age of 20. In 1974, he finished third in the World Championship in both the 250 and 350 cc classes. Five years later, he finally arrived, becoming the first French World Champion, in the 750 cc class. In 1980, he became only the third European rider (after Agostini and Jarno Saarinen) to win the Daytona 200. On August 10th the same year, he was killed at Silverstone. He is reported as having said: "If I die, I'll die after ten years of racing, which is fabulous."[18] Another early Coupe Kawa winner, Christian Sarrou, who went on to become 250 cc World Champion in 1984, summed up the feeling at the time: "Racing then was still a matter of making it up as you went along. I spent my entire career being scared. We tried to overcome our fear and push ourselves to the limit."[19] Whether thanks to the Coupe Kawasaki or not, these years saw the establishment of a "French touch," with riders such as Michel Rougerie, Olivier Chevallier, Christian Sarron, Patrick Pons, Éric Saul, Thierry Tchernine, and Bernard Fau. It was these men—as well as others that are less well known, or have even been forgotten—who, between 1970 and 1985, left the old world behind them.

The first *Moto Revue*-sponsored Coupe Kawasaki in 1971. The bikes are all Kawasaki 350 A7 Avengers, with drum brakes, of course.

FOLLOWING PAGES: The 1972 Coupe Kawasaki. The S2 350, which was dominant in 1972 and 1973, is seen here from behind at Chaumont, an improvised circuit at an airfield.

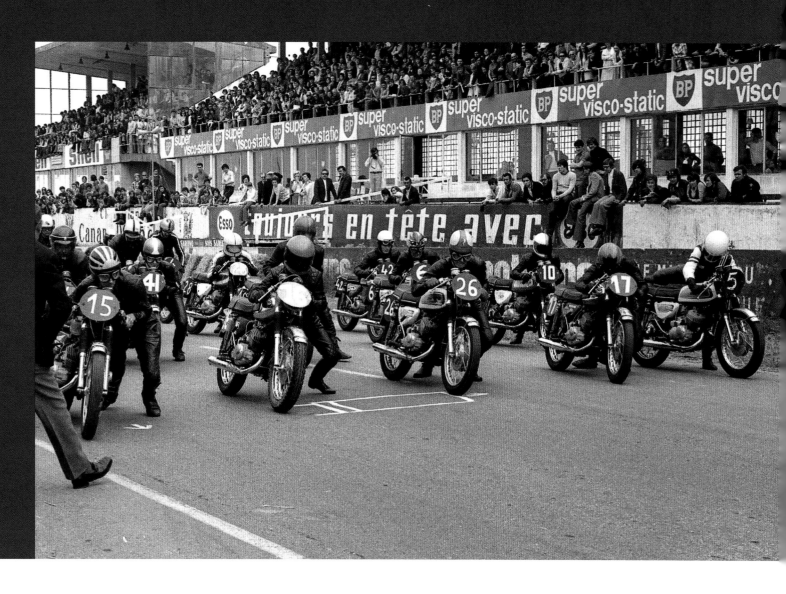

THE WORLD IS YOUR OYSTER!

The world is impatient and can't wait to ride on after the dead end of the Sixties. Swinging London proves to be the last fling of an era that will soon turn a corner and open up new horizons. But first, the advent of café racers is a reminder that British bikes once ruled the roads. And the new generation of open-minded, adventurous, and self-confident riders—men and women—had a simple motto, which they proclaimed from Iran to Senegal: "Freedom for me first."

The 1972 Raid Orion reaches Iran.
How did this fabulous but fragile Yamaha XS 650
make it that far?

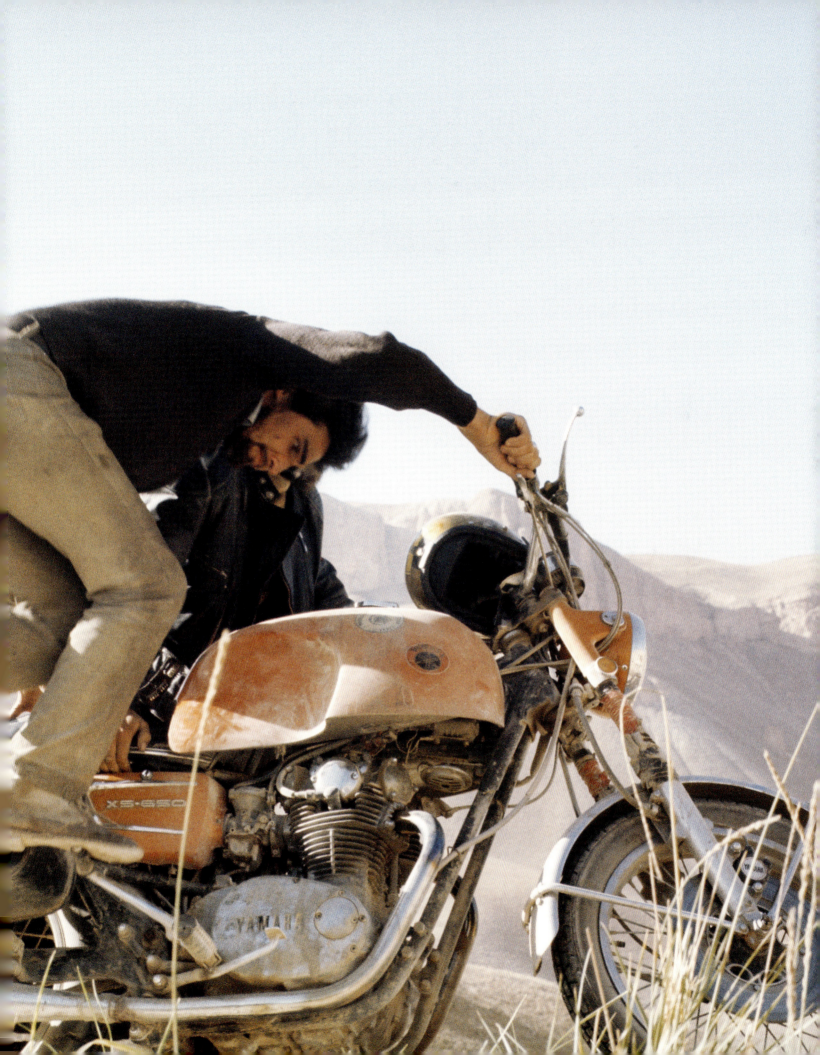

LAST FLING
FOR SWINGING
LONDON

**For the time being, British bikes (and British music) are still in the running. The café racer— the ultimate city speed machine—is a must-have, and London's Ace Cafe *the* place to be.
The British Empire is at its height ... the riding empire, that is.**

As the Sixties draw to a close, British bikes are on their way out. And yet, London is *the* place to be. Swinging London (an epithet coined by *Time* magazine) is the epicenter of emancipation as young people graduate from rock 'n' roll to pop. The nexus of fashion is a scattering of streets—Carnaby Street, King's Road, Abingdon Road—where trends are set by Mary Quant, with her miniskirts, and Barbara Hulanicki with her Biba boutique. The new style is "hippie chic"—ethnic, bohemian, and eccentric—with embroidery and fabrics from the Far East, though riders resist the fad for velvet and feathers, sticking to their good old Lewis Leathers. The rejection of traditional working-class clothing is the perfect expression of counterculture. Marc Bolan, lead singer of the rock group T. Rex, makes the point when he declares: "Clothes were then, I suppose, wisdom and knowledge and getting satisfaction as a human being."[1] Even rock stars wear dresses designed for men!

The Swinging
London look:
Vidal Sassoon
bob and
Mary Quant
mini-dress.

At the Rolling Stones' concert in Hyde Park on July 5th, 1969—paying homage to Brian Jones, who had recently drowned in his swimming pool (or so it was said)—Mick Jagger appeared in an all-white outfit created by Mr. Fish, one of the leading designers of the day. The Hells Angels acting as security staff at the venue couldn't believe their eyes.

Ever since the 1950s, London had held a fascination for artists, designers, musicians, and journalists, who all made their homes there. Now, in the late Sixties, Swinging London was at its zenith. Twiggy became "the face of 1966" and a worldwide fashion icon, and in 1968, Paul McCartney persuaded The Beatles to ask Richard Hamilton to design the cover of their *White Album*. (It was in London, in 1956, that Hamilton had sparked the pop art movement with his iconic *Just What Is It That Makes Today's Homes So Different, So Appealing?*) But not everyone in Britain was "swinging:" racial discrimination was rife and homosexuality was illegal until 1967.

In this new cultural, aesthetic, and social context, Brando's Johnny (in *The Wild One*) would have seemed rather out of touch—irrelevant, even. He no longer represented the torments, excesses, and newly acquired freedom of youth. Britain, with its Swinging London image, was now in the power seat … unlike its motorcycle industry, which had suffered an equal and opposite decline in fortune, both on and off the racetrack…

THE CAFÉ RACER SETS A NEW STANDARD

And yet…

Against all odds, British riders had also become the international gold standard. Naturally averse to bikes that spat oil (spitting rain was quite enough for them), they had recently invented a new riding concept: the café racer.

What on earth—racing a bike while sipping coffee? The origin of the term was no doubt typically tongue-in-cheek, suggesting a machine suitable for those who would rather zip around the neighborhood than compete on a circuit. A classic/racing bike hybrid for a tour of the local pubs, with a pit stop at each for a beer ... or a pot of tea? The metamorphosis required lowering the handlebars and moving the brake and gear levers backwards; the saddle was rudimentary, and baffles were added to the exhaust pipes to give the engine note a timbre appropriate to the age of rock 'n' roll.

The concept, which had emerged in the 1950s, caught on, and café racers soon became the "tribal badge" of the new generation of riders. Improbable motorcycle clubs sprang up—such as the 59 Club. Founded in 1959 by the Reverend John Oates, curate of St. Mary of

Eton church in Hackney, London, "the Nine" really took off in 1962, when Father Bill Shergold moved to the parish. A committed rider, Shergold believed that young people generally dismissed as "yobs" (a British slang term for "thugs") could be redeemed by the Church. From that moment on, Saturday nights were dedicated to prayer and ... riding!

MODS AND ROCKERS

For some time yet, the world's most highly prized bikes would be British. Although their basic design had hardly changed since the 1930s, the addition of wishbone suspension and telescopic front forks made them look new. According to expert Paul d'Orléans, the ultimate café racer was the BSA Gold Star—named after the pewter pins awarded to riders who lapped England's famous Brooklands track at

In Sixties Britain, clergymen were often apostles of riding—such as John Oates, founder of the 59 Club, and his successor Father Bill Shergold, pictured here.

Mods asserted their individuality with a style influenced by American soul music and Italian design, with a hint of French *nouvelle vague.*

Motorcycles were far too crude for the dandyish mods, who preferred scooters.

over 100 mph. The iconic Gold Star was the DBD34, which appeared in 1956. But let's not forget the Norton Manx and the two-cylinder Triumphs ... The organizers of the Isle of Man TT race were quick to see an opportunity, and in 1947 they created the Clubman class for production bikes ridden by amateurs, who used "boost bottles" to uprate their BSA, Velocette, and AJS/Matchless engines.

In the late 1950s, a new group of riders appeared who would challenge the rockers

and their café racers: the mods. Motorcycles were far too crude for the dandyish mods, who preferred scooters. In their thigh-length parkas and Sta-Prest pants, they pointedly turned their backs on the rock scene and contributed to the emergence of the more elegant style of Swinging London. For the next few years, mods and rockers fought it out—literally—on the beaches of Brighton and Margate.

Despite all these upheavals, riders didn't abandon their allegiance to the café racer at the start of the Seventies. After all, pubs were still pubs, and the motorcycle was still the epitome of rebellion. But they felt no shame in "going Japanese," succumbing to the Eastern promise of the 305 cc Honda CB77 (or Super Hawk), which came out in 1961 and offered

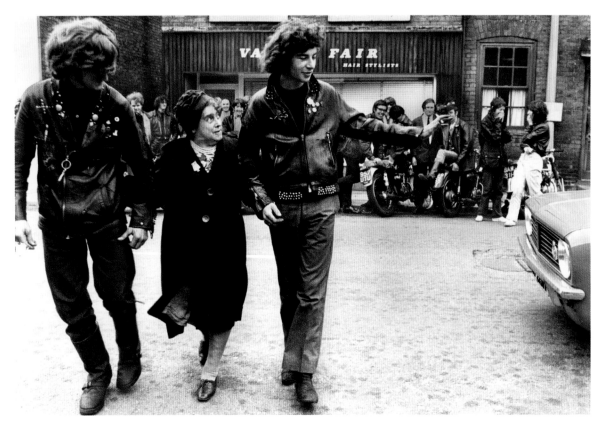

an electric start—a technological advance of titanic proportions. Italian manufacturers were also "reinventing the wheel." First came the two-cylinder Benelli Tornado and the Laverda 750 (both launched in 1968), which were carbon copies of the Super Hawk but more powerful; then the Ducati 750 Sport (1974), which *Cycle* magazine described as "a bike that extends the boundaries of the sport—the most radical production café racer on the market;" and finally the Moto Guzzi Le Mans (1976). As for the Germans, they responded with the BMW R90S (1973).

The original café racer—from the Ace Cafe era—would eventually develop in two opposite directions: into a sophisticated machine created in a design studio (the option favored by British manufacturers) and into a much cruder, no-frills affair, as if put together by a "creative" enthusiast. Norton, for example, released two contrasting café racers in the 1970s: the Commando 750 Production Racer (nicknamed

the "Yellow Submarine," no doubt after the 1968 animated movie inspired by The Beatles' eponymous song); and the John Player Special (JPS), with a standard engine and bodywork reminiscent of the fastest Norton racers. Smaller companies, run by design geniuses like the Rickman brothers or the Swiss racer Fritz Egli, would go on to take the café racer to the very heights of competition.

"WAS TAKING PART IN THE TT THE ULTIMATE SHOW OF BRAVADO?"

By the early 1970s, Britain's winning streak had come to an end. Swinging London was grinding to a halt and the legendary Tourist Trophy was running out of gas. In 1972, the continental circus stars boycotted the TT, and the following year was almost its last. One month before the event, in the Nations Grand Prix at Monza, Jarno Saarinen and Renzo Pasolini both died. Were the track marshals guilty of negligence? Was there an oil leak from Pasolini's Aermacchi

when its engine seized? No one will ever know. But the entire racing world was shocked by this double tragedy—especially since Saarinen had declared that he only raced for pleasure and killing himself was not, as it was for many other riders, his ultimate aim; on the contrary, he envisaged living to old age after retiring from the circuit. In his book on the 1973 TT, Jean-Louis Basset wrote: "One month after the disaster at Monza, was taking part in the TT the ultimate show of bravado or pure madness? If scientists were to analyze the TT, they might well come to the conclusion that the race survived for no other reason than that it was British. In Britain, institutions are sacrosanct. The Queen, afternoon tea, baked beans, and pubs are all part of tradition and punctuate the peaceful landscape of the United Kingdom."[2]

The afghan coats of Swinging London, as worn by The Beatles and David Bowie, transcendental meditation, as practiced by the Hindus, and *Blow-Up*, the successful 1966 movie by Michelangelo Antonioni, were just some of the outward signs that the new decade would shut the door on the Sixties and open another to a wider world, which would be all about "the journey." Richard Neville, creator of the legendary underground magazine *Oz*, remembered the famous hippie artists Michael English and Nigel Waymouth, who specialized in psychedelic posters, showing him a leaflet and saying, "All our ideas come from trips." He thought they meant trips to India. "Oh, no. Psychedelic trips."[3] Drug-induced journeys ... and soon real ones. It is time for us to leave Carnaby Street and to rediscover our taste for travel.

Leather look: Lewis Leathers, Mascot, Pride & Clarke, and Highwayman were the brands of jacket favored by members of the "ton-up club."

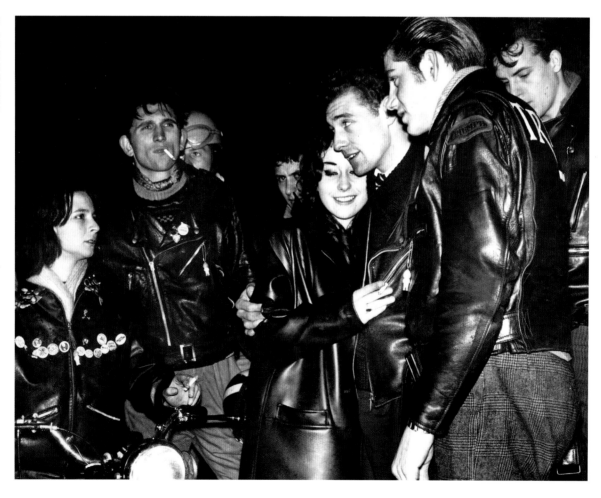

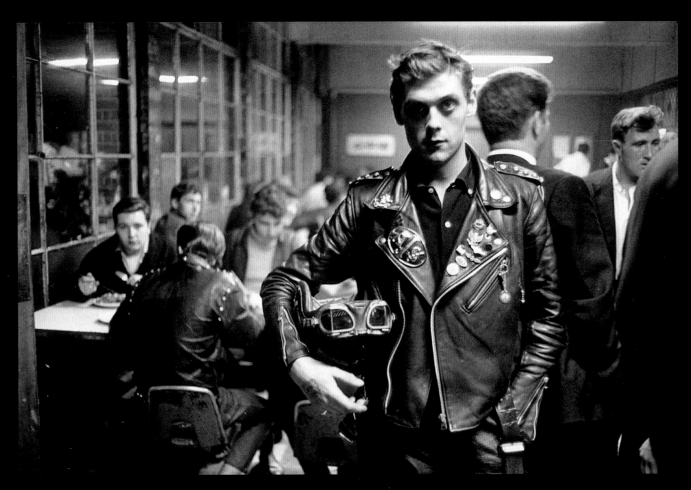

A biker with the club membership badges
that were *de rigueur*.

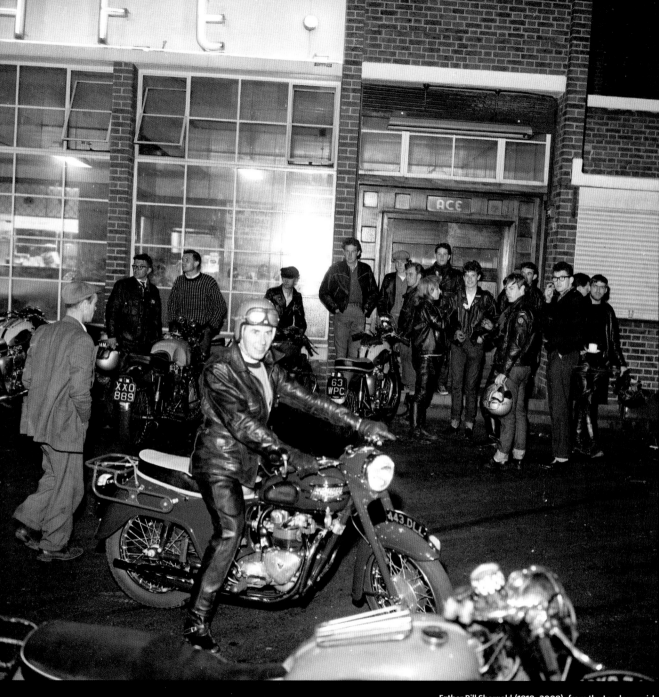

Father Bill Shergold (1919–2008), from the London parish of Hackney, arrives at the Ace Cafe on his Triumph. Shergold was the driving force behind Club 59, which at one time had 4,000 members.

RIDING MAKES A GOOD READ

The subject of three novels published between 1963 and 1974 —André Pieyre de Mandiargues's *La Motocyclette*, Hunter S. Thompson's *Hell's Angels*, and Robert M. Pirsig's *Zen and the Art of Motorcycle Maintenance*—riding unexpectedly becomes literary subject matter!

The French writer André Pieyre de Mandiargues (1909–1991), an associate of the Surrealists, is well known—famous, even—for his romantic-erotic poetry (as well as for his large collection of pornographic artifacts). In 1963, he wrote the seminal *La Motocyclette (The Motorcycle)*, in which 19-year-old Rébecca is given a Harley-Davidson by her lover, Daniel: "This beautiful American motorcycle, which she sits astride, the huge fuel tank between her thighs like a man's black body ..."[4] Daniel himself rides an exotic Moto Guzzi "as brilliantly red even in these shadows as the flags brandished in protest by starving miners."[5] As for Rébecca's husband, whom she had cheated on even before they were married, he rides ... a bicycle.

Mandiargues modeled his central character on a friend of his, the German journalist Anke-Eve Goldmann. Or, rather, he took from her a single element of his story: Anke-Eve's leather riding suit. She was among the first female riders to wear an all-in-one suit, which Mandiargues found supremely erotic. Her fictional counterpart, Rébecca, goes to meet her lover in "a shiny black-leather suit lined with white fur [...]."[6] *La Motocyclette*, which was published by Gallimard in its exclusive "Collection Blanche" series, is unashamedly a work of erotic fiction, in which the young heroine is hypnotized by her own sexual desire and that of her lover. When she is not with him, her motorcycle is a sexual substitute: "In the absence of the man in whose arms she wants to be, she turns to the motorcycle, waiting on its stand by the bench."[7]

"THE POWERFUL ENGINE MADE THE STEEL FRAME VIBRATE. THE SLIGHTEST MOVEMENT OF HER FINGER WOULD BE ENOUGH FOR IT TO ERUPT AND CARRY HER AWAY."

Mandiargues reminds the reader that Rébecca is no mere plaything: "Between her legs, the powerful engine made the steel frame vibrate. The slightest movement of her finger would be enough for it to erupt and carry her away. She was in control of its energy."[8]

Being at this time in the midst of its own sexual revolution, European cinema eagerly snapped up this steamy tale—and made no secret of its erotic overtones. The 1968 Franco-British movie adaptation was titled *The Girl on a Motorcycle* and released in the U.S. as *Naked under Leather!* It was directed by Jack Cardiff and starred Alain Delon and Marianne Faithfull—a genuine Austrian princess by birth, but also the

In *The Girl on a Motorcycle:* Alain Delon borrows the Harley-Davidson he has given the heroine (Marianne Faithfull) to take his wife, Nathalie, for a ride. In the movie, his own bike is a Norton.

Hunter S. Thompson on his KTM Penton in January 1976. He might not look it, but Thompson was a real motorcycle connoisseur.

queen of Swinging (and Singing) London and then engaged to Rolling Stones singer Mick Jagger. In the movie, Delon rides a Norton Atlas 750—a British bike for a British adaptation. Faithfull's mount is a Harley-Davidson Electra Glide.

THE BIRTH OF GONZO JOURNALISM

1967 saw the appearance of a publishing phenomenon: *Hell's Angels*, with the lengthy subtitle *The Strange and Terrible Saga of the Outlaw Motorcycle Gangs*, by Hunter S. Thompson—a head-first dive into the crazy world of Californian Hells Angels. Their leader, Sonny Barger, would say of the book that it had given them mythical status, which they'd never had before. In it, Thompson denounces the media's habit of vilifying bikers with headlines such as "California

Takes Steps to Control Terror on Wheels." Thompson eventually became famous for adopting "gonzo journalism"* as his defining style. After immersing himself in the world of drug and alcohol abuse, which drove him almost crazy and made him lose his memory, he invented a doppelgänger, Raoul Duke, to write for him. As Duke—and this was his stroke of genius—he produced articles that are largely subjective and yet succeed in revealing an objective truth.

In this, he felt that he was closer to the Beat Generation of Allen Ginsberg and William S. Burroughs than to the hippie movement. *Rolling Stone*'s star reporter, Thompson became a legend in his own lifetime, but vowed to end it as soon as his health started to decline. He committed suicide in 2005, at the age of 67.

THE GENIUS ROBERT PIRSIG

A book with an altogether more enigmatic title appeared in 1974: *Zen and the Art of Motorcycle Maintenance*, by Robert M. Pirsig. At first, nobody wanted to publish it. In fact, Pirsig holds a Guinness World Record for having received 126 rejections. And yet it has sold over 5 million copies worldwide. A certified genius (he had an IQ of 170), the 40-year-old Pirsig was a biochemist with an urge to answer metaphysical questions that eventually drove him insane: He was admitted more than once to a psychiatric hospital suffering from schizophrenia.

In his search for "quality" he holds imaginary conversations with the ancient Greek

Robert M. Pirsig with his son Christopher on the Honda CB77 they used for the road trip recounted in *Zen and the Art of Motorcycle Maintenance*, whose mix of practical advice and philosophical speculation made it an unexpected bestseller.

FROM THE VERY FIRST PAGES, HE DESCRIBES THE JOURNEY AS ONE OF THE ELEMENTS OF MEDITATION

philosopher Phaedrus, whom he keeps threatening to kill. Zen Buddhism and motorcycle maintenance might seem worlds apart, but Pirsig's title was a play on *Zen in the Art of Archery*, a work by the contemporary German philosopher Eugen Herrigel, who argued that a state of "no mind" can be attained by practicing the Japanese martial art of archery.

Whether to escape or to understand his madness, Pirsig decides to ride a motorcycle from Minneapolis to San Francisco. The bike he chooses is a 305 cc Honda CB77 Super Hawk (also known as a CB305).

His 11-year-old son Christopher, who is also psychotic, rides pillion, and they are accompanied by two of Pirsig's friends on a BMW R60. For Pirsig, the trip becomes an odyssey, as he tries to find himself … or a possibility of redemption.

The strangest thing about the book is that Pirsig never actually talks about the Honda; it remains an abstraction—both for him and for the reader. He devotes almost as little attention to the search for wisdom that is the foundation of Zen Buddhism. Yet, from the very first pages, he describes the journey as one of the elements of meditation: "[…] you spend your time being aware of things and meditating on them. On sights and sounds, on the mood of the weather and things remembered, on the machine and the countryside you're in, thinking about things at great leisure and length […][9] The story of this road trip, which was made in 1968, fitted into the "voyage of self-discovery" literature so popular among the hippie movement—from *Steppenwolf* by Hermann Hesse to *Naked Lunch* by William S. Burroughs. Christopher Pirsig, the author's son and traveling companion, was stabbed to death outside the San Francisco Zen Center when he was 23. Robert died at the age of 88 in 2017.

* An ultra-subjective approach in which the writer immerses himself so deeply in his subject that he becomes a protagonist in his own story, which he writes in the first person.

OPPOSITE AND
FOLLOWING
PAGES:
Photographs
taken for the book
Blousons Noirs
(Black Leathers)
(La Manufacture
des Livres, 2016)
by Yan Morvan,
a lifelong biker,
photojournalist,
and war reporter,
who said that his
aim was to show
"guys who bum
around most,
if not all, of the
time."

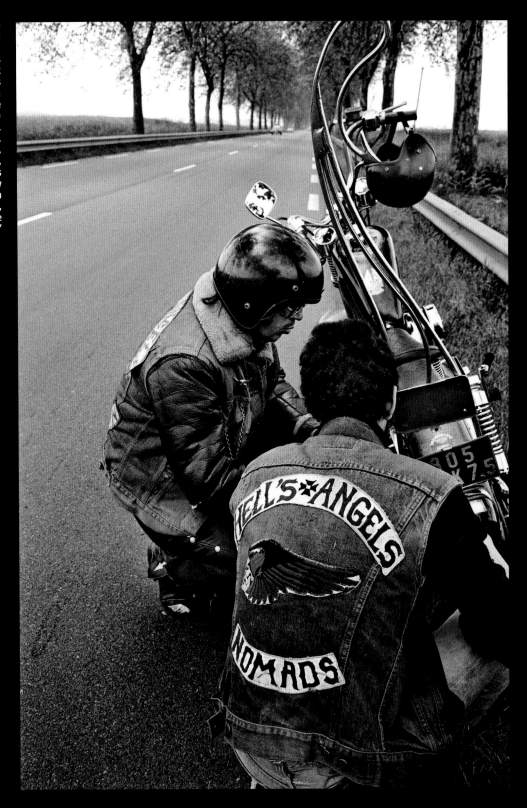

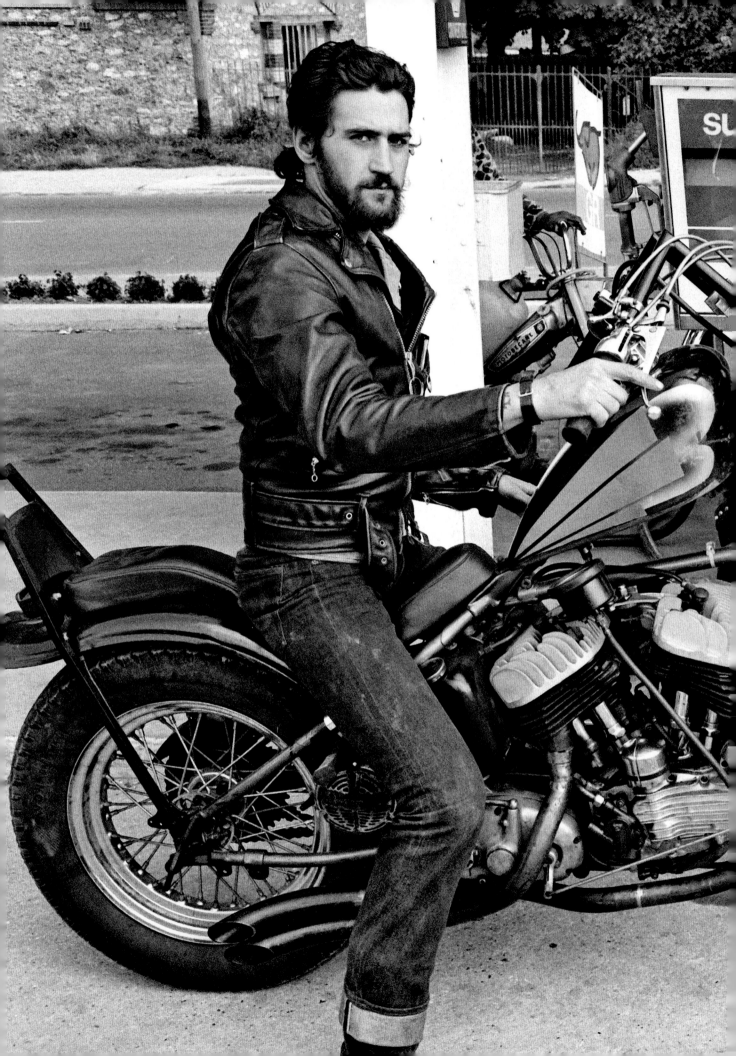

THE WORLD IS YOUR OYSTER!

RIDING TOWARDS
A NEW WORLD

The world might still be ideologically divided between East and West—a rift symbolized by the Berlin Wall—but geographically it was open sesame, with all kinds of new territories to explore. The search for freedom—a certain kind of freedom, at least—would now play out under the blue skies of Africa and the Middle East.

The 1972 Raid Orion, organized by the Guilde Européenne du Raid, was a 5,000-mile (8,000-km) rally from Paris to Isfahan in Iran. The aim was not to post the fastest time, but to make it to the finish, having reached a number of checkpoints by a certain deadline. The rally attracted 112 entrants with 92 bikes. They were a motley assortment—most riding solo, but some two-up or with a passenger in a sidecar—and had a mix of modern and vintage bikes, including a 1950 Vincent Rapide. The bikes had been modified, to a greater or lesser extent, to cope with the 15-day ordeal: a 750 Honda with an extra-large fuel tank, a home-made chain tensioner, a pressure gauge, and an oil temperature gauge; a sidecar with a wheel borrowed from a 2CV; a Moto Guzzi 700 with three spare tires, a camping gas stove, and a basket for dirty linen strapped to the back…

Although there were a number of female passengers, only one bike—a heavy 750 cc Moto Guzzi—was ridden by a woman, 28-year-old advertising copywriter Anne-France Dautheville. By her own admission, she was an unlikely candidate for the role of motorcycle

"Before the Raid Orion, my life was stifling. If I wasn't jumping out of windows, I was preparing to run away."

crusader—"I was brought up like a young lady in the 19th century"—Dautheville nevertheless had an unquenchable thirst for freedom and a fiercely independent streak. "Before the Raid Orion, my life was stifling. If I wasn't jumping out of windows, I was preparing to run away," she confessed. Motorcycle riding would forever be her passport to freedom: "I always had the bug for adventure." A few years earlier, she had bought her first bike, a Honda CB50, and made her first road trip—along the Côte d'Azur. "People said, 'Don't do it; it's dangerous.' But in fact, it was great; I loved it." She "couldn't care less" about what happened in May 1968, but acknowledged the liberating effect of belonging to a generation that was advancing toward freedom: "There were so many restrictions, so 'Thank you, May '68.' If I'd been born 10 years earlier, I couldn't have lived the life I did. I never waved banners; I just wanted to be happy and to understand the world I was living in."

"THE NICE GIRL WITH THE DIRTY HANDS"

Anne-France Dautheville, the first woman to ride around the world on a motorcycle. Hats off!

Dautheville got her driver's license in 1969: "I wore a red wax jacket with a little fur collar. A delivery man loaned me his bike for the test." Those were the days! After completing the

Raid Orion, she was the target of chauvinistic attacks and accused of cheating. In fact, after a crash on the Mont-Cenis Pass between France and Italy, she was helped out by a truck driver, who got her as far as Belgrade. "I couldn't go on; I was so … shaken up. I took a bend too fast for the Guzzi. I was trying to keep up with some guys who were going real fast. There was a big drop and I jumped right into it!" The Guzzi's speedo went up to 150 mph (241 km/h), and some critics asked Dautheville seriously if it wouldn't take off at that speed. After that, she continued the rally, despite other mishaps:

"Just north of the Great Salt Desert in Iran, the track was made of corrugated iron and you had to ride fast. I crashed. A truck stopped, but when they saw I was a woman, they ran off ... Lesson: Always ride a bike you can lift yourself." But the rigors of the trip were more often offset by the fascination aroused by the sight of a woman on a motorcycle.

When she reached Isfahan, Dautheville defied her competitors by deciding to go on to Kabul in Afghanistan with 11 other riders—and then, in a group of just four, as far as Peshawar in Pakistan. She returned to Paris by ... bike—a two-month round trip of over 12,000 miles (19,312 km)! In 1975, her first book, *Et J'ai Suivi le Vent (And I Followed the Wind)* was published and "my new life began." Her early reputation had been tarnished by suspicions of cheating. That was something Dautheville, who was known as "the nice girl with the dirty

hands" and "the broad with the big mouth," couldn't live with. So she set out to clear her name by embarking on a solo round-the-world trip, this time on a bike she could lift herself—a theme that became both an obsession and a symbol of female independence.

The machine Dautheville chose for her odyssey was the humble Kawasaki G5, with a 100 cc single-cylinder, two-stroke engine. It might have been ideal for a day out, and unbeatable for getting through traffic between the Place de la Concorde and the Arc de Triomphe, but for conquering the world? "I'm not so much interested in bikes themselves as in what I do with them. I absolutely love riding them but ... well, you can't talk to a bike. I always need to travel alone. When I'm alone, I feel part of the world." On her efficient but fragile yellow Kawasaki Dautheville would cross Canada, Alaska, Japan, India, and—for the second time—

The only female rider to take part in the 1972 Raid Orion, Dautheville crashed just north of the Great Salt Desert in Iran, between Nishapur and Shahrud.

Afghanistan and Pakistan. In Japan, she was honored by a reception at the Kawasaki factory, where mechanics dismantled the G5's engine to show her how it worked. But they put it back together so shoddily that it gave up the ghost as she approached Mumbai.

After completing her round-the-world journey—which, this time, raised no questions at all—Dautheville spent some time writing. After all, you can't earn a living as an adventurer: "If I'd had enough money, I wouldn't have become a writer. I was young, and I wouldn't have thought twice about carrying on. My generation has lifted many restrictions, but money is the most obstinate restriction of all. What about our value to society, our worth as human beings, our political usefulness? It's a matter of putting them in order of importance, knowing which comes first."

Like any other rally rider, Dautheville wore a stout pair of boots. Ah yes, but hers were designed by Yves Saint Laurent!

"Always ride a bike you can lift yourself."

"THE ONLY COUNTRY I FEEL AT HOME IN IS MY OWN."

Not content with riding around the world, Dautheville set off for Australia in 1975, on a BMW R75—alone, as usual. It was "the dream destination for a self-confessed globetrotter," she said. First, she rode her Suzuki 250 to Munich to ask BMW to loan her a bike, but none ever arrived in Sydney. It was thanks to a local dealer that Dautheville was able to cross Australia, a country 17 times the size of her own. Her only modification to the flat-twin R75 was a set of Metzeler trail tires; her only concession to French style was a pair of Yves Saint Laurent boots.

She was accompanied by an Australian TV crew, who made a documentary about this "crazy Frenchie" with the corny title *Follow That Girl!*

Her opinion of Australia? "It's the only other country I could have lived in. But my 'thing' is to travel through a country and then go back home. Some people are 'leavers,' others are 'returners.' I've had some fantastic journeys across continents I've loved ... because I was traveling through them. But the only country I feel at home in is my own."

This time, Dautheville turned her hand to fiction, and in 1978 she won the Prix Hermès for her first novel, *L'Histoire de Jeff Walcott (The Story of Jeff Walcott)*. It was an outstanding

performance—this time without the help of a motorcycle—since she beat literary lions such as Alphonse Boudard and Didier Decoin. But she continued to travel the world, retaining her independence by submitting articles to magazines such as *Cosmopolitan, Paris Match*, and *Moto Journal*, for which she was paid by the line.

In 1978, she returned to Australia with a BMW R80 ("easy to lift") to work on an ABC documentary about top sportspeople. This time, she said of the country: "I don't have a big enough ego for Australia."

Her last trip was in 1981, when she spent seven months in South America. A bizarre French law that restricted the amount of money an individual could take out of the country had broken the dream; the magic of travel had gone.

From then on, Dautheville, the first woman to ride solo around the world, spent her time gardening and studying plants. Having always eschewed fashion and "frills," she became the subject of Chloé's 2016/2017 autumn/winter collection. Its theme was riding, with the label "Romantic Voyager," and the blurb quoted from Dautheville's first book, *And I Followed the Wind*: "Up there, autumn was waiting for me, with its clear, dry, biting wind. I knew it would be, so I'd slipped a thick sweater and a wool scarf into my saddlebag."

It was like a journey back in time, a concatenation of the catwalk and the Raid Orion, where, as the models pass by, the outfits take you from Lahore to the Khyber Pass and on to Islamabad...

The freedom a young woman had found on an unassuming Honda CB50 had changed her life and, unwittingly, she had become a role model for other adventurers, other seekers of space: "I have lived for the pleasure of living. I was brought up to believe that I had no right even to exist, that my place was 'in the wings.' Riding gave me a life of luxury with real friends and authentic experiences."

Anne-France Dautheville striking a pose during the Seventies. The fashion house Chloé would revive this image in its 2016/2017 collection.

LIVING LIFE TO THE FULLEST

In the early 1980s, a young English architect by the name of Elspeth Beard spent three years riding around the world on a BMW R60/6. She was one of a small group of women at the forefront of motorcycling, whose watchwords were freedom and independence.

Although their paths have never crossed, Elspeth Beard could almost be Anne-France Dautheville's little (English) sister. Their common determination to be independent, their shared idea that freedom is within easy reach thanks to the motorcycle, and their similar sense of style will unite them forever in the mind's eye.

Beard discovered riding when she was barely 16 and covered her first few miles on a Yamaha 100. She then rode a Honda 250, but wanted a more powerful machine for the round-the-world trip she planned to make. She worked in a pub for several months to earn enough to buy a BMW R60/6, with a 600 cc "boxer" engine. It cost her £1,000—a fortune at the time. Dating from 1974 with double-rotor brakes and 30,000 miles (48,000 km) on the clock, it was already outmoded, but Beard was an excellent mechanic and knew all there was to know about flat-twin engines. She even designed aluminum saddlebags to protect her possessions in countries where strangers were seen as a threat.

When she set off in 1982, it was on a personal journey around the world. Starting in New York, she rode through Canada, the States, and Mexico. Then she crossed the Pacific to Australia and New Zealand, where she had to walk part of the way while waiting for her bike to arrive by boat.

Unlike Phileas Fogg and Passepartout in Jules Vernes's famous story, Beard was not aiming to circumnavigate the globe in 80 days. She stopped in Sydney and stayed there for seven months, working for an architectural firm. Then, on her way through Queensland, she had her first serious accident, in Townsville.

Her next stop was Singapore and, after that, Thailand and Kathmandu. In the end, it took her over two years to complete her world tour, after covering 35,000 miles (56,327 km). Now head of an established architectural firm in southern England, Beard (and her R60) appear on the homepage under the heading: "Not many people have done this." Remembering her world tour, Beard said in an interview: "Motorcycles are the best way of getting around. They aren't expensive, they can get anywhere, and I love the freedom they give you."[11]

Elspeth Beard is ready to ride after purchasing a second-hand 1974 BMW R60/6 with 30,000 mi./48,000 km on the clock. Ready to go?

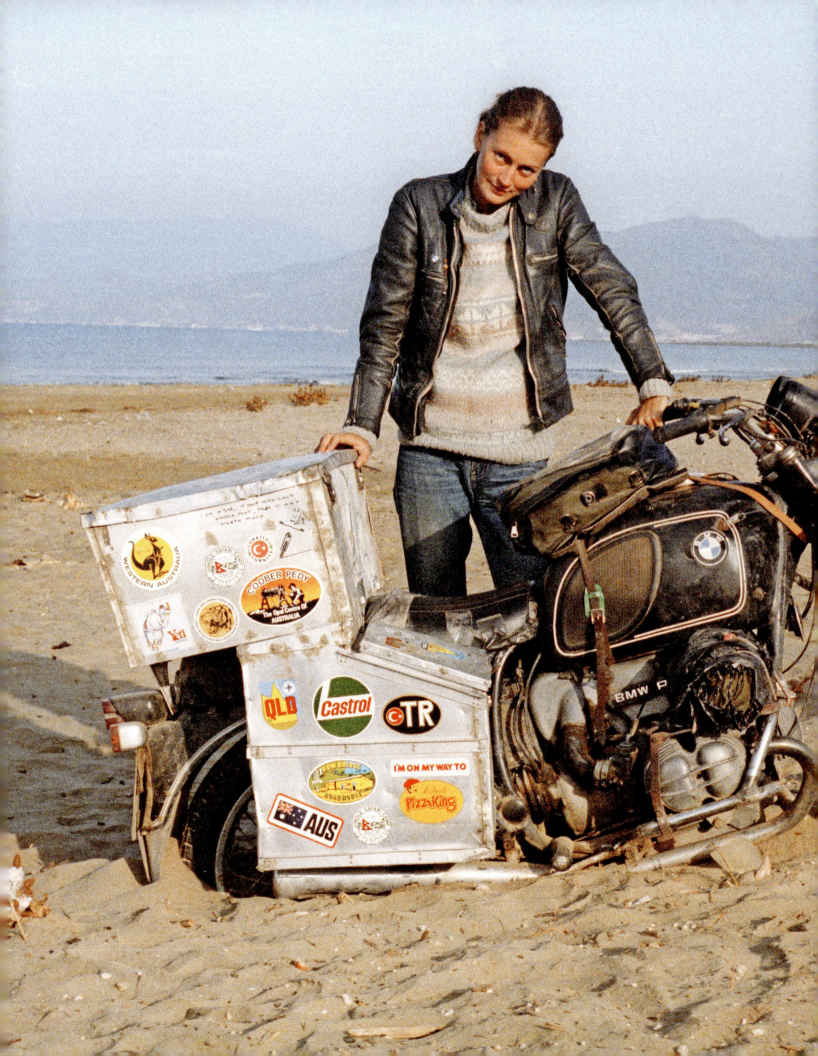

The heavy BMW
gets stuck in the sand
in Turkey. Its metal
saddle boxes were
designed by
Beard herself.

All you needed for the 1972 Raid Orion: a sturdy bike and appropriate attire ...

Two-up from Paris to Isfahan—a snapshot of another century, when rallies were more like a Sunday outing.

ROADS TO NOWHERE

Protests and utopian dreams are a thing of the past. What else can there be to live for? From now on, both riders and machines are just as comfortable off the road as on it—well, almost— and the smell of asphalt has given way to the scent of hot sand in distant lands…

The French travel writer Sylvain Tesson, who rides Royal Enfields with Ural sidecars, has said: "The motorcycle reminds us of our *raison d'être:* progress." Progress, yes, but in what direction? It is this question that preoccupied young people in the early 1970s. For them, political agitation, the questioning of established values, and the creation of alternative or utopian social models were losing momentum in an inexorable return to postwar stability. "Normality" was re-establishing itself and bringing with it—for the time being, at least—growth and prosperity. Which meant that they, too, were bored!

But riding was still the key to freedom, the magic (mechanical) formula that enabled anyone to go where they pleased … provided they were in their twenties. And freedom no longer meant riding around a track, but making tracks—preferably in sand. That meant the emergence of a new breed of riders: desert racers. One of the most famous was Jean-Claude Morellet, known universally as "Fenouil" (Fennel). "In May '68, I was behind the barricades. I didn't want to hurt anyone, but I belonged to a group that called itself The Apaches," he explained.

Fenouil's Kawasaki 900. The goatskin is not a fashion accessory, but supposedly helps to keep the fuel tank cool.

A girl said to me, 'Your hair looks like fennel. We should call you Fenouil (Fennel).' I said, 'I like it.'"[13]

FENOUIL, THE DESERT FOX

Jean-Claude Morellet was born in 1946 in Yaoundé, Cameroon. Knowing nothing about motorcycling, he pretended he knew something about filmmaking and became a movie critic for the magazines *Jeune Afrique* and *Positif*. He did the rounds of the movie festivals in a Peugeot 203 coupé ... until one day, a girlfriend's uncle gave him a lift on a Japanese motorcycle—and he was hooked.

But before he could earn his other nickname, "The Desert Fox," by plotting the route of the first Paris–Dakar rally or creating the Rally of Tunisia and the Pharaons Rally, among others, Fenouil

had to ... pass his driving test. He was already 27—a critical age in motorcycle racing. What's more, he had to take the test with a sidecar!

Having acquired his license, he bought himself a Honda CB750 with a bank loan ... after telling them he was going to open a restaurant!

Fenouil knew what he wanted, but he was lucky, too—and, like motorcycles, luck also has a part to play in "progress." When his brand new Honda broke down on a street near Paris, a guy stopped his car to assist; it was Pierre Barret, editor of the recently launched *Moto Journal*. The two men started talking, and Barret—"switched-on and funny," Fenouil recalls—suggested they work together. (This was before fixed-term contracts and job centers.) Fenouil drew on his movie-reviewing experience, and his first article, "Motorcycles + Movies = Sex," not only appeared in the magazine, but was also featured on the cover. Backing his argument up with photographs and press clippings, Fenouil showed how the movie industry had a highly sexualized image of the world of riding. And didn't it?

It was this unconventional approach to writing about riding—as opposed to straightforward bike test reports—that made Fenouil stand out from his peers.

absorbed the shocks from the corrugated iron, which made even Mercedes trucks fall to pieces. Fenouil was accompanied by future Grand Prix and enduro champion Hubert Rigal in an ancient Volvo 544 Sport, which he had bought for less than it cost him to tax it. (Admittedly, the thing had been dragged out of a ditch…) He had fitted it with studded tires—on the assumption that there might not be any snow, but there would almost certainly be a lot of sand! When they reached Ain Salah, Fenouil had an idea worthy of the veteran racer he would later become: To insulate himself from the heat being thrown out by the engine, he laid a goatskin over the fuel tank. A photograph of his Kawasaki "in sheep's clothing" went round the world. Fenouil described the trip in a book (published by Flammarion in 1974) titled *Une Moto dans l'Enfer Jaune (Riding through a Yellow Hell),* which is now highly sought-after.

"A METAPHOR FOR LIFE"

In May 1968, students in Paris had called for "imagination to take over." In Fenouil's case, imagination was just what he needed to plot a route through the shifting sands of the desert. Realizing perhaps that he was on the brink of a new life, Fenouil created a second "desert trail," the Paris–Dakar, in 1973, riding a Kawasaki 350 Big Horn. The following year, he was back in his native country, Cameroon, on a Yamaha DT 400, and in 1975 he was in Algeria's Hoggar Mountains on a Kawasaki KZ 400, accompanied by French enduro champion Gérard Choukroun. It was typical of Fenouil: He never stopped. In 40 years, he covered more than 450,000 miles (724,204 km). Although tracking the desert for very different reasons, Fenouil had a similar attitude to T. E. Lawrence, who wrote in his great *Seven Pillars of Wisdom* (1922): "To the thinkers of the town the impulse into Nitria had ever been irresistible, not probably that they found God dwelling there, but that in its solitude they heard more certainly the living word they brought with them."

H is article on the new Japauto 950 SS, for example, described a ride from Paris to the Alps and back—a journey of 1,000 miles (1,600 km)… in a single day! Fenouil even managed to fit in a run on the ski slopes and a hot dog at Chamrousse before racing back to Paris in time to take in a classic Western at an art house movie theater. "*Moto Journal* was an extension of the utopian world of May '68—a brotherhood of riding comrades. I was no longer Jean-Claude Morellet; I was Fenouil. Riding had brought me freedom."[14]

The first serious challenger to the Honda CB750 was the Kawasaki 900 Z1. "The Z1 made the CB750 look dated. When I went to Algiers for the film festival there, I drove around in my Peugeot 203. That gave me the idea of a race from Algiers to Tamanrasset in the south: 600 miles (1000 km) of asphalt followed by 600 miles (1000 km) of dust, corrugated iron, and potholes."[15] With trail tires, the Kawasaki

The Place de la
Concorde in Paris
before the start of
the 1983 Paris–
Dakar rally.

In 1978, the "impulse into Nitria [an early Christian site in Egypt]" prompted Fenouil to set himself a bizarre challenge: to cover 1,250 miles (2,012 km) between sunrise and sunset—a duration he figured to be exactly 12 hours and 48 minutes. The bike he chose for the attempt was the majestic Yamaha XS 1100, which weighed in at a massive 615 lbs (279 kg). Despite treacherous conditions (which would spell disaster for the crew of a Porsche not long afterwards), Fenouil achieved the feat.

Lawrence's "thinkers of the town" became, in 1972, the racers themselves—men and women impatient for victory. The African rally was born. The first of its kind was the Paris–Dakar. The basic concept was Thierry Sabine's, but Fenouil persuaded him to modify it, for logical reasons. Sabine had initially proposed a race from Paris to the Cape of Good Hope, but Fenouil pointed out that it would be better to choose a destination that wasn't subject to racial segregation and an international boycott. (Nelson Mandela, hero of the anti-Apartheid movement, would

remain incarcerated in a South African jail until 1990.) Although the Paris–Dakar was a "joint initiative" between Sabine and Fenouil, such was the tension between them that neither acknowledged the fact; it would bring bad luck, they decided.

Taking part in the first race were 167 motorcycles, cars, and trucks, which set off from the Place du Trocadéro in Paris on December 26th, 1978. Now called the Dakar Rally, the event is still going strong—though the winning machines have changed. Ever iconoclastic, the "Desert Fox" claimed that BMWs could rival the agile, adaptable Hondas and Yamahas. He was proved right: Hubert Auriol won the Paris–Dakar in 1981 and 1983 and Gaston Rahier triumphed in 1984 and 1985—both on BMWs.

Fenouil heralded a new era of motorcycle racing—in the literal sense of the word. Not only did he arouse a passion for desert racing in succeeding generations of riders, but he also wrote 12 books about his experiences—at a

time when most riders, for all their skill in the saddle, were more or less taciturn. Above all, Fenouil was responsible for the idea that crossing the desert is a metaphor for life. It was he who persuaded "the thinkers of the town" to defy the dunes again and again—and eventually to face the ultimate challenge when, in 1982, he created the Pharaons Rally across the so-called Libyan Desert (two-thirds of which is actually in Egypt). Three hundred miles (480 km) of uninterrupted dunes, this "ocean of sand" is virtually impossible to cross. "It stretches to the horizon in every direction," wrote Fenouil. "Even camels have to wear blinders so as not to get dizzy when they reach the top of a dune [...]. And all that without a GPS."[16] Even the army asked Fenouil to find them a way through it...

But rallies weren't just bike races. Competitors exist inside a bubble, crossing entire conti-

nents and remembering only their own performances, not the people they encounter along the way. With that in mind, Fenouil, whose credo had always been "freedom for me first," created the Peace Rally between Egypt and Israel in 1994. Although it took place only once, it was "a powerful symbol," wrote Fenouil.

RIDING AS DELIVERANCE

For Fenouil, rallies were all about personal discovery, about "total freedom"—and sometimes the complete opposite, when riders were competing against hundreds of others. The most powerful driving force was adrenaline—as much for the last over the line as for the first. As for organizing a rally, Fenouil remembers that it can be "awesome but at the same time tainted by pettiness."[17]

Rider and photographer Michel Montange, known as "Micou," props his Yamaha XT250 on a termite mound during the 1981 Paris–Dakar.

The most powerful driving force was adrenaline—as much for the last over the line as for the first.

And then there are the improbable encounters that take place far from the competitive arena. Take, for example, the French naturalist Théodore Monot, one of the world's leading experts on deserts. Born in 1902, Monot lived until 2000 and published more than 1,200 articles, books, and papers. He and Fenouil met, and Monot politely expressed his amazement that anyone could cross vast expanses of sand at over 60 mph (100 km/h). And, having been born in the early 20th century, he posed this poetic, yet specific, question: "How do the wheel surrounds survive at such a speed?" By which, of course, he meant tires!

The Paris–Dakar, the Rally of Tunisia, the Pharaons Rally, the fleeting Peace Rally... It was a time, Fenouil recalls, when riders sought to throw off the shackles of civilization, of routine, of a destiny implacably controlled by social conventions. It was Fenouil who promulgated the idea that anyone could "cross the desert."

Time occasionally shuffles the deck in paradoxical ways. Desert racing inevitably became institutionalized and standardized, but the Ace Cafe, which had closed in 1969, reopened in 1997, and Sixties-style clubs attracted a new generation of riders that was emerging from skateboard culture. Black leather jackets were back, but this time the parking lots were filled

Pascale Geurie reaches the Dakar coast on her Honda XL250S to claim 45th place overall in the 1979 Rally.

with R.U.B. (Rich Urban Bikers), with their Yamaha OW01s and Suzuki GSX-R1100 s. Designers and "graffers" like Conrad Leach came into vogue, and fanzines celebrating the new low-brow culture became style-leading magazines, such as *Sideburn*.

The age of freedom and counterculture had been remodeled as the new generation reinterpreted its predecessors' approach to riding and lifestyle. But the essential motivations remained the same: liberation, independence, and the creation of new symbols. Custom-culture and the retro revival would draw on the Sixties and Seventies to pave the way to future decades.

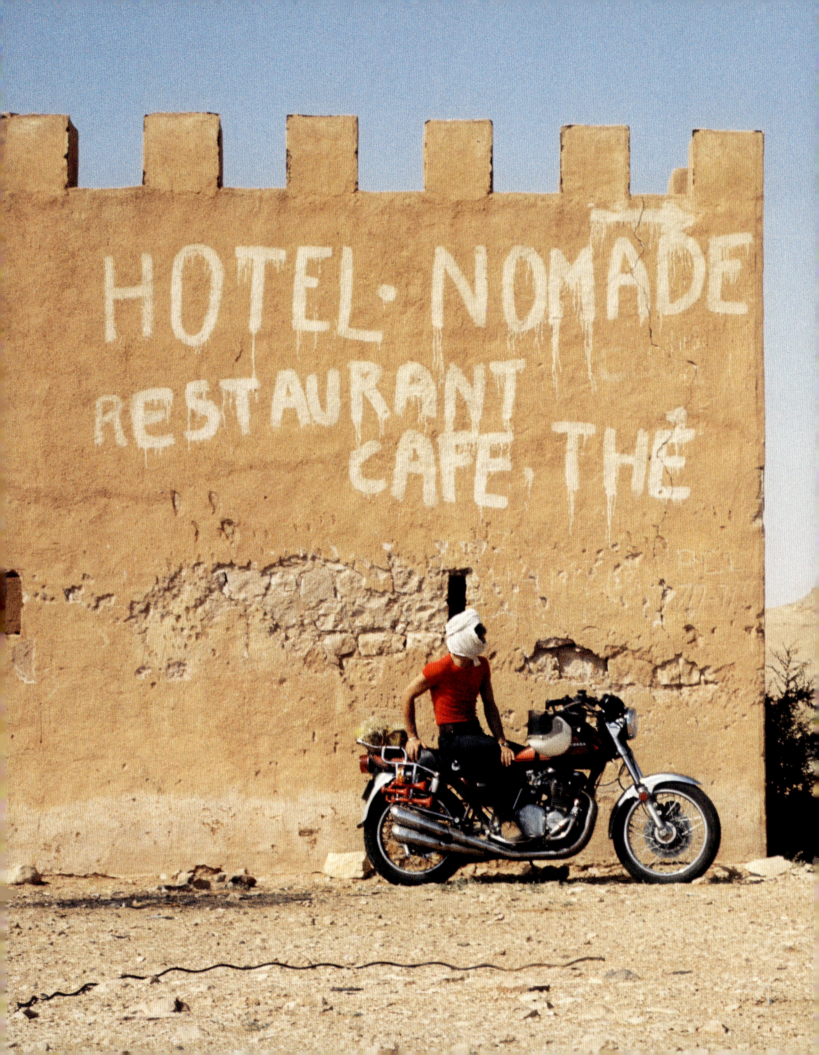

Fenouil and his
Kawasaki 900 make
a welcome stop in the
middle of the desert
on their way to ...
Tamanrasset?

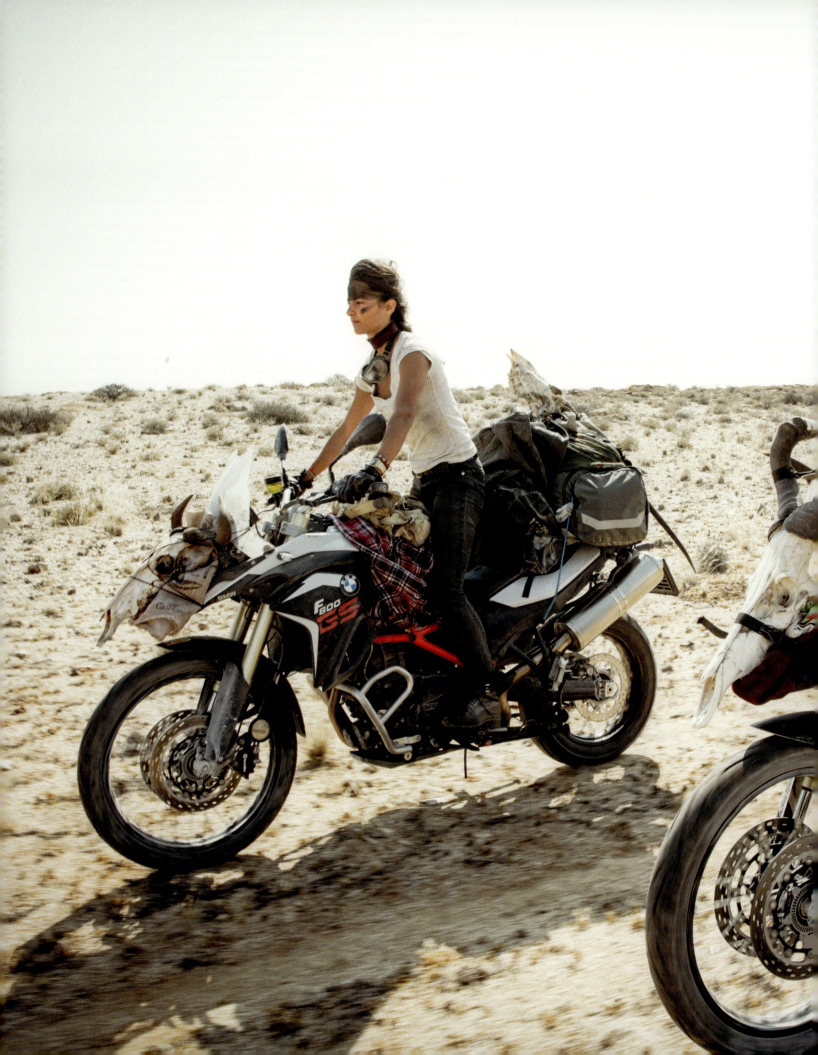

NEW DIRECTIONS

As much as movies, art, or literature, riding had been a vehicle for expressing counterculture. It had now established its own culture, but it was still a symbol of freedom—and one that women took up with enthusiasm.

Following in the tire tracks of Anne-France Dautheville and Elspeth Beard, a new generation of women riders take the saddle.

TODAY'S BIKES

Riding was one of the most striking and radical symbols of the quest for freedom undertaken by young people in the Sixties and Seventies. Today, it has become a brand exploited by advertising agencies in search of new markets.

Riding was once as much an expression of counterculture as the movies of John Cassavetes, the New Hollywood of Francis Ford Coppola, Terrence Malick, and Martin Scorsese, the graphic novels of Robert Crumb and Gilbert Shelton, the stories of Philip K. Dick, the poetry of Allen Ginsberg, or the gonzo journalism of Hunter S. Thompson. It was taken up like a banner by the protesters of the Sixties, whose target was a society that had run out of answers, whose standards were stuck in the past. Motorcycles challenged and disparaged the supremacy of the automobile. Since then, riding has established its own identity, vocabulary, and cultural references. Although counterculture has faded into the past, the desire and thirst for freedom are undiminished. The only difference is how are expressed.

In 1998, riding "came out of the closet" (well, the garage) and was officially recognized as an art form in a surprising exhibition at the Guggenheim in New York entitled *The Art of the Motorcycle*, which attracted record crowds. The show went on tour: to Chicago, Bilbao ... even Las Vegas.

A ride on the wild
side as young
people develop
a new formula:
bike + board = fun.

Riding had finally made it! Exhibition consultants included legendary figures such as Nobby Clark, mechanic to Mike Hailwood and his 6-cylinder Honda (among many others), Bud Ekins, and Sammy Miller, another champion racer. Even the catalogue included words by Dennis Hopper and purple prose from the pen of Hunter S. Thompson, such as: "The Ducati is like the magic bullet in Dallas that went sideways and hit JFK and the Governor of Texas at the same time. It was impossible. But so was my terrifying sideways leap across the railroad tracks on the 900SP."[1]

The motorcycle also became part of industrial history, as well as of popular and sporting culture, in that same year, when Honda celebrated 50 years in business. Five decades earlier, it had been a means of challenging the social order; now it was an object of desire. Riders no longer had to be rebels or restless adventurers; today's motorcyclists were men and women who had everything they wanted. Motorcycle manufacturing had become an industry that responded to a variety of needs, kept its ear to the ground and tried to anticipate the next fad—or, instead, to capitalize on its own heritage. Both Triumph and Ducati,

for example, produced scramblers—a concept that had originated in the U.S. in the Seventies, when riders modified road bikes for off-road riding.

CLANS RATHER THAN GANGS

Of course, there are still hardened riders, immune to fashion and with no need of "street cred," who hammer along highways day and night, in all weathers, winter and summer. These are essentially solitary beings. For them, two wheels—whether on a motorcycle or on a souped-up scooter—are a tool, an object, mundane and soulless. Passion doesn't enter into it.

And then there are the clans—adoptive descendants of the gangs of yesteryear—who ignore the marketing hype and plunge into the past.

Rather than counterculture, theirs is a custom culture—retro, neo-retro, neo-vintage ... call it what you like. New bikes with old names: bobber, café racer, scrambler, chopper (oh, yes!). Once upon a time, customizing was cool: covering your chopper with chrome, dolling up your bike with bling, making your Harley look like Jean Harlow... But every action has an equal and opposite reaction. Extravagance has given way to sobriety, excess to austerity. The Brat Style is in: straight handlebars, hard seats, rectangular frame... It is a look created by the modern magician of custom culture Go Takamine—"the Japanese Steve McQueen," according to some—whose designs have become the biking benchmark. The Brat Style is to modern machines what the "bitsa" was to bikes of the Fifties and Sixties: an assemblage of bits and pieces—of the engine as well as the frame—that paradoxically created a harmonious whole. The same goes for the clothing manufacturers: Barbour, Belstaff, and Bell are re-inventing their classic designs. Successful businesses are often fueled by a mixture of nous and nostalgia. The motorcycle industry certainly has both in abundance.

Double-take? Modern bikes are a synthesis of old and new, past and present.

"The Japanese had been 'customizing' the Yamaha SR500 ever since it came out in 1978."

Motorcycle advertising has come a long way since the corny and supposedly macho commercials of the Sixties and Seventies. Today, manufacturers study the market and try to maximize sales by offering different bikes to different segments. Remaining true to the traditions of riding means disregarding the marketing and deciding for yourself what type of machine is right for you. French designer Philippe Starck has this to say about the neo-retro trend: "It's not just about going back in time; it's a rejection of everything that's over-stylized. It seems that bikes have to look like a Batmobile, or something out of *Star Wars*, or a Hells Angels Harley, or a desert sled, or what some ex-World Champion rode... But the whole thing about a bike is that it should be unique, authentic. For a long time, the marketing people ignored bikes and concentrated on cars [...]. Today's whizz-kids need to be reminded that a bike is something minimalist [...]. They also need to look at the whole culture of riding, use their imagination, and find other ways of promoting their products."[2]

"THE JAPANESE STARTED MAKING WHAT AMERICANS WANTED"

Riders in their 30s often want to differentiate themselves from previous generations, and among their gurus is Australian businessman Dare Jennings. A former surfer, Jennings is from a different culture—where "grommets" are youngsters and "A-frames" are perfect waves —and started out by creating a brand of clothing specially for it called Farting Dog (yup!).

Jennings is an inveterate traveler, as well as a keen observer. In 2006, before founding the clothing brand that made him famous, Deus Ex Machina, he rode through Japan. Christophe Gaime, Editor of *Moto Revue Classic*, points out how crucial this was: "The Japanese had been 'customizing' the Yamaha SR500 ever since it came out in 1978. This single-cylinder bike has an extraordinary history: it was imported into Europe three times. It dropped out of the French market in 1981, when new licensing regulations came in, and was replaced by the SR400. Then it reappeared in 1992, and again in 1998—with drum brakes instead of discs! The idea was to break with tradition and 'personalize' each bike. It was a lesson Jennings took home with him."[3]

The big companies were also paying attention to the siren calls of nostalgia, the yearning to own a custom-made bike—even if it came off a production line! Christophe Gaime takes up the story: "It goes back a long way. Guys came home from the Korean War and rode around on Indians or Harleys. They formed clubs modeled on the Boozefighters. They were bored and started racing each other—and got whipped by smaller, lighter British bikes. So they stripped their machines down to make them go faster. By the middle of the Vietnam War, people wanted to forget, get free,

Dressed up and ready to ride—a new sociocultural phenomenon that would have been unimaginable only a few years earlier.

get out of their heads. Everyone turned up at the 1970 Daytona on choppers. Then the Japanese started making what Americans wanted. Honda saw the growing demand for custom bikes; they even included the word in the model names, like the CX500 Custom (1980–1983). And each one was available in a range of engine sizes, from 125 to 1,000 cc. Kawasaki followed suit in 1991 with its 750 Zephyr roadster, echoing the Z900 of the Seventies, and then the W650 and 800."[4]

GROUP FREEDOM

In 2006, Dare Jennings brought the worlds of riding and surfing together with his new brand, Deus Ex Machina, and bikes became laid-back, even ad lib. Elements such as fuel tanks and exhaust pipes began to look as though they'd come from a scrapyard—whereas they were in fact the result of extremely sophisticated design. These "new wave" machines attracted new riders: It was no longer about

getting from A to B as fast as possible, but about short bursts of speed, a few hundred yards of eye-catching velocity. Your choice of jacket, boots—Red Wings, for example—scarf, and gloves said more about you than your skill at handling a bike. The new thing was group freedom—belonging to a clan.

Rallies are now of a different kind. For adherents to the American way of riding, the Sturgis Rally (in South Dakota), the Free Wheels Festival (in southern France), the Gérardmer Motordays (in eastern France), and DirtQuake (in southern England) have become the go-to events. For hipsters, the big meet is Wheels and Waves in Biarritz, where they have been flocking since 2011. A distant derivative of Australia's Deus Ex Machina scene, it looks like a remake of a Bruce Brown's *Endless Summer* and *On Any Sunday*, merged into one: cool dudes on cool bikes by the cool sea. With its mix of street artists and vintage motorcycle collectors, could this be the start of another

The 2017 Wheels and Waves festival in Biarritz, France. "Lifestyle" is the new watchword as the worlds of riding, surfing, and skateboarding come together, unified by custom culture—but for how long?

counterculture—hedonistic and non-violent? The birth of the "arty biker"—as evidenced by *Art Ride*, a recent exhibition put together by artists, designers, and photographers including Steven Burke and Conrad Leach? Identity is defined by the quality of a bike's customization, the imaginativeness of its design. Harmony or iconoclasm? You choose...

Sun, sea, and ... now ice. Harleys, Indians, and Oilers: The Race of Gentlemen.

Today, freedom is to be found in the specialist workshops that have mostly sprung up since 2010. Leading the way were Blitz, The Lucky Cat Garage, and Clutch Motorcycles. In France, there are names such as Jambon-Beurre Motorcycle, Dauphine-Lamarck, Le French Atelier, and Sur les Chapeaux De Roues; elsewhere in the world are studios such as El Solitario, Roland Sands, Shinya Kimura ...

According to Christophe Gaime, motorcyclists are riding with the times more closely than ever before: "Young high-flyers are morphing into hipsters. It's a transformation that's linked to social media. Everything contributes to the online image you create via Facebook, Instagram ... Custom culture is a way of life for digital natives. Everyone is looking for their quota of fame, as predicted by Andy Warhol, who wrote in the catalogue to an exhibition of his work at Stockholm's Moderna Museet in 1968: "In the future, everyone will be world-famous for 15 minutes."

FOLLOWING PAGES:
A smoky single-cylinder at the 2014 Wheels and Waves festival evokes the world of Seventies America.

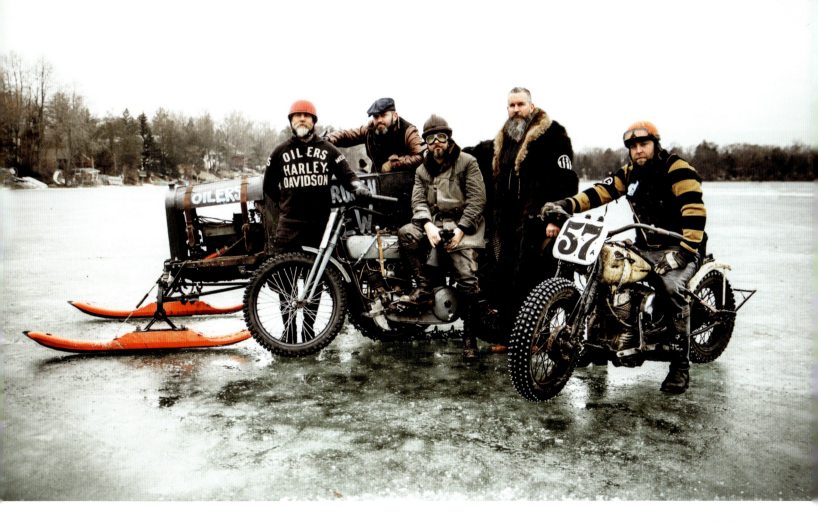

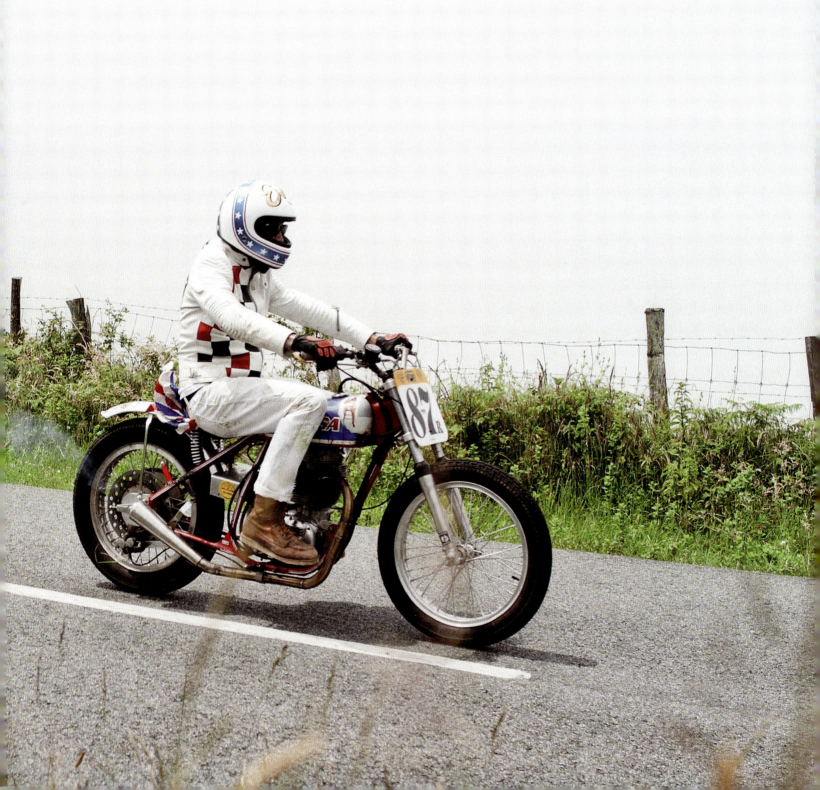

RALLYING (ALL YEAR) ROUND
CHAMOIS AND ELEPHANTS

Question: What are chamois in summer and elephants in winter? Answer: riders with a taste for the unusual. Two unlikely events, created a decade apart and fallen victims to changing fashions, have recently enjoyed a resurgence.

In 1965, champion sidecar racer Jean Murit, Hermès President Pierre de Seynes, and the BMW Club de France created the Rallye des Chamois—a motorcycle rally in the French alpine resort of Val d'Isère. The idea was to bring together thousands of riders of all types in a rock-festival atmosphere. (In fact, it anticipated rock festivals, which would later proliferate.) It was France's answer to another great gathering—in winter rather than summer—across the border in Germany: the Elephant Rally, which had been running since 1956. The Elephant Rally was the brainchild of Ernst "Klacks" Leverkus, Editor of *Das Motorrad* magazine, who chose the Solitude race-track in Stuttgart as the venue for a rally of Zündapp KS 601 enthusiasts. The Zündapp was a German bike that owed its nickname, "Green Elephant," to its color. The curious—not to say outlandish—idea of a riding event in the middle of winter was a runaway success. After various changes of venue, there are now two Elephant Rallies: one in Bavaria, the other at the Nürburgring. As for the Rallye des Chamois, it returned to the French Alps in 2016.

FOLLOWING PAGES:
Riding on snow is obviously not without hazards!

Started in 1956, the Elephant Rally lives on. This is the 2011 event.

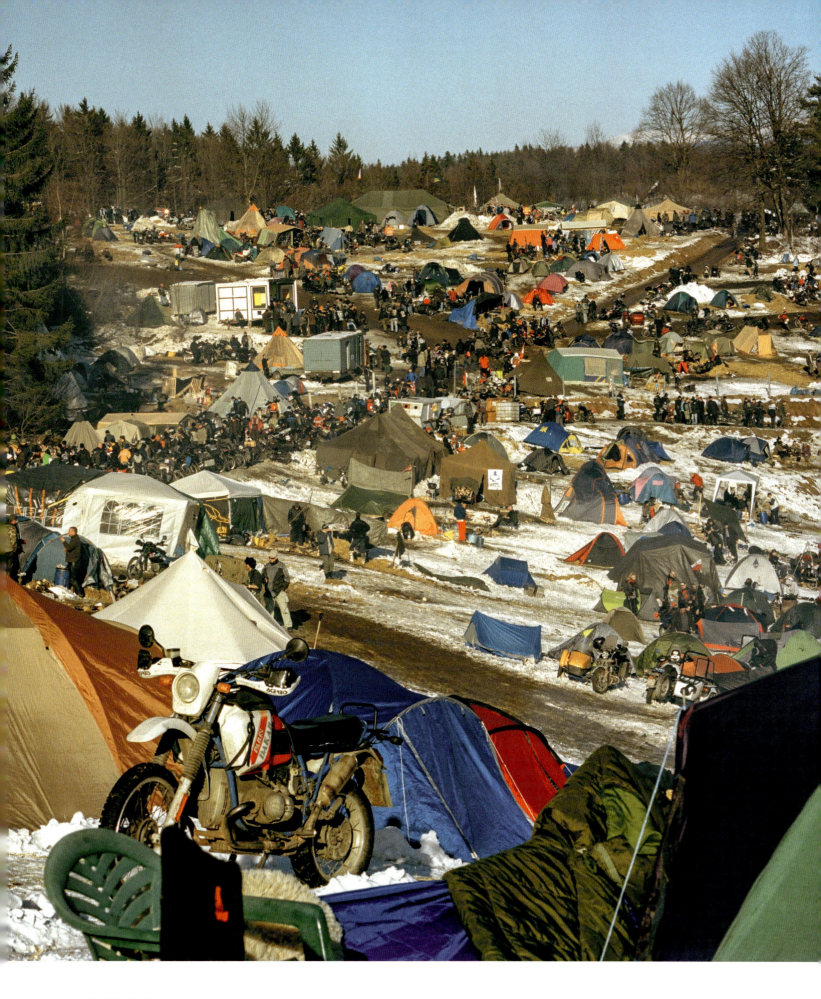

BIKES AND WOMEN

For a long time, riding was the exclusive domain of men—a world of testosterone, of guys for whom a motorcycle was an emblem of masculinity. But the new generation has broken the taboo of women riding bikes.

Riding started well for women, as Henri Loevenbruck pointed out in an article for the French magazine *Freeway*. In 1911, the San Jose Motorcycle Club had eight female members, and in 1930, two female riders, Linda Dugeau and Dot Robinson, decided to create their own club. "In 1941," wrote Loevenbruck, "the AMA finally granted them a charter (#509) to form Motor Maids of America, a national club exclusively for women, whose members had to own their own bikes and had to have been riding for at least three months [...]. Today, Motor Maids of America is one of the oldest women's riding clubs in existence, and has over 1,300 members. It still organizes women's runs all over North America and hosts various charity events."[6]

In the second half of the 20th century, however, things went into reverse. Women literally took a back seat, quietly riding pillion and passively absorbing the shocks from the road. After the War, young women lacked the independence to take a driving test, and only a very few have passed into the annals of motorcycle history: Bessie Stringfield, the

Bessie Stringfield (1911–1993), photographed here in the 1970s, was the first African-American woman to ride all across the United States. During the Second World War, she delivered mail between army bases on a Harley-Davidson.

first African-American woman to ride across the U.S.; Anke-Eve Goldmann, a skilled racer, multi-linguist, and leading journalist; Anne-France Dautheville, the first woman to ride around the world; Elspeth Beard, an English architect who reproduced Dautheville's feat a decade later, taking over two years to complete her tour; and French rally racers Martine de Cortanze and the Bassot sisters...

WHAT IF WOMEN WERE THE FUTURE OF RIDING?

The current fashion for all things retro has made riding less extreme. The worship of speed and the fascination for "bullet bikes" have given way to more civilized behavior and machines with manageable horsepower. The concept of women's liberation, which came to the forefront in the 1960s, has finally embraced the ultimate social marker of machismo: the motorcycle. Up until then, women on motorcycles were mere pendants to the men who

rode them. In Jerry Leiber's and Mike Stoller's 1955 hit *Black Denim Trousers and Motorcycle Boots*, the biker loves his "doggone motorcycle" more than his "pretty girlfriend;" and in Serge Gainsbourg's 1967 *Harley-Davidson*, famously sung by Brigitte Bardot—the ultimate pin-up of the era—the sex-symbolism of bike riding is unequivocal: "When I feel my machine / Vibrating beneath me / I get mounting desire / Deep down in my gut."

Who could have guessed 50 years ago, when Japanese bikes began to invade the European market, that women would one day be the "prime target" of manufacturers looking to "broaden their customer base," to use modern marketing parlance? In France alone, it is estimated that a million people have obtained a rider's license ... and then put it in a drawer, never to be used. It is these "dormant" riders whose passion for motorcycling the marketers are hoping to rekindle. Husqvarna (now part of KTM) has abandoned its legendary allegiance to off-roading and is now devoting its attention to road bikes. The Svartpilen ("Black Arrow") and Vitpilen ("White Arrow") 401 and 701 are "neo-vintage" designs, indicating that the modern world is not about speed, which

Sandrine Dufils
at Lurcy-Lévis
in 2007, on a
Yamaha TZ 350
Nico Bakker
Special.

has gone out of fashion. People today buy a bike because they fall in love with it; they want to ride a machine that's different, that revives memories, not the same old, same old, according to Yannick Reverdy, boss of Husqvarna Motorcycles France. We are living in a rather—in fact, a very—narcissistic age, and bikes reflect that. Are the latest models an attempt to turn back the clock? No, says Reverdy, because freedom is always forward-looking.

And what if women were the future of riding? What if they best represented this idea of freedom? One woman in particular embodies this desire to normalize the relationship between women and machines: Sandrine Dufils. Brought up in a small town, Dufils only ever wanted one thing: to run away. With the help of a Mobylette, she was able to escape the family home (in

the snow!), and thanks to her natural sense of line—whether on skis or on horseback—she obtained her rider's license in 1986. She spent the whole of her first year's wages on her first bike: a Yamaha Virago 250. Cars were simply not her dream: "On my bike, I could go where I wanted, when I wanted."[7]

In 1995, she fell in love with the Yamaha SR500, with its kickstart—which she finally got the hang of. She then took up racing, undergoing a baptism by fire at the Lurcy-Lévis circuit in central France, where certain events are restricted to women (known as "Petrol Heads"). The most skeptical observers were left open-mouthed by her prowess. She constantly pushed her own limits, even when riding an Aermacchi 350 that had been adapted for racing. Soon she was ready to participate in so-called "demonstration races"—in which there were no winners or

losers, but nevertheless some serious fighting for position, especially going into the corners. No podium places at stake; only pride.

In the early 2000s, Dufils finally hit the big time with a Yamaha TZ 350—the ideal two-stroke machine for real racing. Encouraged by Éric Saul, former Grand Prix racer and founder of the International Classic Grand Prix (ICGP) circuit, Dufils sent a signal to her male rivals by taking on the Daytona banking. "The banking is the nearest you get to flying. Right at the top, you're riding alongside a barbed wire fence. It's my most vivid memory of racing."[8] Supported by legendary racers Gary Nixon and Yvon Duhamel—and despite her orange jacket, to let other riders know she was a "beginner" —she finished 4th out of 18.

Mélusine Mallender in Nepal—walking in the footsteps of great explorer Alexandra David-Néel, perhaps?

For the next ten years, she was the only woman to compete in the ICGP—a circuit that is all about endurance, with races that even hardened competitors find arduous. At the Bol d'Or Classic, on a Yamaha RD350LC co-piloted by Monique Laoudi, Dufils finished a respectable 17th out of 55 entrants. The Le Mans Classic

"Freedom is having the greatest possible choice ... and an awareness of the responsibility that entails."

would be her swan song, after a bad crash on her Yamaha TZ 350. After that, she worked with an association called Toutes en Moto, created in 2010, which organizes motorcycle rallies all over France in support of campaigns for women's rights. The events take place on March 8th, International Women's Day. What would Bessie Stringfield have thought of that?

"I FELT ALIVE"

Achieving personal freedom in order to bring about universal freedom—this was the mission of Sandrine Dufils in the world of motorcycling ... and of Mélusine Mallender in the world at large. Her father was English, her mother French, and their home was always open to strangers—even to a family of gypsies, who parked their motor home in the garden! Not surprising, then, that Mallender always had a taste for adventure. In 2003, she took off on a 125 cc Honda Varadero and rode around France. Her first big expedition was in 2009, when she spent six months in Southern Patagonia with the explorer Christian Clot looking for forgotten peoples—this time not on a motorcycle, but on foot and in a kayak. The following year—again on her faithful Varadero, which by this time had clocked up almost

70,000 miles (113,000 km) —Mallender made a 14,000-mile (22,531 km) round trip from Paris to Vladivostok and back: "I felt alive. Conscious of my own freedom, I wondered what being free might mean to other people."[9]

This gave her the idea for *Road for Freedom*—a record of a solo journey across several continents to find out how different people understood the concept of freedom. And so Mallender found herself following in the footsteps of Anne-France Dautheville and Elspeth Beard a few decades later. Like them, she found that being a woman on her own made her welcome everywhere, sweeping away preconceptions about the dangers of countries such as Iran and Pakistan. In 2011, she traveled to "Persia," crossing 18 European countries and spending four months in Iran and Central Asia—a

trip of 17,500 miles (28,163 km) on a Honda Crossrunner 800.

Mallender turned each of her expeditions into a series of documentaries (sometimes four, sometimes six), all with women as their central theme: "A country can be measured by the extent to which its women are free. In most cases, they still have less of a voice and less influence [than men]. In countries such as Mali and Syria, they have very little freedom, but they are gradually becoming aware of their own importance."[10] Her partnership with Honda having come to an end, Mallender naturally turned to Triumph: "My mother had a Triumph Tiger.

She encouraged me to contact Triumph. She got her motorcycle license at 35 and had a 125

Life on the road—Mélusine Mallender is treated as a guest in Nepal.

for many years. When I got the contract with Triumph, she laughed and said, 'They used to say I was a head case; now I'm a pioneer!'"[11]

In 2014, on her Triumph Tiger 800 XCA, Mallender spent four months traveling around the great East African lakes—in Ethiopia, Kenya, Uganda, Rwanda, Burundi, and Tanzania—a distance of nearly 10,000 miles (16,000 km): "I was surprised by the diversity of Africa and especially by Rwanda, where there has been an enormous effort to reconcile the Tutsis and the Hutus. [Author's note: Civil war between the Tutsis and Hutus in 1994 left 800,000, mostly Tutsis, dead, according to the U.N.] More superficially, I was impressed by the availability of 4G and the ecologically-inspired ban on plastic bags."[12]

The title *Road for Freedom* was not chosen glibly. Mallender plans all her trips in great detail—not only logistically, but also ethnologically: "I'd heard about acid attacks on young women in Bangladesh and female enslavement in Nepal. I also wanted to meet women who were fighting for their rights, like Behnaz Shafiei, one of the very few female riders in Iran, where women are forbidden to drive cars, let alone ride bikes."[13]

In 2015, again on her Triumph, Mallender embarked on a 10-month marathon around South Asia, returning to France from Indonesia. For her, one journey leads to another. At the time of writing, she is preparing for a trip to South America, where she will cross Chile, Bolivia, Peru, Mexico, and Cuba ... in the foot-

steps of Che Guevara this time? Her definition of freedom has become more specific: "You feel free when you're no longer afraid to be yourself. Freedom is having the greatest possible choice ... and an awareness of the responsibility that entails."[14] She expects to be still using her passport when she is 90, and to go on traveling until she dies—like her idol, the great feminist explorer Alexandra David-Néel*. Today, she feels, other riders have a more positive opinion of her—more respectful, less condescending—than when she made her first trips on that little 125. "He who thinks freely for himself, honors all freedom on earth," wrote Michel de Montaigne in the 16th century. And everywhere, Mallender is approached by women who tell her that, thanks to her, the idea of freedom as a journey is taking root. "Wherever people are struggling to come to terms with the question of freedom, seeing my bike acts like a detonator,"[15] explains Mallender.

Which goes to show that riding is indeed a universal symbol of freedom.

* Beginning in 1911, David-Néel explored every corner of the Far East, including India, China, and Mongolia; and in 1924, she was the first Western woman to enter Lhasa, Tibet. She died in 1969 at the age of almost 101, leaving an impressive legacy of literary and scientific works.

"He who thinks freely for himself, honors all freedom on earth."

MICHEL DE MONTAIGNE
(1533–1592)

Mélusine Mallender
in Bangladesh—
"a country no one
ever talks about"—
in 2015.

INDEX

Page numbers in bold type refer to illustrations.

ENDNOTES

A LIFE ON THE ROAD

1. http://www.quotecounterquote.com/2012/01/today-is-first-day-of-rest-of-your-life.html
2. *IVoyage à motocyclette*, Ernesto Che Guevara, ed. Mille et une Nuits, 2007, p. 12.
3. *Ibid.*, p. 13.
4. *Ibid.*, p. 200.
5. *Portrait de l'aventurier – T.E. Lawrence, Malraux, Von Salomon*, Roger Stephane, ed. 10/18, Christian Bourgeois, 1972, p. 188 (reed. Points Aventure, 2014).
6. *Voyage à motocyclette*, Ernesto Che Guevara, ed. Mille et une Nuits, 2007, p. 16.
7. *Ibid.*, p. 22.
8. *Ibid.*, p. 24.
9. *Ibid.*, p. 28.
10. *Ibid.*, p. 41.
11. *Ibid.*, p. 53.
12. *Kerouac: Language, Poetics, and Territory*, Hassan Melehy, Bloomsbury Academic, 2016.
13. *Ibid.*
14. *Ibid.*
15. Article by Robert Sanford Brustein in the U.S. magazine *Horizon*, September 15th, 1958, quoted in *Sur la route. Le rouleau original*, Jack Kerouac, Gallimard, 2010, Preface by Howard Cunnell, p. 66.
16. Reply by Jack Kerouac to Robert Brustein in a letter dated September 24th, 1958, quoted in *Sur la route. Le rouleau original*, Jack Kerouac, Gallimard, 2010, Preface by Howard Cunnell, p. 66.
17. *Chroniques*, Bob Dylan, Fayard, 2005.
18. *Marlon Brando*, Tony Thomas, Henri Veyrier, 1974, p. 21.
19. *L'Assaut des motards*, Henri Lœvenbruck and Jean-William Thoury, Serious Publishing, 2017, p. 16.
20. *Marlon Brando*, Tony Thomas, Henri Veyrier, 1974, p. 73.
21. *Ibid.*, p. 78.
22. *McQueen et ses motos*, Matt Stone, ETAI, 2017, p. 28.
23. *McQueen's Motorcycles: Racing and Riding with the King of Cool*, Matt Stone, Motorbooks, p. 29.
24. *Ibid.*, p. 84.
25. *San Francisco, l'utopie libertaire des sixties*, Steven Jezo-Vannier, Le Mot et le Reste, 2010, p. 15.

FREEDOM AT ANY PRICE

1. Exhibition Catalogue "Revolution – You say you want a revolution", Labels et Rebelles 1966–1970, June 17th–October 29th, 2017, Musée des Beaux-Arts de Montréal, p. 115.
2. Exhibition Catalogue "Dennis Hopper and the New Hollywood," October 15th, 2008–January 19th, 2009, Skira-Flammarion-La Cinémathèque française, p. 130.
3. https://www.imdb.com/title/tt0064276/mediaviewer/rm1288191232
4. Exhibition Catalogue "Dennis Hopper and the New Hollywood," October 15th, 2008–January 19th, 2009, Skira-Flammarion-La Cinémathèque française, p. 62.
5. *Ibid.*, pp. 130–131.
6. *Hollywood Hellraisers*, Robert Sellers, Arrow Books, 2010, p. 64.
7. *The Chopper: The Real Story*, Paul d'Orleans, Gestalten, 2014, p. 169.
8. *Ibid.*, p. 175.
9. https://www.cram.com/essay/Easy-Rider-a-Pursuit-Of-American/FKAQFM3XC.
10. *The Chopper: The Real Story*, Paul d'Orleans, Gestalten, 2014, p. 170.
11. *Ibid.*, p. 185.
12. *Hollywood Hellraisers*, Robert Sellers, Arrow Books, 2010, p. 117.
13. *San Francisco, l'utopie libertaire des sixties*, Steven Jezo-Vannier, Le Mot et le Reste, 2010, p. 137.
14. Exhibition Catalogue "Revolution – You say you want a revolution", Labels et Rebelles 1966–1970, June 17th–October 29th, 2017, Musée des Beaux-Arts de Montréal, p. 67.
15. *Génération 1 : les années de rêve*, Hervé Hamon et Patrick Rotman, du Seuil, 1987, p. 176.
16. *Café Racer*, #92, article by Jacques Bussillet.
17. *Triumph, l'art motocycliste anglais*, Michael Levivier and Zef Enault, E/P/A, 2017, p. 60.
18. *Bob Dylan, une biographie*, François Bon, Le Livre de Poche, 2nd Ed. 2016, p. 234 (originally published by Albin Michel, 2007).
19. *Ibid.*, p. 365.
20. https://www.thestar.com/entertainment/music/2009/12/06/the_blood_and_the_stones.html
21. *Altamont 69. Les Rolling Stones, les Hells Angels et la fin d'un rêve*, Joel Selvin, Rivages Rouge, 2017, p. 219.
22. *Les Diggers. Révolution et contre-culture à San Francisco*, Alice Gaillard, L'Échappée, 2014, p. 124. (translated from French).

THE CONTINENTAL CIRCUS

1. https://emmapeelpants.wordpress.com/2010/09/30/hairy-and-melodic-marc-bolan/
2. *L'Âge d'or du Continental Circus*, Jacques Bussillet, GM Editions, 2015, p. 26.
3. *Ibid.*, p. 64. (translated from French)
4. *Moto, notre amour*, Paul Ardenne, Flammarion, 2010, pp. 28–29.
5–9. Personal communication.
10. *Moto Heroes*, #16, quoted by Philippe Canville.
11. *Ibid.*
12. *L'Âge d'or du Continental Circus*, Jacques Bussillet, GM Editions, 2015, p. 174.
13. *L'Année motocycliste 1970-1971*, Vol. 2, Pratiques automobiles, Maurice Cazaux and Henri Lallemand, 1970, p. 148.
14–15. Personal communication.
16–19. *Champions français moto GP : Pons, Sarron, Rougerie et les autres*, https://www.youtube.com/watch?v=wvPd62Cy_6M.

THE WORLD IS YOUR OYSTER!

1. Exhibition Catalogue "Revolution – You say you want a revolution", Labels et Rebelles 1966–1970, June 17th–October 29th, 2017, Musée des Beaux-Arts de Montréal, p. 243.
2. *Île de Man. TT73*, photographs BY Herve Tardy, text BY Jean-Louis Basset, E/P/A, 2017, p. 21.
3. *Hippie, Hippie Shake*, Richard Neville, Rivages Rouges, 2009, p. 138 (first published 1995).
4. *La Motocyclette*, Gallimard, 1963, p. 108.
5. *Ibid.*, p. 74.
6. *Ibid.*, p. 13.
7. *Ibid.*, p. 36.
8. *Ibid.*, p. 208.
9. *Zen and the Art of Motorcycle Maintenance*, Robert R. Pirsig, William Morrow and Company, 1974, p. 3.
10. All quotations from Anne-France Dautheville are personal communications.
11. Interview with Elspeth Beard on www.bmw-motorrad.fr 12. *Moto Revue Classic*, #98.
13–17. Personal communications.

NEW DIRECTIONS

1. Song of the Sausage Creature, Hunter S. Thompson, Cycle World, 1995.
2. *Moto Heroes*, #5, quoted by Philippe Canville.
3–5. Personal communications.
6. *Freeway Magazine*, #314, Henri Lœvenbruck, February 2018.
7–15. Personal communications.

PHOTO CREDTS

© Anne-France Dautheville/Chloé/DR: 149–152
© Archives JL Basset: 71
© Aurimages:
 A.I.P./The Kobal Collection: 51
 Corona/Allied Artists/The Kobal Collection: 33
 Richard Busch/The Granger Collection, New York: 85
 SunsetBox/AllPix: 38
© Barney Peterson/San Francisco Chronicle/Polaris/Starface: 24
© Bridgeman Images:
 Christie's Images: 19
 Collection CSFF: 35, 39
 Dieter Demme/Picture Alliance: 32
 Henry Diltz: 4, 52–53
 Mondadori Portfolio: 28
© Coll. Bernard Fau: 109
© Coll. Bruno des Gayets: 70
© Coll. Didier Ravel/DR: 116
© Coll. Sandrine Dufils/DR: 182
© Courtesy Ann Ferrar, biographer of Bessie Stringfield: 181
© Courtesy Don and Derek Rickman: 37
© Daniel Beres/Clutch Motorcycles: 170
© DR: 26, 75, 138, 141
© Élise Boularan/Hans Lucas: 174–175
© Elspeth Beard: 153, 154–155
© Fenouil: 159, 164–165
© François Beau: 115, 122–123
© François Gragnon/Paris Match/Scoop: 43, 44, 45
© Frank Monaco/Rex Features/Sipa Press: 136
© Getty Images:
 Allen Ginsberg/Corbis: 18
 Bill Eppridge/The LIFE Picture Collection: 79
 Fotos International: 55
 GAB Archive/Redferns: 83
 Gilbert TOURTE/Gamma-Rapho: 59
 Henry Diltz/Corbis: 81
 ISC Images & Archives: 73
 John Dominis/The LIFE Picture Collection: 40–41
 John Springer Collection/Corbis: 23
 Michael Ochs Archives: 140
 Movie Poster Image Art: 34
 Paul Popper/Popperfoto: 135
 Peter Hall/Keystone Features: 137

PYMCA/UIG: 133
Robert Altman/Michael Ochs Archives: 82
Silver Screen Collection: 31, 62–63
Spencer Platt/AFP: 21
SSPL: 134
Susan Wood: 61
Ted Streshinsky/Corbis: 48–49
Ullstein Bild: 56
Universal/Corbis/VCG: 7
© Hervé Tardy: 98–103
© Jean-Pierre Bonnotte/Gamma-Rapho: 139
© Leemage:
 Mirrorpix: 57, 94, 97, 112–113, 132
 Photo Angelo Deligio/MP/Portfolio: 108
 Seine-quiquere: 69
 SSPL/NMeM/Daily Herald Archive: 131
 Zumapress: 20
© Magnum Photos:
 Elliott Landy: 86, 87
 Danny Lyon: 4, 8-9, 66–67
© Mihail Jershov/MJ Studio: 171, 172
© Photo Mil Blair/Easyriders Magazine Archive via Paul d'Orléans: 65
© Roger-Viollet: 11, 161
 Gilberto Ante/BFC/Gilberto Ante: 13
 Janine Niepce: 76-77, 111
 John Dominis/The Image Works: 88-89
 Lisa Law/The Image Works: 47, 84
© Ron Custard Collection/DR: 37
© Rue des Archives:
 Everett: 12, 14–15, 29, 50
 RDA: 17, 58
© Sails and Rods:
 Goetz Goeppert: 5, 166–167, 169, 173
 Micou: 72, 74, 93, 96, 105, 107, 110, 120–121, 125, 126–127, 160, 162, 163
© To Be Continued: 119
© Triumph Motorcycles: 27
© Uwe Ommer: 5, 128–129, 156, 157
© Yan Morvan: 5, 90-91, 142–147, 176–177, 178–179
© zeppelin:
 Christian Clot: 183, 184
 Suman Paul: 186–187

ACKNOWLEDGMENTS

This book owes its existence to the numerous books and articles that have been published on riding, adventure, 20th-century history, and many other subjects. I would like to thank in particular Philippe Canville, of *Moto Heroes*, for allowing me to reproduce extracts from his perspicacious interviews; Christophe Gaime, of *Moto Revue Classic*, who patiently conveyed his insights into the contemporary riding scene and the neo-custom era; Henri Lœvenbruck and Jean-William Thoury, for sharing their knowledge of the "Hollister Riot," as described in their book *L'Assaut des motards* (Serious Publishing, 2017); Jacques Bussillet, whose articles I have loved reading for many years; Jean-Patrick Vella, for the Swiss-watch precision of his information on the Coupe Kawasaki and the 1969 Bol d'Or; Jean-Pierre Lagriffoul, for his research and support; Thierry Conrad of Chloé; Vincent Brançon of TBC Production; Anne-France Dautheville, Elspeth Beard, Nanou, Sandrine Dufils, Mélusine Mallender, Fenouil, Bernard Fau, and Micou, for giving me their time; Stéphanie Varela, who gave Christian Ravel an unexpected life *post mortem*; Didier Ravel, who described his brother with such subtlety and skill; Raphaël, from the Passion Automobile bookshop, for putting me in touch with Rina Tanaka; Arnaud Letrésor, of Sails & Rods, for his understanding; Yan Morvan, for his generosity; Uwe Ommer, who allowed me to rummage through his collection of photos of the 1972 Raid Orion; Richard Verdelet, whose article on the same rally for *Automobile Magazine* is a model of its kind; and Hervé Tardy and Jean-Louis Basset, for allowing me to use photographs from their book *Île de Man. TT73* (E/P/A, 2017). I would like to pay special tribute to Sylvain Tesson and Paul Ardenne, whose books *En avant, calme et fou* (Albin Michel, 2017) and *Moto notre amour* (Flammarion, 2010) have ensured a place in literature for the world of riding. Finally, thank you to all those anonymous writers and contributors for their many pertinent articles, which I have been reading since the early 1970s, when riding entered its Golden Age.

Jean-Marc Thévenet